AUDIO AND VIDEO RECORDING

AUDIO AND VIDEO
RECORDING DAVID KIRK

FABER & FABER 3 QUEEN SQUARE
LONDON

First published in 1975
by Faber and Faber Limited
3 Queen Square London WC1N 3AU
printed in Great Britain by
Latimer Trend & Company Ltd Plymouth

ISBN 0 571 10530 0

CONTENTS

TO JENNIFER

The magnetic tape recorder and the gramophone have long been every-
day tools in the school, the factory, the office, and the home. In recent
years, the implements of electronic communication have grown in
variety and complexity to a degree which can fairly be called a techno-
logical revolution. Yet this revolution is concerned not so much with
technology as with price. Not until the present decade, the nineteen
seventies, has mankind as a whole gained access to machinery allowing
the almost zero-cost recording of endless sound-accompanied moving
pictures. Television, once confined by financial considerations to cor-
porate bodies—commercial and state broadcasting organizations, is now
within reach of any human individual who chooses so to channel his or
her resources.

What can be accomplished with this new generation of tools: low-
price video tape recorders, video mixers, television cameras, capacitor
microphones, electronic sound synthesizers? How will true public
access to television influence the evolution of that art form? And will
audio survive as a separate branch of communication or become totally
and permanently integrated with its optical equivalent? Such questions
are beyond the scope of this book. My simple purpose has been to pro-
duce a practical guide to the audio and video equipment now widely
available. I have endeavoured to present a coherent account of how
each component functions, what it was designed to accomplish, and
what can additionally be achieved by occasionally bending the rules.

In writing a book of this nature, one is faced on almost every page by
two opposing questions. On the one hand, am I getting too involved in
technicalities? And on the other, am I incurring the reader in later con-
fusion through oversimplification? Whether I kept sufficiently close to
the straight and narrow path is for the reader alone to decide. Certainly
this is not intended as more than a primer of engineering theory. At a
practical level, however, it contains the fruits of fifteen years' involve-
ment in sound recording and some five years in closed-circuit television.
During this period, I have enjoyed encouragement from many quarters.
I would like in particular to thank the late H. W. Hellyer and the late
Terence Long, Raymond Cooke of KEF Electronics, Thomas Reps of
Magnetic Tapes, and Roderick Snell. Any merit in this book is due in
substantial measure to them; any errors entirely to me. Nor should I

omit to thank Heather White for transcribing my longhand original into a more presentable state.

A concluding note before I get down to business. In the hundred years or so since the development of Edison's cylindrical phonograph, audio technology has been evolved to a point which, though hardly yet perfected, is at least within reach of perfection. This cannot, however, be said of television. Video is still very much in its formative period and all who become involved with it do so at some risk to their sanity. Miracles come easily on elaborate equipment but the educationalist, the dramatist, and the visual artist will find their talent and their patience fully stretched in coping with a single-camera, single-recorder, single-monitor video system. Many hours may be consumed in trying to emulate broadcast television standards, often to no avail, until the operator realizes his or her particular abilities in that demanding medium. Nevertheless, there is more lasting pleasure in creation than in mere consumption. And more value.

In 1877, Thomas Alva Edison produced the first practical sound recorder—the original phonograph. Unlike the ancient Romans, who are reputed to have tried storing sound in bottles, Edison realized that sound was essentially vibration. Place your fingers against your throat while talking aloud and this characteristic becomes obvious. It is also possible to feel the vibration of many musical instruments simply by touching their soundboard. The effect is more obvious in the bass than in the treble.

When a musical instrument vibrates, this virtually invisible motion in turn vibrates the surrounding air. This air movement correspondingly vibrates our eardrums and produces the sensation of hearing.

Edison produced a form of artificial eardrum, a flexible 'diaphragm' connected to a small needle. The needle pressed against a sheet of tinfoil which was pulled along by hand. Any fairly loud noise produced near the artificial eardrum caused the needle to vibrate. This affected the shape of the small furrow being traced in the tin-foil by the needle. The edges of this furrow were relatively smooth during the silent interval between each spoken word but became increasingly rough as the ingoing sound grew louder. This roughness was no random pattern, however. It corresponded closely to the speaker's vocal chord vibrations and thus constituted a permanent sound record.

How to replay such a record? Quite simply, the needle was returned to the beginning of its furrow and the tin-foil pulled in the same direction as before (actually rotated on a cylinder). Now the rough sides of the furrow caused the needle to vibrate, and in turn the flexible diaphragm. The artificial eardrum had become an artificial voice, though as effective with music as with human speech.

Here in essence we have the gramophone system. Modern plastic discs have replaced cylindrical sheets of tin-foil but the principle is little changed. Today's needles are smaller, tracing a smaller furrow, and transistor amplifiers are now used in place of the old ear-trumpets to cure the gramophone's appalling deafness.

Recording with magnets
At first sight, a magnet would appear to have little use beyond picking up strong nails. Most people must be familiar with the following

B

method of magnetizing pins and other small steel objects: one end of a permanent magnet is stroked down a pin from head to tail, the magnet then being lifted away and applied again to the pin head. If this motion is repeated some eight or ten times, the pin becomes a permanent magnet in its own right. Like any other such magnet, the pin will now attract other steel objects and can even be used to create further magnets. If the pin is suspended from its middle by a thin cotton strand, one end will always point in the same direction. Should the sharp head point northwards, this is identified as the 'north seeking pole', usually abbreviated to the magnet's 'north pole'.

Sound, remember, is essentially vibration. Any recording device capable of storing at least 3,000 vibrations per second (3 kiloHertz) would be capable of handling sound. Supposing we had a machine which magnetized pins at a rate of about 10 kiloHertz (kHz). The louder the sound, at any instant, the more strokes a pin would receive and thus the stronger would be its magnetism. Our machine would lay the pins in a straight line, head to tail; we might even glue them together so that they could be wound round a spool.

Thanks to Michael Faraday's work on electromagnets, this arrangement is not merely easy, it is fantastically easy. We can forget about separate pins and use instead a continuous magnetic medium such as steel piano wire or indeed magnetic tape.

The very first magnetic recorder, produced in 1888 by the Danish physicist Valdemar Poulsen, used steel wire in just such a manner. This was a primitive device compared with later wire recorders, being designed to record the pips and squeaks of Morse Code.

How is it possible to convert sound vibrations into a corresponding row of magnetic patterns? *Figure 1* shows a permanent magnet suspended (by a flexible spring) inside a coil of wire. It is in fact a crude microphone. If we suspended such a device from the ceiling and spoke upwards to it, the air vibration produced by our voice would strike the bottom face of the magnet. Being on a flexible mount, the magnet would then vibrate in sympathy. A high-pitched sound would produce very rapid vibration, and a low-pitched sound correspondingly slow vibration.

Inside the coiled wire, the wire itself, strange things are happening. This solid-looking stuff, like everything else, is composed of atoms. Atoms, in turn, comprise a number of small particles—many of which would not be affected by our vibrating magnet. One group of these particles, the electrons, is very sensitive to external magnetism. Our vibrating magnet creates an electrical wind which blows nearby electrons alternately to and fro. The magnet has in fact generated a weak electric current in the wire. Like our mains power supply, this is an 'alternating' current—a current which flows backwards and for-

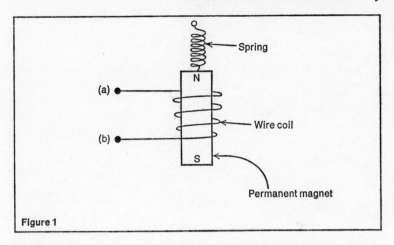

Spring

(a)

Wire coil

(b)

Permanent magnet

Figure 1

wards like a solid line of ping-pong balls in a large hosepipe. If the microphone is subjected to a loud bass sound, it will create in the electrons a strong shove, followed by a similarly strong tug, for every vibration of the surrounding air. Should this 'alternating' electron movement be difficult to comprehend, remember that our vocal chords also move alternately forwards and backwards—or 'oscillate'.

Having turned sound into electrical vibrations, we require a means of storing it. For most practical purposes, the medium generally considered the most convenient and effective is magnetic tape. *Figure 2* shows another simple magnetic device resembling the familiar bar magnet. Here we have a coil of wire wound round an iron core. The choice of iron rather than steel is important. Although they have similar mechanical qualities (both make good bedsteads), iron and steel have an important magnetic distinction. By stroking steel pins with a magnet, we can magnetize them permanently. Iron pins, on the other hand, 'forget' their acquired magnetic properties as soon as the 'parent' magnet is removed.

Our model microphone demonstrated how easily electricity can be generated by a (moving) magnet. This process also works backwards—magnetism can be generated by electricity. If an electric current flows through the wire coil in *fig. 2*, the iron core becomes a magnet and stays that way until the current is turned off.

If we now connect wires *a* and *b* of our microphone (*fig. 1*) to the *A* and *B* coil of our *fig. 2* electromagnet, we finally have a magnetic recorder in its very simplest form. A voice near the microphone generates an alternating current in the microphone coil. This is connected (*a* to *A* and *b* to *B*) to form a single circulation path for the

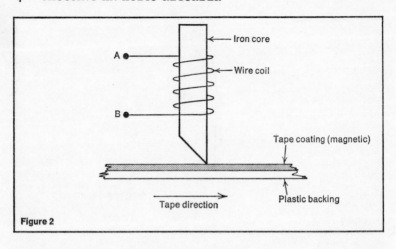

Figure 2

electrons in the wires. The microphone coil electrons then tend to push and pull the electrons in the *fig. 2* electromagnet coil. This creates alternately north- and south-seeking magnetic fields at each end of the iron core which may be 'recorded' on a steel wire, steel tape, or iron oxide tape pulled past one or other pole of the electromagnet.

So how is the tape replayed? Merely by rewinding it to its beginning and again pulling it past one end of the iron electromagnet. If we now listen to our 'microphone', as was the case with Edison's phonograph, it will be heard emitting the sounds previously recorded. (In practice the sound would be so weak in level as to be almost inaudible; the system again requires an electrical amplifier to overcome its inherent deafness. The sound would also be distorted, for a reason later to be explained.)

Why should our microphone act as a loudspeaker when these two objects, in everyday life, look so different? The main reasons for their superficial difference is that the sound levels experienced by a microphone are usually much lower than those emitted by a loudspeaker. Consider a public address system. You speak fairly quietly into a microphone. The electrical signals are amplified and then fed to a relatively large loudspeaker. Unlike a microphone, a loudspeaker is designed to vibrate larger quantities of air than could be achieved by the unaided talker or performer. The vibrating element is thus larger, stronger and more flexible in a loudspeaker. But here we are moving from elementary electromagnetism into the world of acoustics, a field which will be considered later.

Tape speeds

The very first magnetic recorder, as we have discussed, used steel wire of the kind employed in the treble end of pianos and harpsichords. Later recorders used steel tape, a particularly dangerous medium when the tape snapped in the vicinity of an engineer's arm or body. During the Second World War, the Telefunken company in Germany pioneered a method of painting iron oxide powder on paper ribbon. This gave better electrical characteristics than steel and was much lighter and safer to handle. The iron oxide is closely related to the rotting metal we know as 'rust'. By the end of the war, it was clear that 6·25 mm wide tape running at 100 cm/s was a practical medium for high-quality sound recording. American and British engineers, confiscating the Telefunken recorders as part of German reparations, converted the speed to a round Imperial figure of 30 inches per second (76 cm/s) and began manufacturing remarkably similar equipment. These early machines were mainly restricted to film and sound broadcasting studios but, before long, lighter and cheaper tape recorders were designed for use in the home.

Then, as now, magnetic tape was not the cheapest of commodities. Manufacturers therefore offered the domestic market recorders with lower tape speeds, allowing two, four and eventually eight times more sound to be recorded on any one spool of tape. Thus speeds of 19, 9·5 and 4·75 cm/s came into use. The reduction in speed unfortunately brought a comparable reduction in recording quality. The sound, one might say, became more 'grainy', though it was none the less a considerable improvement on the hissy 78 rpm gramophone records to which many ears were accustomed.

Track widths

As tape speeds diminished, so too did track widths. Initially the track width was the same as the tape width: 6·25 mm. But why not divide the tape into an upper half and a lower half, thereby doubling the recording time without further lowering the speed? Why not indeed. 'Half-track' tape recorders came rapidly into vogue during the early 1950s, followed fairly soon by 'quarter-track' machines. *Figure 3* shows these three formats. Again, reducing the track width has a detrimental effect on quality, to the extent that a shoddily made recorder playing a quarter-track 4·75 cm/s recording can sound chronic, even to the most uncritical listener. I will immediately complicate the issue by adding that a good recorder can sound quite reasonable playing the same tape at the same speed and track width. Just why will become obvious as we progress.

Squeezing more and more tracks on a narrow tape is like cramming extra lines of print on a page by reducing the height available for each line. The smaller the spacing, the more difficult the book becomes to

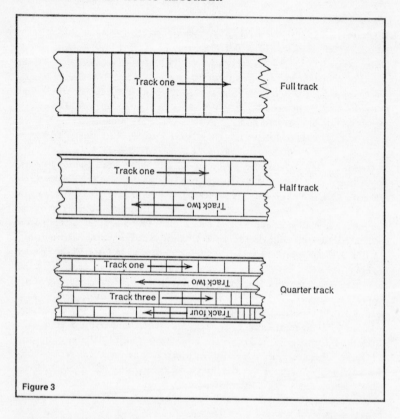

Figure 3

read—until eventually your eyes drift from one line to another in con-
fusion. To avoid this kind of 'mistracking', a narrow 'guard-band' is
left between the two (or four) tracks. If this were not present, track 2
would be heard faintly beneath track 1 (running backwards, to spoil
things further).

Spool capacity

The majority of domestic tape recorders are large enough to take spools
of 18 cm diameter. *Figure 4* shows the way a tape is threaded from the
left-hand 'feed-spool' to the right-hand 'takeup spool'. A spool of this
diameter will carry enough 'standard play' (standard thickness) tape for
32 minutes uninterrupted recording. This can be extended by purchas-
ing thinner tape, available as long play, double play, and triple play.
Long play gives 1½ times the duration of an 18 cm spool of standard
play (48 minutes per track). Double play gives 64 minutes, and triple
play 96 minutes, per track.

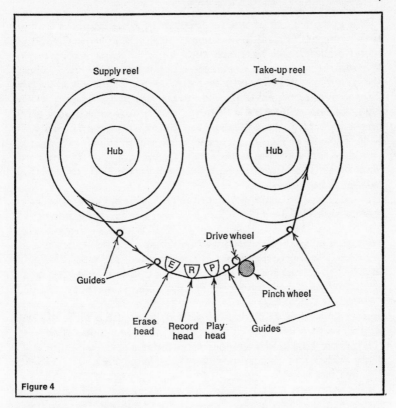

Figure 4

Recording levels

Virtually all tape recorders incorporate some kind of measuring device to show the level at which the recording is being made. Like our ears, a tape recorder will adjust to suit a wide range of sound levels from the soft ticking of a clock to the painfully loud output of a pop group.

The technical term for this effect is 'automatic volume control' or 'automatic gain control'. Many domestic tape recorders incorporate such devices, making them very easy to operate. They cannot confidently be recommended for music, however, as they tend to compress the very loud *fff* down to a uniform *f*, raising *ppp* in a similar manner. The resultant music is dull, in the long term uninteresting, and for some purposes worse than useless. Imagine a student pianist presenting a compressed tape to a teacher. However good the original performance, the student would be blamed for paying insufficient attention to the dynamics.

The great majority of tape recorders incorporate 'manual gain controls', comparable with the volume control of a household radio. A mono recorder will have one such knob, a stereo recorder two. Whereas the controls on a radio receiver govern the sounds you hear, the record level controls on a tape machine are heard only indirectly. They govern the signal level going to the tape itself. If this is set too high, the tape will record a distorted pattern that sounds very gritty on playback. If the controls are set too low, however, the tape will have to be replayed at a much higher level than normal and will hiss like an old 78 rpm disc. Between the two extremes, a good recorder will make relatively undistorted recordings with background hiss levels low enough to be ignored.

Some form of visual guide is provided in almost every recorder so that the signal level may be adjusted by eye. The most common device is a Volume Unit (vu) meter (*fig. 5*). This is used in the following manner: a microphone placed reasonably near the performer is connected to the appropriate input of the recorder. The tape machine is switched to record and the input level control raised until the meter needle swings actively across the printed scale. At this point, the performer is asked to play the loudest passage he expects to encounter during the session. If the input level has been set too high, this will send the meter needle beyond the 'o' mark into the high-distortion zone.

If the recording level is set too low, the meter may scarcely move at all. When such a tape ('under-modulated') is played back, the hiss level may be objectionable.

Like many mechanical devices, the vu meter has an Achilles' heel. Although the vu needle may appear to react rapidly to changes in sig-

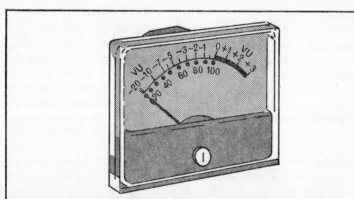

Figure 5 Volume unit meter scale (closely resembling European peak
programme meter)

nal level, it is in fact a sluggard. Consider the sound produced by a violin. In most instances the music will be fairly consistent in level—each note following smoothly on from the other. A vu meter will cope with this quite effectively, giving clear warning of any 'peaks' likely to be distorted.

Now consider a piano. Each note is produced by striking one or more metal strings with a felt-lined hammer. Each note begins very loudly but rapidly falls away to a lower—slowly diminishing—sound level. The piano, has a sharp 'attack' and a slow 'decay'. When a piano note is struck, the vu needle rises as quickly as it can towards the initial loudness peak. Yet already this peak has passed into history and the sound level is falling. The vu needle meets the true signal level on the latter's way down and the operator is left with no idea of the high level really achieved.

Given such a meter, which underestimates the level of transient and percussive instruments while being more accurate with (for example) organs, we immediately meet a need for pure and simple experience in interpreting the vu reading. No matter what a vu meter may indicate (nominally an *average* signal level), if the resultant recording sounds distorted then the advice of your ears should take precedence.

The peak programme meter
Having covered the main disadvantage of the vu meter, let us now consider a device which overcomes the vu's inability to measure rapidly rising and falling peaks. The peak programme meter (PPM) reads the *maximum* level attained by an audio signal during any given fraction of a second. Since this maximum may vary enormously over a very short period, a meter which exactly followed the sound-level contour would move so wildly that it might scarcely be visible. The PPM needle is therefore arranged to fall much more slowly than it rises.

If the PPM misleads, it does so on the side of safety—assuming you regard too much tape hiss as preferable to too much distortion. It is in my opinion totally preferable to the vu meter.

Just to make life complicated, peak programme meters come in two kinds. One is calibrated in virtually the same way as the vu meter (*fig. 5*), from −20 dB through 0 dB to +4 dB. What is this curious 'dB'? Short for 'decibel', it is a unit of ratio employed in measuring relative voltage levels, sound levels, and electrical power levels.

Working with a dB calibrated peak programme meter, the needle may be allowed to approach and even cross the 0 dB point without risk of overloading the tape. My own practice has always been to adjust the recording level so that loud music passages touch 0 dB, leaving 4 dB 'headroom' for the very loudest. If the performers become so carried

away that the meter stays hard on the 4 dB extreme for several seconds, only then would I gently lower the recording level.

The dB-calibrated PPM is generally known as the 'European type' to distinguish it from a variant used (at the time of writing) throughout the BBC. This behaves in much the same way but is calibrated in the style of *fig. 6*.

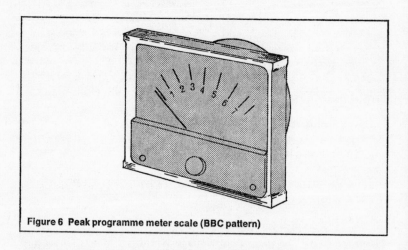

Figure 6 Peak programme meter scale (BBC pattern)

Other forms of signal-level indicator exist but are so rarely found on modern recorders that a brief survey will suffice.

The 'magic eye', also used as a tuning device for radio receivers, disappeared when valves were superseded by transistors. It comprised a small green phosphor bulb which flickered in accordance with the ingoing audio level. At optimum level, two fingers of light would almost touch. Too high a level and they would overlap, glowing still brighter to indicate the fault condition. These devices registered peaks and were sometimes superior to VU meters though lacking any sensible form of calibration.

A more recent development is the 'incremental light-emitting diode display', which comprises a column of tiny lights, one above the other. When the incoming signal level is low, all the lamps remain off. A low-level signal illuminates perhaps the first two or three bulbs, the lowest of the column, while higher-level signals increase the height of the illuminated column by turning on progressively more bulbs. The device is very versatile since it is narrow enough to allow a single operator to watch a very large number of separate signal levels. Some audio devices contain as many as thirty separate meters and it is little short of impossible to watch them all.

The tape transport

Mankind is rapidly exhausting the earth's accessible supplies of raw metal and this has been reflected in recent years by the more economical construction of everyday commodities. Plastics are increasingly taking the place of steel. In situations where metal is still expected, we again find plastic—chromium plated.

Plastics are widely used on the visible surfaces of the cheaper tape recorders but, being much weaker than steel, are not adequate for the vital components. Obliged to use expensive metals, the manufacturer therefore reduces his costs by minimizing the size and thickness of the metal parts. Where a more generous maker would use a steel lever, the cost-conscious designer may employ a steel wire. Elsewhere, a rotating shaft the size of the reader's smallest finger will be pared down to the diameter of a panel pin. Where one maker uses three large motors, another will use a single small one. Factors of this kind have to be considered when choosing a tape recorder though the rules governing this choice are fortunately straightforward. Opt for the *simple* design rather than the complex; there will be less to go wrong. Choose the heavily built machine (within reason) in preference to the lightly constructed; there should be greater resistance to wear.

Wow and flutter

These expressions refer to the most important characteristic of a sound recorder—its speed steadiness. Most people know the slurring effect produced when a gramophone record is slown by dragging a finger against the turntable. As the disc speed falls, so do the pitch and tempo. If the speed is substantially increased, the result is a tendency towards 'Mickey Mousing'—on speech at least.

Readers possessing 'perfect pitch' will be aware that many gramophones and tape recorders run so fast, or so slow, that music is reproduced in the wrong key. Where this occurs with commercial discs, the offending record player may confidently be blamed and either tolerated, repaired or replaced.

Where a tape recorder appears off pitch, there is no immediate cause for alarm. If Mr Green's tape sounds flat on Mr White's recorder, it is possible that White's is running below standard speed. But it is equally possible that Green's machine was running fast when the tape was recorded. This problem is one of absolute tape speed and the remedy may be a new tape machine.

If the speed of a disc or tape machine is audibly unsteady, due perhaps to a badly made drive system, the effect is known as 'wow'. Where the unsteadiness occurs faster than about 15 fluctuations per second, the audible effect changes and so does the name—to 'flutter'.

A wowing recorder will add *vibrato* to a classical guitar recording, regardless of whether the guitarist is playing *vibrato* or not.

Wow is much more objectionable on instruments that are never played with *vibrato* in reality—such as the piano. While severe wow produces a regular or random *vibrato*, lower levels of wow merely (!) make the piano sound out of tune with itself. Severe flutter is audible not as a rapid pitch change but as distortion.

The ideal machine

To summarize, it is quite easy to outline the essential requirements of a recorder to suit any one purpose.

We require a recorder ideally suited to recording live instrumental music, singing and speech. It must be light enough to carry to and from a car, be mechanically reliable, and have the following basic specification:

Tape speeds: 38 and 19 cm/s.
Tape width: 6·25 mm.
Spool capacity: 18 cm (at least).
Tracks: Half-track mono or (preferably) half-track stereo.
Meters: Peak programme (ideally) or Volume Unit meters.

Typical recorders meeting these requirements are manufactured by Ferrograph (Britain), Revox (Germany and Switzerland), Brenell (Britain), and Magnetic Tapes (Britain), none exceeding about half the price of a very small motor car. (With prices in a near-continuous state of flux, I dare not be more specific.) Now there is no reason why even this comparatively high sum should be spent on what after all is only likely to be an adjunct to a pleasurable hobby. If you have the money, then choose a new recorder of the kind outlined—holding a little back for one or two microphones.

And if you choose not to spend so much, tolerate a little inconvenience and buy second-hand. This is one of the safest fields for second-hand equipment since many tape recorders are purchased on impulse and are used no more than an hour or two each week.

Inflation or no inflation, a figure of £60 should remain sufficient throughout the 1970s to pay for a good 19 or 38 cm/s recorder. This is unlikely to buy any manufacturer's most recent models but major design changes are an extreme rarity due to the high cost of factory re-tooling. Both Revox and Ferrograph ran essentially unchanged designs for some sixteen years before substantially altering their recorders. The last major change coincided with a shift from valves to transistors. At the time of writing, the cheaper second-hand recorders (Revox *E36*, *F36*, *G36*, Ferrograph *2*, *3*, *4*, *5* and *6* series, Brenell *Mark 4* and *5*) all employ valves. Since the valves in question are all common types, no difficulty should be experienced in obtaining replacements.

Recorders of the foregoing kind are generally termed 'semi-industrial' since they are used in domestic sound systems and in a wide range of industries, including recording and broadcasting studios. The latter often use such machines for routine editing and copying where very high quality is secondary to price.

Many people, and indeed many educational establishments, own recorders designed solely for the domestic environment. This equipment is almost without exception less robust than the 'semi-industrial' type but is usually correspondingly cheaper. The majority of modern open-reel domestic recorders are quarter-track (four-way mono or two-way stereo) and operate at 9·5 cm/s. Many have switched speeds above or below this standard, these being 19 and 4·75 cm/s. Provided these machines are kept meticulously clean around the heads and tape path, and provided reputable brands of long-play or double-play tape are employed, the resultant sound quality can be reasonably good. Thicker tape than long play (standard play) can result in poor contact with the head faces, resulting in audible 'dropout'. This in turn is caused by oxide particles flaking away from the tape surface, making the tape relatively insensitive at that point. Dropout problems are seriously aggravated by low speeds and narrow tracks; hence the necessity for frequent head cleaning and for high-quality tape.

The twentieth century has seen a number of parallel developments in respect of sound reproduction, giving the consumer a wide choice of programme sources quite apart from his or her own tape recordings. Commercial recordings may be obtained on disc, cassette, cartridge and open-reel tape formats, all four media being additionally capable of carrying small-quantity independent productions. Radio broadcasting in turn has evolved along three branches: amplitude modulated audio (AM) for long-distance penetration, frequency modulated audio (FM) for high-quality local broadcasting (rendered non-local by networks of repeater transmitters acting in concert), and very-high-frequency/ultra-high-frequency (vhf and uhf) television. Treatment of the latter is left to Chapter Nine.

Discs

An end to the popularity of gramophone systems has been predicted for many years though there are good reasons for believing the format, albeit much reduced in size, will survive into the next century.

The principle of disc reproduction has changed little since Edison's original experiments in 1877. Emil Berliner is credited with developing flat discs in preference to bulkier cylinders though in doing so he introduced a curious fault into the system. All commercial disc reproducers (to date at least) employ a constant turntable speed. For most practical purposes this is currently 33 revolutions per minute (rpm). Since the groove circumference diminishes as the pickup stylus progresses towards the centre of the disc, the effective groove velocity also falls. This causes greater cramming of groove vibrations as the record approaches its end. The result can be a progressive deterioration in quality though, as it is incurred gradually, the ear is not unduly conscious of the slow rise in distortion.

To prevent high-level bass notes from causing excessively wide groove modulation, which would drastically reduce the available recording time, audio signals are passed through a bass filter before reaching the disc cutter.

If the reproduced signal from a disc is simply amplified, it will be heard severely lacking in bass and generally 'treble heavy'. A corresponding 'equalizer' is therefore employed to raise the bass and reduce the treble, recovering the original 'flat' frequency response. Needless

to say, a standard pair of treble pre-emphasis/de-emphasis curves are essential and are indeed employed throughout the world.

Stereo discs

When Columbia Broadcasting System developed the mono 33 rpm 'microgroove' disc, they chose lateral (sideways) groove modulation in preference to the hill-and-dale (vertical) alternative. When stereo became the order of the day, use was made of both lateral and vertical modulation to carry the two signal channels. More precisely, the lateral and vertical axes were tilted from a + to an × arrangement to overcome a series of minor production problems. *Figure 2:1* illustrates a pickup incorporating the two transducer elements necessary for stereo. Note the familiar moving-coil system on the same principle as that employed in moving-coil microphones. A few manufacturers have modified the capacitor principle for disc tracking.

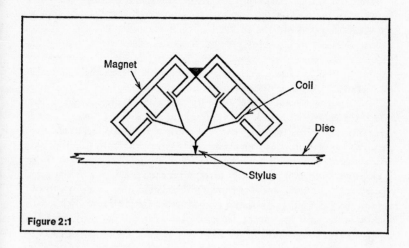

Figure 2:1

Quadraphonic discs

These must not be confused with the 'pseudo-surround' system which employs a simple technical 'trick' (no other word is appropriate) to derive a third channel from the two channels inherent in a stereo disc. A true quadraphonic disc employs a high-frequency 'carrier' as a vehicle for the additional pair of channels, incidentally making great demands of the pickup. In essence, two channels are handled in the usual 20 Hz to 20 kHz audio spectrum while the remaining pair are lifted 'upstairs' between 20 kHz to 40 kHz.

Gramophone pickups

The two most common pickup types are the magnetic and the ceramic. The former has been discussed; the latter employs the piezoelectric principle found in ceramic microphones. Like ceramic microphones, ceramic pickups generate relatively high signal voltages and tolerate less sensitive (therefore cheaper) amplifiers than do magnetics. With very few exceptions, moving-coil pickups give higher audio quality than their ceramic counterparts.

Tracking weight, the weight with which the pickup bears down on the groove, has gradually lessened since the early years of microgroove discs. The lighter the tracking weight, as a general rule, the higher the quality since the stylus is that much less encumbered. It should be kept in mind that a record stylus is subjected to very high acceleration and deceleration forces when it tracks a modulated groove. Another benefit of light tracking weight is reduced disc wear.

What decides the tracking weight of any given pickup? This is a function of the supporting arm and the disc itself as well as the pickup structure. A good pickup allows sufficient flexibility for the stylus to follow the minutest useful groove contours, defined as 'high compliance'. Poorer pickups have an excessive tendency to resist groove motions, trying to force a straight path through these obstacles rather than contort round or over them. Some types of programme are more difficult to track than others, one of the worst being organ music. The wear factor is complicated by tracking at too light a weight since any consequent 'mistracking' can add permanent distortion to the host groove modulation. For this reason, it is safest to err on the high side when setting or resetting tracking weight. Provided a diamond stylus is employed (cleaned with a soft brush after each playing, and inspected occasionally for wear) records can be tracked at as high as 4 gm without significantly decaying. Repeated reproduction from a carefully handled pickup is the least important cause of disc wear and for most practical purposes can be ignored. Much more serious are the effects of careless handling: scratches and sweat marks on the disc surface. Pickup accidents, which happen to everyone, can be minimized by employing a mechanical arm lifter. If not incorporated in an arm, this can be constructed or purchased separately and added to the turntable surrounding.

Record handling still excites argument among individuals brought up with the less fussy '78'. Whatever the latter's handling resistance, a modern long-playing disc must be protected from dust, sweat and, above all, scratches. The plastic is relatively soft and a single side swipe from a skating stylus can render a disc unplayable, causing the familiar one-per-revolution 'click'.

Many newly purchased discs are difficult to remove from their

sleeves and can only be freed by pinching the outer rim (between thumb and forefinger) and tugging the bottom end of the container. A microgroove disc should only be handled by the unmodulated outer rim and the inner label. The rim locks easily into the crook of the thumb if the four remaining fingers are used as a pedestal for the label (*fig. 2:2 (a)*). If the more obvious grip of *fig. 2:2 (b)* is used, sweat is inevitably left in the disc grooves. While this is not inherently harmful, it acts as a glue to airborne dust and leads to audible pops and crackles. Anyone repeatedly handling discs for other than casual entertainment is well advised to keep fingernails short.

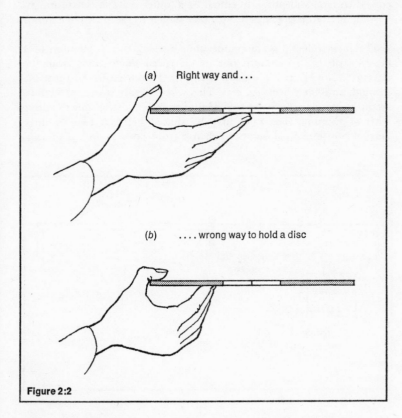

(a) Right way and . . .

(b) wrong way to hold a disc

Figure 2:2

Disc cueing
No harm is caused if a gram turntable is stopped and the pickup left sitting in mid disc. Advantage may be taken of this in cueing the start of a sequence. A disc may be played normally until the desired starting

C

point is heard, then stopped and the turntable rotated backwards by hand with the stylus still in the groove. The opening programme sequence will then be heard backwards and the starting point easily identified. This technique is very useful in cueing the start of a side or band such that the sequence begins as soon as the turntable is switched on. A few centimetres of rotation must be allowed for the initial run up to speed or a deplorable 'wow' will be heard. The necessary few silent seconds may not be available in the middle of a disc though a little practice with a programme level control leads to fairly accurate trimming. For more precise disc 'extraction', the passage is either copied to tape and properly edited or a 'quick start' mechanism employed. The latter operates in a manner similar to the clutch of a motor car.

The most reliable gramophone units employ the momentum of a heavy turntable to smooth out minor speed fluctuations from the electric motor. Drive is usually transmitted from motor to turntable through an idler wheel (*fig. 2:3*). This wheel ideally is firm enough to retain its circular shape yet sufficiently 'sticking' to transmit the drive without slipping. The idler may be shifted between two or three vertical positions to allow speed change from 33 to 45 and 78 rpm.

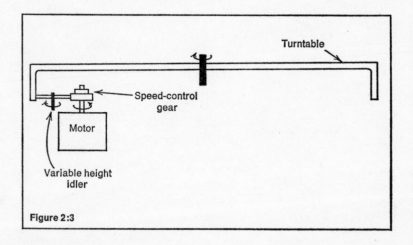

Figure 2:3

Another popular form of turntable drive is through a flexible belt, replacing the idler wheel. This system is less inclined to cause rumble (mechanical vibration rendered audible by the pickup) though the life of a belt tends to be shorter than that of a well-designed idler transmission.

A variety of refinements have been made by turntable designers, the most elegant in theory being direct drive from a servo-controlled motor. The speed control circuits and (usually lightweight) motor used in these devices are arguably less reliable than a heavily built mains-driven motor, however, and many operators prefer the latter system for long-term working.

AM radio

The human body possesses no direct ability to sense radio waves, which is why we have to part with the price of a wireless receiver. Yet radio waves represent only a small portion of the electromagnetic radiation spectrum. Higher up this spectrum (higher in vibration frequency) is another member of the electromagnetic family: light. The sensation of colour is a direct means of experiencing the frequency of light waves and, in seeking a particular shade of green for example, the brain 'tunes' itself in the manner of a radio receiver. Light provides a good model for radio waves since their behaviour is at least comparable. They travel at the same speed (299,798 kilometres/second in a vacuum), can pass through certain solids and are deflected by others. Their widely differing frequencies cause differing styles of penetration, however, radio passing through many non-metals which entirely halt light.

Low-frequency radio waves travel in a fairly straight line, deflected very slightly by the pull of gravity. Radio communication between England and Australia would thus be impossible but for the Van Allen Belt high above the Earth. A layer of ionized air particles, this behaves as a mirror to low-frequency radio waves, bending wireless transmission back to Earth. The belt is efficient enough to allow a reasonably powerful transmitter to bounce a programme right round the world. Unfortunately, the high frequencies required for 'frequency modulated' radio do not reflect in this way and are therefore lost to receivers round the curve of the Earth. Occasional atmospheric conditions cause some degree of vhf reflection but this is too random to be of practical use.

It would be possible to transmit radio waves at the same frequencies used by the original sound forming the programme (20 Hz to 20 kHz). This raises technical problems in designing a receiver capable of following the wide frequency variation. A simpler arrangement is to transmit and receive a tone of just one fixed frequency, using this as a carrier for the audio signals. The chosen carrier frequency must be higher than the highest audio frequency if intermodulation distortion (beating) is to be avoided. *Figure 2:4* (*a*) shows a typical audio waveform as might be displayed on an oscilloscope. The relatively high frequency carrier is seen in (*b*) while (*c*) shows the result of modulating (*b*) with (*a*).

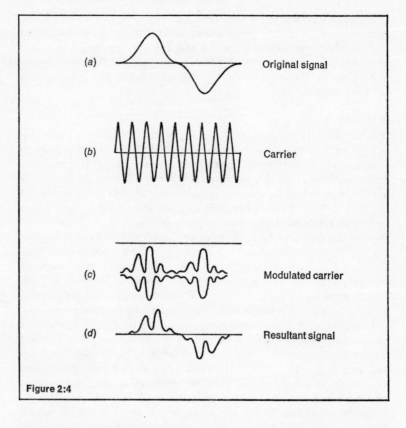

(a) Original signal

(b) Carrier

(c) Modulated carrier

(d) Resultant signal

Figure 2:4

Amplitude modulation, for the reason already described, is by far the most economical method of long-distance global communication. As a medium for local or national broadcasting, however, its long-distance properties become a disadvantage. The radio spectrum is wide but the number of AM transmitting stations is so enormous that interference is the inevitable result of overcrowding. Another major cause of AM interference is the line whistle emitted by television receivers. Both forms of interference are at their most severe after sunset when the local Van Allen ceiling is working most efficiently and when the populace switch on their television receivers.

FM radio
Where low noise and low distortion are more important than long-distance reception, 'frequency modulation' is the obvious choice in radio. Here again a carrier is employed but varied in pitch rather than

intensity. Provided a high basic carrier frequency is employed (at least double the highest programme audio frequency) very good results can be obtained from FM. The technique is not restricted to radio; many video tape recorders employ FM coding to store television signals.

Several years after the introduction of FM radio broadcasting, a method of transmitting stereo over a single FM carrier was introduced. The system is known as 'multiplexing' and the theory behind it is illustrated in *fig. 2:5*. Two microphones represent the stereo transmitter and two loudspeakers the stereo receiver. A mono amplifier represents the single broadcast channel. If switches (*a*) and (*b*) are set to connect the left microphone and loudspeaker, that channel is clearly heard. Setting both switches to the right has a corresponding effect on that channel. Now if both switches are operated at very high speed the illusion of two independent channels is created. It is essential that the transmitter and receiver switch at the same speed so an ultrasonic switching tone is transmitted as a switching reference.

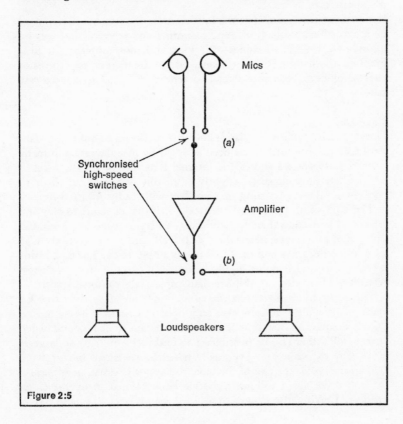

Figure 2:5

In practice, a slight increase in background hiss may be expected when a receiver is switched from mono to stereo. If this proves intolerable, most stereo radios can be switched back to mono for the duration of the programme. Local weather conditions can have a marked effect on FM reception if only a small indoor aerial is employed. Ideally the aerial should be located as high as possible, either in the loft or on the roof of the host building. Precise dimensions of an aerial suitable for FM reception in any locality can be obtained from the engineering information office of the relevant broadcasting authority. The structure should be rotated laterally for lowest background hiss, then fixed firmly in place.

Experimental quadraphonic broadcasts have already been made in several countries, often employing two stereo transmission channels and this requiring two stereo receivers. Whether the public really require this expensive refinement has yet to be seen.

Magnetic tape

For some twenty years after the introduction of oxide-on-plastic magnetic recording, virtually all tape recording and reproduction was by means of open-reel machines—the kind still most popular for programme origination. At the audience end of the market, two forms of packaging have been introduced to reduce the need to handle raw tape.

Cassettes

Developed by Philips (Holland) and first marketed in 1963, the standard *C60* cassette format has been adopted by manufacturers in many countries. *Figure 2:6* shows the internal structure of a basic *C60*. A few makers have departed slightly from this design in an effort to prevent accidents occurring in recorders with badly adjusted brakes.

The tape width (3·81 mm) practically half that of standard play and tape thickness equivalent to 'triple play'. Playing time is 30 minutes on each of two tracks, hence the *C60* title. Thinner tape gives the *C90* 45 minutes per track and the *C120* one hour per track. The tape inside a *C120* is so thin as to be highly inconvenient to use on an open-reel recorder, where nothing thinner than triple play is normally seen.

Practically all open-reel recorders function from left to right and this traditional tape direction is also employed in cassettes. There are no spools as such and their absence allows more tape to be accommodated than would otherwise be possible. The feed reel is initially so large as to occupy the same area eventually taken by the small but growing takeup reel. Near the end of the tape, the opposite situation applies.

Tape drive again follows the style conventional in open-reel recorders. Leaving the slightly tensioned supply reel, the tape moves

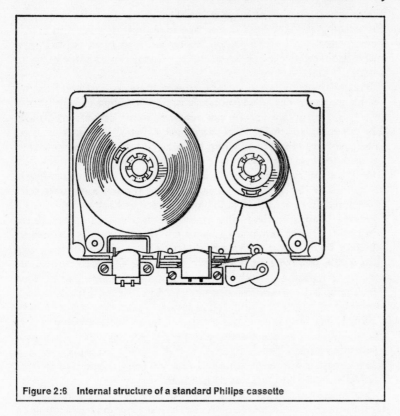

Figure 2:6 Internal structure of a standard Philips cassette

round a guide, over the erase and record/play heads, between the drive capstan and pinch wheel (which deliver motion), over another guide and thence to the lightly driven takeup rotor. One consequence of this arrangement is that the standard of cassette construction has a greater effect on signal quality than has that of the spools of an open-reel recorder.

Cassette prices vary and so do standards of construction. It is not advisable to store important audio material on cassettes unless a safe means of opening the plastic surround is available. Ideally, all cassettes should be manufactured with screws holding together the upper and lower sections. If the tape tangles or the head pressure spring fails, removal is then a delicate but practical operation. Opening a riveted or welded cassette, however, is a difficult task in which the tape can easily be damaged.

The prime consideration in cassette reproduction is cleanliness.

'Cleaning cassettes' containing soft ribbon material may be purchased for cleaning the tape-head faces, capstan and pinch wheel. In severe cases, where oxide accumulation has caused substantial treble loss, a moist handkerchief over a small finger provides an effective cleaning tool.

Track disposition across a cassette tape bears only a superficial resemblance to any open-reel format. *Figure 2:7 (a)* shows the disposition of a half-track mono and (*b*) quarter-track stereo cassette recording. The mono arrangement is conventional enough, leaving the usual (albeit narrow) guard-band along the centre of the tape. In the stereo format, however, virtually no guard-band is left between the left and the right channels. This leads to some crosstalk (left signals leaking on to the right channel and vice versa) though no more than is tolerated from stereo discs. This arrangement has two advantages over merely copying the format employed on open-reel four-track recorders. It almost eliminates two of the latter's three guard-bands, allowing wider signal tracks and therefore higher programme levels than would otherwise be obtained. Secondly, it allows stereo recordings to be reproduced without complication on a mono player. This has simplified the production of commercially recorded 'Musicassettes', almost all of which are produced in stereo.

When long-term continuous music reproduction is required, a few manufacturers produce cassette changers which may be loaded in a manner resembling disc changers. Whereas discs may be badly scratched when dropped one on to another, cassettes lend themselves well to vertical stacking and mechanical handling.

The small size and very light weight of cassette equipment makes it ideal for use in conditions of high mechanical vibration, particularly in motor cars. Cassettes require no threading in the open-reel sense and in most players are simply 'posted' into a rectangular slot. Even this operation can distract a motorist, however, and such equipment should be handled during pauses in a journey or left to a passenger.

Choosing a cassette recorder will depend on the anticipated applications. Small battery-powered cassette machines are in fact the cheapest sound recorders on the market. Ideal for voice recording (interviews) and reproduction, they are only marginally satisfactory for music or any kind of qualitative analysis. Versions with larger loudspeakers are available at slightly higher cost though even these are better worked into headphones.

Where mains power is available, a more substantial design may be preferred. Cassette units are available in various forms for mono or stereo playback into external or internal amplifiers and/or loudspeakers. Since the mechanisms are inherently fragile, particular attention should be paid to the guarantee and service arrangements supporting the

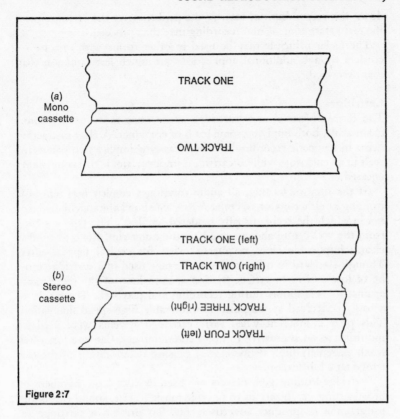

Figure 2:7

equipment. If in doubt as to the reputation of a particular manufacturer, it should be remembered that Philips Electrical Ltd. developed the system and have devoted perhaps the most thought to it.

The majority of cassette recorders incorporate a refinement allowing an important or expensive programme to be safeguarded against accidental erasure. At the rear of each cassette are two plastic pips, that on the left corresponding to the 'uppermost' of the two mono tracks or stereo track pairs. If the pip is broken off, the relevant track is rendered more or less permanent. Many commercial Musicassettes are actually supplied with their erase pips removed. The presence or absence of a pip is sensed by a feeler which protrudes towards the cassette. If the pip is missing, the record interlock button is immobilized.

Occasionally, the need may arise to record on a de-pipped track. Then the pip should be improvised with a piece of card and adhesive tape. Alternatively, push back the feeler with an insulated probe, hold

down the record button, remove the probe, insert the cassette, press the main start control, and recording may then proceed.

The feeler principle may be used in other forms with cassette recorders though additional applications are much less common than that described.

Cartridges

The terms 'cassette' and 'cartridge' were once more or less interchangeable, both implying some form of container. A clear distinction exists in magnetic recording, where a 'cassette' implies two connected reels in an enclosure while a 'cartridge' implies a single reel comparably encased.

At the time of writing, all audio cartridges employ 6·25 mm tape running at either 9·5 or 19 cm/s. *Figure 2:8* shows the ingenious manner in which the reel is usually rendered 'endless'. The tape is pulled from the reel centre and rewound on the outer rim. Reverse wind is clearly impossible since no means exists for central tape re-entry. Though standard in other respects, the tape used in a cartridge must be of low surface-to-surface friction as each loop of the reel scrapes against its neighbours during recording and playback. The result, in a badly conceived system, can be intolerable high-speed fluctuation. This proved inherent when early cartridge systems were used by motorists as an alternative to radio entertainment. Car interiors often reach extremely high temperatures, causing deterioration of the cartridge tape lubrication.

Cartridge-loading tape players are used in very large numbers by broadcasting organizations to provide music inserts, sound effects and programme or product advertisements. To prevent a cartridge recycling through operational error, many players incorporate an automatic stop device of which the most common is activated by a 'halt' pulse recorded on the tape itself. A typical track configuration involves two-channel operation, the top track carrying audio and the bottom track cue pulses. As in half-track stereo, a guard-band is left between the two channels to prevent crosstalk from one track to another.

A few cartridge machines incorporate a fast forward-wind facility, though the term 'fast' is perhaps an exaggeration. Additionally, some conventional open-reel recorders will accept certain types of endless cartridge where continuous repetition of long sequences is required. In an emergency, tape may be removed from a cartridge, loaded on a spool, and recorded upon or reproduced with an open-reel machine.

Track formats used for domestic and motor car cartridge systems are largely incompatible with open-reel recorders though this is a minor disadvantage. A popular early system offered the listener automatic or manual selection of four mono tracks. An essential difference from the

open-reel quarter-track mono format described earlier was the track direction: all four cartridge tracks were recorded in the same direction. The audio head either incorporated four segments, one per track, or relied on a single segment which was mechanically raised or lowered to the desired track height.

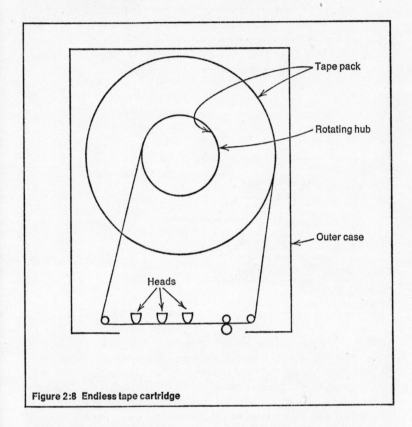

Figure 2:8 Endless tape cartridge

Eight-track cartridges have more recently captured a major part of the domestic and car markets, being a stereo extension of the mono cartridge format. *Figure 2:9* shows the two configurations with each movable head in its track 1 setting. Note the wide spacing of the stereo head segments, helping to prevent crosstalk occurring through transformer-induction inside the head itself. Only careful engineering can prevent adjacent tape tracks from weaving across the head face though in practice this problem causes little difficulty.

The obvious question arises as to whether cartridges are superior to

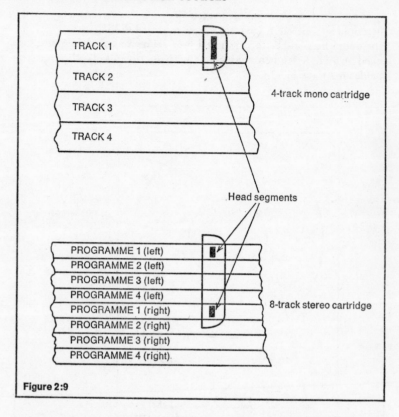

Figure 2:9

cassettes. There is no clear answer since the two formats have differing advantages and disadvantages. Cartridges offer potentially lower background hiss than cassettes but generally poorer speed constancy. Cartridges permit rapid track selection but have limited fast-wind capabilities and no reverse wind. Cassettes are limited to two-programme tracks but display excellent fast-wind characteristics. This comparison could be carried to greater length but no overall superiority would emerge. Only in terms of programme origination does the cassette system display an advantage—portability—but this chapter is concerned only with sound reproduction.

Choosing a cartridge machine, the potential buyer should ensure that the unit under consideration possesses recording facilities if these are in fact required. The format should be clearly identified, eight track being the norm for commercially recorded cartridges; half track for studio applications. Most currently available cartridge machines are players designed for installation in a car. These generally operate from

a 12V dc supply whereas studio and home units function from ac mains. The usual strictures regarding checking availability of after-sales maintenance apply.

Open-reel magnetic tape

Provided the operator is prepared to tolerate the slight inconvenience of handling and threading raw tape, this format is capable of much higher signal quality than discs, cassettes, cartridges or AM radio. Only the best FM broadcasts, received under optimum conditions, can offer comparable freedom from background hiss, distortion, wow and flutter.

As discussed in Chapter One the choice of tape speeds and track formats employed in open-reel recording is wide but so too is the degree of audio quality available from them. The optimum compromise between perfection and practical economy is half-track mono or stereo operation using 6·25 mm tape at 38 cm/s, leaving 19 cm/s for programme material where signal quality is comparatively unimportant.

The subject of commercially recorded open-reel tapes should be immediately disposed of. Though popular in the early years of stereo, these were almost priced off the British market following changes in the purchase tax structure. Prior to the 1968 National Budget, tape recordings (unlike discs) were exempt from tax. Even then, they were only barely able to compete with discs as tape-copying technology had been left at a primitive state of development. When purchase tax was added, tape recording prices became absurd and sales collapsed.

At an industrial level, recording and broadcasting studios make very wide use of the 6·25 mm open-reel format for programme distribution and storage. One of the biggest problems arising during such exchanges may be attributed to the existence of two marginally different track standards. A 'stereo' recorder and a 'two-channel' recorder would at first sight seem to be two ways of describing the same object. *Figure 2:10* shows the two formats to be indeed similar enough to provide *almost* total compatability. But note the slightly wider middle guard-band in the 'two-channel' format. This assists in maintaining low crosstalk between the two tracks: low enough to allow the recording and reproduction of two entirely separate programmes on parallel sections of tape. The effect of audible crosstalk from an adjacent music programme on to a speech track can easily be imagined. Separate erase head segments allow independent erasure of one or other track. These segments are usually stacked in vertical line, inevitably leaving a small region between tracks which the recorder is incapable of erasing. Needless to say, nominally 'two-channel' machines are often used to record or replay stereo programmes in which role they function quite acceptably. Where tape hiss must be at the lowest possible level, how-

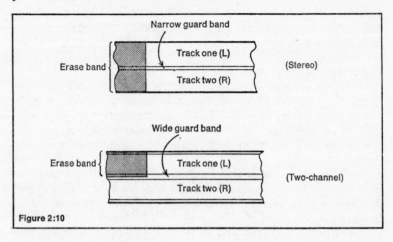

Figure 2:10

ever, stereo programmes are best recorded on wider tracks even if this incurs fairly high levels of crosstalk. Such crosstalk occurs in nature (blocking the left ear does not leave a listener entirely insensitive to sound arriving from the left since much of this sound spills to the right) and a signal-to-crosstalk ratio as low as 30 dB is considered tolerable. Much more offensive to the ear is 'ping-pong' stereo where sound may be heard coming from the extreme edges of the sound stage. Deliberately or accidentally induced crosstalk may thus actually be advantageous in many cases of poor sound mixing.

As a stereo optimized recorder is quite unsuitable for independent two-channel operation, most incorporate a single full-track erase head, this being the simplest way of ensuring total erasure of the guard-band area in the event of vertical 'weave' as the tape passes the heads.

All quite foolproof and efficient until the following occurs. Studio One, using wide guard-band 'two-channel' equipment (by far the most common), receives tapes from Studio Two made on a full-track mono or narrow guard-band 'stereo' recorder. These are played, then perhaps dubbed with local material which is returned to Studio Two. There they are hurriedly checked to ensure correct labelling and in due course broadcast, or copied to disc. Unfortunately, Two's tape machines replay both the new One programme and, as a background garble, their own earlier recording. Such mistakes can be difficult to identify in the heat of the moment. They occur again in domestic circles when tapes are interchanged between half- and quarter-track recorders, due once more to differing guard-band standards for both formats. As tape improves, however, the demand for narrow guard-band recorders diminishes and the great majority of modern machines marketed as

'stereo' conform to the track format recommended for 'two-channel' operation. Full-track mono recorders are similarly becoming rare.

Like discs, open-reel tapes are much more vulnerable to dust and accidental damage than are the contents of a cassette or cartridge. When tape manufacturers attempt to predict the lifetime of their products, they think largely in terms of head passes and the consequent coating abrasion. In practice, the greatest enemies of magnetic tape are warped spools, human handling, and stray magnetic fields; in that order.

The deforming effect of stretching the edge of crêpe paper must be known to all who have erected festive decorations. The paper is left anything but flat and no amount of persuasion will return it to its original state. If plastic-backed magnetic tape is wound from or to a warped spool, the rims can catch at the tape edge and cause slight or serious tape deformity. The extent will depend on the tape strength. One of the earliest tape backing plastics, acetate, possessed enormous resistance to stretch (comparable with that of paper) but readily snapped if roughly handled. Later polyvinyl chloride (pvc) backings were snap resistant but highly prone to stretch. Polyester has largely solved the problem, being essentially a pvc backing which is strengthened by being stretched during manufacture before the oxide is applied. Most modern tapes are produced on a Polyester backing. It is worth noting that few tape manufacturers produce their own backing material. The majority purchase this in crude semigranular form (from ICI or Du-Pont), melting it into a syrup from which wide rolls of transparent film are drawn off. Magnetic oxide is painted on to the rolls which are then slit to the desired final width. This slitting process is critical since little width variation is needed to cause severe speed fluctuation in certain tape transports. Some of the very cheapest 6·25 mm tapes start life as wider instrumentation or computer tapes, being slit to their smaller size on cutting equipment of dubious precision. Reputable brands of audio tape are never likely to cause such difficulties, however.

One of the biggest problems experienced by the newcomer to audio technology is that of connecting up the separate units forming a sound-reproduction chain. In the preceding chapter, the various programme-source options have been discussed. Although many tape machines, gramophones and radio receivers contain some form of internal amplifier and loudspeaker, these only offer convenience. Loudspeaker design, particularly, has not yet reached the point where a small internal unit can equal the quality of the programme signal itself. Hence the need for 'separates'. *Figure 3:1* shows the basic components of a complete audio reproduction system, in mono for simplicity. The various functions of an audio amplifier may be seen, including the equalizer employed in the gram line to flatten the treble-heavy signal arriving from the pickup. Note also the preamplifier stage which accommodates the volume and tone controls found on many amplifiers. Three heavy lines represent the screened cables used to carry signals from the radio tuner, gram pickup and tape player to the amplifier. An additional screened lead carries the amplified signals to the loudspeaker. This lead need not necessarily be screened for in many situations ordinary bell wire may be found suitable. It is not unknown for such wires to pick up radio interference, however, despite their apparently safe loca-

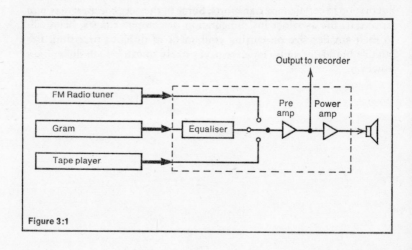

Figure 3:1

tion after the power amplification stage. In practice, radio signals can travel back through the amplifier regardless of the volume control setting, to form an irritating background to the main programme. Nearby national, local or amateur radio transmitters may render screened loudspeaker wire desirable if not essential.

If connecting one piece of audio equipment to another is complicated, the complications arise largely from poor standardization of audio connectors. *Figure 3:2* shows the two most common connectors required for audio amplifiers other than those designed purely for studio requirements. (The latter usually employ either Cannon or jack three-contact connectors, which are easier to wire up and much more resistant to physical damage.) The phono plug is a pleasantly simple device, small, inexpensive and relatively easy to wire. Unfortunately, like the coaxial television plug it resembles, the phono plug is inclined to give intermittent contact when, as its design allows, it is wired without

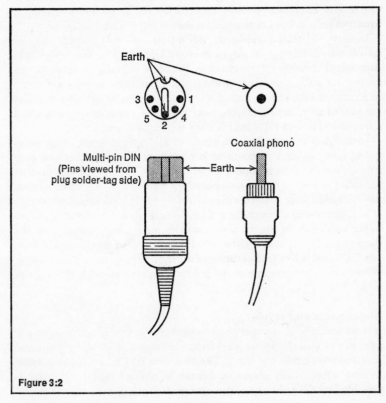

Figure 3:2

D

soldering. It is possible to purchase solid moulded phono to phono leads and these are both convenient and reasonably robust.

The standard European DIN connector is regrettably the cause of more inconvenience and misunderstanding than any other aspect of audio equipment installation. Its extreme versatility is the major cause of difficulty and soldering presents additional problems. Before wiring up a DIN connector, the relevant pins must be identified since some may be outputs rather than inputs and others may have no connection whatever.

A useful tool for anyone involved in wiring DIN connectors comprises a five-pin DIN plug at one end of a short multicable lead, the other end being splayed and stripped to bear each inner core. If the time, cost and trouble can be spared, it is useful to add small crocodile clips to each core. When this device is plugged into a DIN socket, and the output monitored by ear, active input pins may be identified by touching each core in turn (having first tested with a neon screwdriver to ensure total insulation from the mains). When an input core is touched, a loud buzz will be emitted by the amplifier—assuming a loudspeaker has been connected further along the chain.

In a typical stereo amplifier, two inputs and two outputs may be found wired through a single five-pin DIN socket, the 'spare' pin carrying the single return channel. Where a stereo tape recorder incorporates such a multiway socket, the inputs and outputs are wired in a manner opposite to that of an amplifier, thus connecting recorder outputs to amplifier inputs, recorder inputs to amplifier outputs, when a five-core DIN to DIN lead is used to couple them.

Identifying output channels involves a simple reversal of the foregoing procedure. A programme is played into the amplifier and each suspect core in turn is connected to the input of a second amplifier or recorder, the latter being monitored by loudspeaker (headphones are not advisable since any error may cause painfully loud sound emission). It is important to connect the screened braid from the subject amplifier to the earth side of the monitor amplifier, providing a return path for the eventual programme circuit. Now each output core from the five-pin DIN lead is touched in turn against the active input of the monitor. When a clear programme signal is heard, an output pin is thus identified.

Impedances and levels

It is no uncommon experience to connect, say, a tape player to an amplifier only to find the signal level from the former is so high as to cause severe distortion in the latter. The first clue that an amplifier is functioning substantially above or below its normal signal capability is provided by the volume control setting. If this has to be turned almost

to zero for normal listening, then the incoming signal is probably at too high a level. And if the control has to be set near maximum, this may be attributable to insufficient amplifier sensitivity.

Many tape reproducers and radio tuners incorporate output level controls designed to preset the signal strength fed to the succeeding amplifier. If the preset level is left too high the first stage of the subsequent amplifier may be overloaded before the signal ever reaches the main volume control. *Figure 3:3* shows the circuit of an audio attenuator which may be employed with tape players or tuners delivering too high a signal and lacking an accessible level preset. The two variable resistors should be mounted in a small steel or tin box which itself should be soldered to the earth side of the circuit. This maintains screening from outside hum or radio fields.

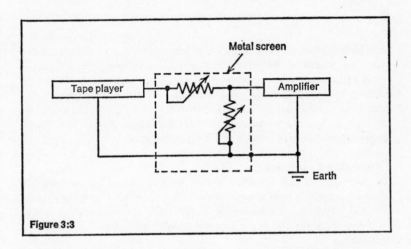

Figure 3:3

In the recording, broadcasting and telecommunications industries, equipment-matching problems were minimized by ensuring that all inputs and outputs operated at the same current and impedance: 1 mW (1 milliwatt or one-thousandth of a watt) at 600 ohms. This level became the o dBm (zero decibel meters) to which all other levels in a 600 ohm line were referred.

In recent years, adherence to the 600 ohm rule has become less rigid. General practice is now to make all output impedances as low as possible, by appropriate circuit design, and all input impedances very high. This has the advantage that a single output may be fed to several inputs simultaneously without draining the source of its available energy. *Figure 3:4* illustrates such an arrangement, known as

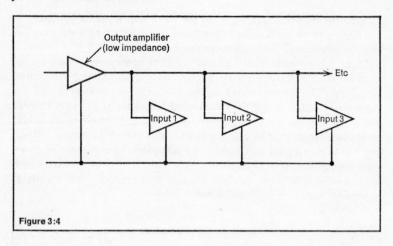

Figure 3:4

parallel bridging. If each input impedance were 600 ohms, the combined impedance of the three inputs would be substantially lower and could easily upset a 600 ohm output stage. The result would be clearly audible distortion. The universal rule of impedance matching, therefore, is to ensure that the output impedance of an electronic device is no higher than the succeeding input impedance. A low impedance output should always look into a high impedance.

Connecting loudspeakers

The aforementioned impedance rule applies equally to signals fed from an amplifier into a loudspeaker. A loudspeaker's impedance is dictated largely by the resistance of the voice coil: the narrower the coil-wire diameter and the larger the number of turns, the higher the resistance.

Distinguishing between resistance and impedance can be a cause of some confusion and warrants brief explanation. A conductor's resistance is a measure of its effect on electrons flowing in one direction only: on a so-called 'direct current'. Only when certain conductors are refrigerated to extremely low temperatures can resistivity be eliminated. Under all normal conditions, even the finest copper wire has some resistance to electron motion. We might describe resistance as 'the impedance at zero changes of current direction per second'. If an alternating current (ac) is applied, the impedance may remain constant or may vary widely at differing alternation frequencies. A straight piece of wire should display a constant impedance regardless of frequency. In a loudspeaker coil, however, several forces interact on the electron flow. The close structural similarity between a microphone

and a loudspeaker has already been described. One can therefore expect a loudspeaker to generate signals (known as 'back electromotive force') in its voice coil even when responding to the output of an amplifier. The internally generated signals can interact with the incoming programme, their precise behaviour depending on the weight and flexibility of the loudspeaker core.

Another major influence on loudspeaker impedance is the crossover arrangement whereby the audio spectrum is divided between large bass, small mid-range and very small treble drive units. Not all loudspeakers employ crossovers, some managing with a single drive unit nominally covering the entire audio range. Most of these, however, rely on the resonance of a supporting cabinet to extend the useful frequency range. The cabinet characteristics may likewise influence the overall loudspeaker impedance.

Many amplifiers provide separate outputs for differing loudspeaker impedances, usually taking the 1 kHz impedance as a working average. A typical specimen may carry separate taps for 4 ohm, 8 ohm and 16 ohm units. There need be no compunction over connecting 8 or 16 ohm speakers to a nominally 4 ohm output though feeding a 16 ohm line into a 4 ohm speaker may introduce distortion, depending on how nominal the quoted figures actually are.

Loudspeakers

An ideal loudspeaker would convert the electrical signals from an amplifier into a precise acoustic copy, each change of electron flow direction being matched by a correspondingly large or small change of air motion. The mechanism is a reversal of the microphone principle, whether the transducer be a moving-coil, ribbon, capacitor or piezoelectric device.

The great majority of loudspeakers employ moving-coil drive units mounted in some form of wooden box. In some designs, the box is little more than a convenient housing. In others, as already stated, the acoustic properties of the cabinet are contrived to extend the useful spectrum of the drive unit.

There is no limit to the number of drive units which may be incorporated in a single cabinet. For many years it has been conventional practice to design loudspeakers around two, three, or four nominal loudspeaker sizes: a large bass 'woofer', a smaller mid-range 'squawker', a small treble 'tweeter' and a miniature 'super tweeter'. Some designers vary the principle by employing, for example, two or more tweeters in addition to one or more other units.

An improvement on multiunit loudspeaker design, perhaps most profitably employed by the Tannoy company, involves a small tweeter sitting in the centre of a larger mid-range/bass cone. Since the two

share the same axis, the ear is more effectively deceived into assuming a single sound source rather than the usual divided sources.

Where a loudspeaker employs two or more separate drive units, these should ideally be mounted one above the other—facing out from the cabinet. Aesthetically, there is nothing to prevent a loudspeaker being placed on its side but this can result in sporadic directional characteristics which are measurable if not immediately audible.

Prior to the introduction of stereo recording and broadcasting, most mono audio systems were connected to a single loudspeaker. The 'point source' nature of a mono loudspeaker was often broadened into a subjectively wider sound stage. This could be achieved by elaborate cabinet design or more simply by placing a loudspeaker in the corner of the listening room. Alternatively, the drive units were aimed at an adjacent wall and scattered fairly randomly into the room. Although the result was in many cases a poorer treble performance, more lifelike reproduction of orchestral music was indeed obtained. But the trick did not work with small-scale programme material. A solitary human voice, for example, amounts under natural conditions to a point sound source. When this is enlarged by a scattering loudspeaker, the result is unconvincing.

The move to stereo eliminated this and other compromises associated with mono systems. A pair of relatively directional loudspeakers, facing directly towards the listener in the manner of *fig. 3:5*, were found to produce the most precise stereo picture. Omnidirectional loudspeakers employed for stereo generally give poorer positional definition but, for the same reasons applicable to mono, can sometimes give exceptional realism. They are worth consideration for domestic sound reproduction where the prime object is entertainment. For monitoring master tape recordings, however, forward-facing directional loudspeakers are practically essential. Similarly, a wide frequency range with minimal peaks and nulls in efficiency across the spectrum are highly desirable if a monitor is to reveal precisely what has been recorded. The object of monitoring is to assess quality, uncovering such flaws as hiss and distortion. Many domestic loudspeakers, on the other hand, are more or less deliberately designed to conceal programme flaws, their relatively narrow audio spectrum omitting deep bass disc rumble and high frequency hiss, distortion and groove crackle. There is nothing inherently wrong with this philosophy but true monitor loudspeakers at least give listeners the option of experiencing 'warts and all' or filtering out any deficiencies with electronic tone controls.

The two commonest forms of moving-coil loudspeaker are the *infinite baffle* and the *bass reflex*. When a loudspeaker drive unit is activated by electrical signals flowing through the voice coil, the cone

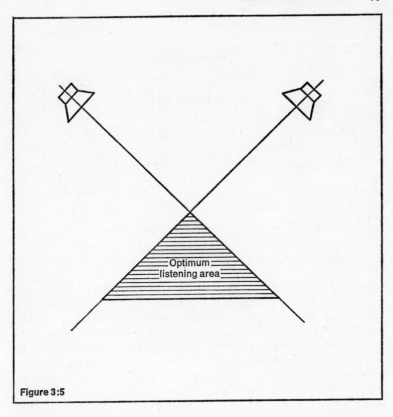

Figure 3:5

is forced backwards and forwards and in turn sucks and blows the surrounding air. If the rate of cone vibration is low (corresponding to a bass sound), the increased air pressure in front of a forward-moving cone may flow round the edge of the cone to the rear where the correspondingly lower air pressure is immediately equalized. This gaseous 'short circuit' makes the loudspeaker relatively ineffective at low frequencies. A simple cure is to isolate air at the front of the cone from air at the rear and this is accomplished in the infinite baffle simply by sealing the drive unit in a reasonably air-tight box (*fig. 3:6*). The bass reflex is an elaboration of this idea, introducing a vent which acts rather as the sound hole of a musical instrument. In other words, the vent and cabinet dimensions are arranged to create a low-frequency cavity resonance. Executed badly, this contributes an audible 'honk' to any programme played through the device. With more careful design, however, the resonance may be employed to extend the useful fre-

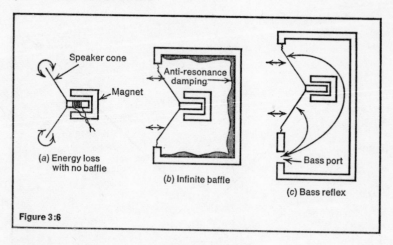

Speaker cone

Magnet

(a) Energy loss with no baffle

Anti-resonance damping

(b) Infinite baffle

Bass port

(c) Bass reflex

Figure 3:6

quency response of a drive unit having an otherwise poor bass performance.

A third type of loudspeaker, still relatively popular, is the *horn* (*fig. 3:7*). Before the development of electronics, metal horns provided a simple and effective means of sound amplification. Far from adding energy to a weak sound source, horns merely improve the efficiency of energy transfer from a vibrating solid to a vibrating gas. Even the human voice is inefficient in this respect, hence the increased volume obtained from a megaphone. (Many modern megaphones incorporate a microphone and amplifier though the original is shaped more or less as a horn.)

Acoustic input

Acoustic output

Figure 3:7 Exponential horn

The megaphone is an appropriate reference since it demonstrates the severe loss of quality incurred by certain horn systems. Sound vibration passing through a horn tends to excite sympathetic vibrations of the horn structure. The latter must therefore either be perfectly rigid to reflect, or sufficiently well damped to diffuse, sympathetic vibration. Thin metal is in fact one of the worst possible materials from which to manufacture a horn. Like a bell, it is easily excited into sustained resonance and this accounts for some of the distortion experienced in public address relays.

For domestic sound reproduction (and occasionally for studio monitoring), wood is the most common horn material. Concrete provides a more rigid alternative, albeit often impracticable except for permanent installations.

Few rooms allow the convenient installation of a straight exponential horn though there are several ways in which a more-or-less horn-shaped construction can be folded into more convenient dimensions. Although usually only approximately exponential, such a loudspeaker can be much more efficient than an infinite baffle or reflex design. Most commercial applications of the folded-horn principle suffer from comparatively poor treble frequency response, however, making them less than ideal for monitoring. High-frequency sound waves are reflected less efficiently than lower frequencies, particularly in a wooden structure. Added to the bass and mid-range resonances contributed by most folded horns, the resultant sound usually leaves much to be desired.

Electrostatic loudspeakers, while in principle even simpler than moving-coil magnetics, raise several problems in practice. Very few electrostatic designs have achieved popularity, by far the most successful in Britain being the Quad *ELS*. Introduced in the 1950s, this was still being manufactured without substantial change in 1975. Its lightweight closely controlled diaphragms, and the absence of any wooden cabinet structure, produced uncoloured sound over a wide frequency spectrum. The efficiency of electrostatic loudspeakers is not inherently high, being comparable with the average infinite baffle design. But whereas an infinite baffle can fairly easily be designed to operate at high sound levels, electrostatics driven at too high a level can incur severe distortion. This is caused by the diaphragm striking the charged plate forming the opposite half of the capacitor. Distortion of this kind can occur most easily in the bass region, involving wide to-and-fro diaphragm motion. In general, therefore, electrostatic loudspeakers are unsuitable for the reproduction of pop music where the latter involves amplified bass guitars. Organ and choral music can be similarly difficult to reproduce without diaphragm-crash distortion. Here at least, then, choice of loudspeakers can be related to personal taste; musical taste, of course, rather than preference for any particular kind

of loudspeaker colouration. It must be emphasized that the distortion inherent in electrostatic loudspeakers can be extremely low at programme levels within the capability of a practical design. Diaphragm-crash distortion, when it occurs, is a sudden event. Moving-coil loudspeakers, however, distort progressively severely as incoming programme level rises.

If a listener is content with the programme levels normally considered civilized in a thin-walled semi-detached or terraced house, electrostatic loudspeakers are probably the safest choice for consistently high quality. For monitoring, however, the ability to handle all types of programme at reasonably high volume levels makes an uncoloured bass reflex loudspeaker the nearest to ideal. There are many bass reflex designs in commercial production and identifying an adequately uncoloured design itself presents difficulties. The human ear is a good judge of loudspeakers but even the most experienced sound balancers may need several hours of listening, over several days, before pronouncing any one loudspeaker acceptable.

In a practical world, the sound recordist may occasionally be obliged to monitor through unfamiliar or downright awful loudspeakers. A well-equipped operator will carry a short tape of varied programme material which can be replayed through unfamiliar equipment to check the overall monitoring characteristics. Tone controls in the replay amplifier can then be adjusted if necessary to match as closely as possible the remembered balance of the recordist's own system. A remarkably wide range of control is provided within the ± 10 dB bass and treble variation of most reproducing amplifiers. While only nominally influencing severe resonances, the overall sound can usually be brought within acceptable limits.

An altogether more consistant form of monitoring is via headphones. These have the advantages of relative cheapness, extreme portability, and freedom from the misleading influence of local room acoustics. Headphones additionally encourage high mental concentration on sound quality, since the reproduced mono or stereo soundstage appears literally within the head.

A headphone is essentially a small moving coil or electrostatic transducer mounted in a cup (usually plastic). Two such units are coupled by a flexible metal or plastic band which clips over the listener's cranium. Provision to adjust for different head sizes is nearly always made. Most manufacturers have standardized on running the amplifier connecting lead out from the left earpiece, thereby minimizing the inconvenience of tangling among the right-handed majority of users. The right earpiece is then connected to the left by a smaller lead running through or over the headband.

For comfort, all but the lightest headphones incorporate padded

surrounds on all parts in direct contact with the head. The four common padding materials are hard plastic sponge, soft sponge, plastic-jacketed soft sponge and plastic-jacketed fluid. The once common hard foam is now disappearing from use, being by far the most uncomfortable for its inability to mould to individual head contours. Soft foam, used only on relatively light headphones is no more uncomfortable than a plastic bath sponge placed over each ear. It is acoustically highly transparent and can only cause discomfort if the listener's ears, or the surrounding air, are unduly hot.

While arguably less comfortable, plastic-jacketed soft sponge ear-pads are easier to clean than non-covered sponge which can disintegrate if washed too often. Since spare pads are available for most headphones, this is a minor detail.

Plastic-jacketed fluid ear-pads are reasonably comfortable and provide an extremely good shield against external noise. If the transducer cups are comparably soundproof, headphones of this type may be used for monitoring within two or three metres of the performers, assuming local conditions make this necessary. The writer converted such a headset into a pair of highly effective ear defenders when a transducer fault placed them otherwise out of action.

As with loudspeakers, so with headphones the flattest and widest frequency responses are obtained by electrostatic designs. Distortion at low programme levels is similarly much lower than in most moving-coil devices operating at comparable levels. Unfortunately, the problem of diaphragm-crash distortion is no less acute than in electrostatic loudspeakers. This characteristic is even worse in 'self-energizing' headphones. These derive their polarizing voltage from the programme itself and a prolonged low-level programme sequence provides only a low-level polarization. If this is followed by high-level transients, severe distortion can be heard until the stronger signals have contributed correspondingly stronger polarization.

Moving-coil headphones, then, are generally the most appropriate for monitoring in the absence of low-colouration loudspeakers. Most medium-price headphones are both heavy and bulky without offering much attenuation of external sound. Unless the relatively high cost of fluid-sealed noise attenuating headphones can be justified, very lightweight designs are preferable. Curiously, some of the finest lightweight headphones are also among the cheapest, benefiting from low material cost (chiefly plastics) and large-quantity production.

Once a pair of low-colouration headphones has been chosen, they should be kept regardless of subsequent 'improved models'. In time a recordist becomes aware of the headphones' limitations, provided frequent reference is made to live sound and to similarly uniform monitor loudspeakers. This awareness may remain unconscious until other

headphones are used, their differing frequency balance causing mental confusion. The human brain is quite capable of equalizing specific headphone resonances, given sufficient familiarization, then misleading the listener when a new set of resonances are introduced. A detail— but well-chosen audio equipment can approach so near to perfection that details are important.

There are several schools of thought concerning the correct level at which to monitor a recording when using loudspeakers. Many full-time studio engineers monitor at extremely high sound levels, more than adequate to give visitors a headache as a souvenir of the session. Loud sound reproduction is claimed to sustain a balancer's excitement and involvement with the recorded subject, warding off fatigue. It is particularly common among specialists in pop music balancing. This can be justified by the observation that pop has no natural volume level to which monitors may be referred. Music of a purely acoustic origin, such as orchestral and chamber productions, does possess a natural level to which a reproducing system may be matched. This is nominally the sound level in the region of the covering microphones, reproduced with reasonable accuracy in the control room. Few sound balancers trouble to use a portable sound level meter to provide an accurate match of studio and control room sound levels, relying on their aural memory. Nevertheless, the use of such a meter has much to commend it and may become more widespread as studio standards rise.

A third form of monitoring is at normal domestic listening level. In a word: quietly. This makes minimal demands of the reproducing chain since virtually all power amplifiers and loudspeakers perform at their best at fairly low programme levels. Exceptions to this rule apply only with valve or faulty solid-state amplifiers which may contribute a constant level background hum. Raising the listening level often provides an immediate method of reducing the subjective hum level.

The prime case in favour of low-level monitoring is that a recording can thus be balanced in a manner most likely to please the domestic listener. One might reply that the listener would be best satisfied by an undoctored copy of the original performance but two complications must be considered. Since the copy is likely to be reproduced at a quieter level than the original, bringing loud *fff* passages down to a more relaxing *f*, softer *p* playing will reduce to a barely audible *ppp* while true *ppp* vanishes into background hiss. It is impossible to serve both the average (low-volume level) listener and the purist in this respect. The latter will certainly expect to hear the original full dynamic range and will listen at a level as near to the original as can be estimated. Record companies could better serve this section of their market by specifying the original metered sound level on the disc or tape sleeve.

If compressing the dynamic range of programme by hand or elec-

tronically, monitoring is best done at low-volume level since com-
pressed recordings have little appeal to the purist listener or to musicians
experienced in the finer points of sound recording.

The second complication arising from reproducing sound at other
than its original level concerns a curious aspect of human hearing.
Although few people are directly conscious of the phenomenon, the
frequency sensitivity of the ear/brain system varies at differing volume
levels. Common sense would suggest that an orchestral recording
played softly would merely be quieter than the same rendering played
loudly. In fact, however, reducing the level of a programme has the
subjective effect of lowering bass and treble more severely than the
middle range of frequencies. This has been proved experimentally and
changes in the original sound level of a programme must, on replay,
inevitably introduce changes in the overall frequency balance. Although
no recordist can dictate the level at which others may reproduce any
programme, monitoring at the original sound pressure levels will at
least ensure that the recorded balance is correct. Wisely or unwisely,
some balancers try to anticipate defects in the domestic playback chain.
Their safest initial assumption, particularly with pop music, is that
the playback level will be relatively quiet. The human hearing curve
can be approximately equalized for low-level playback by introducing
bass and treble lift into the recording chain. Similarly, the narrow sound
stage generated by one-piece stereo radiograms can be used to greater
advantage by panning recorded instrument positions to extreme left
and right in preference to a natural 'between loudspeakers' placement.

The disadvantage of monitoring in the guise of a poorly equipped
listener is that the standard of domestic audio equipment has been
rising steadily for many years—ever since the introduction of horn
gramophones and crystal-diode radios. Any recording which attempts
to compensate for playback equipment faults therefore becomes obso-
lete when the faults in question are themselves eliminated. Suddenly the
recording is bass and treble heavy, unneccesarily distorted, and suffer-
ing from hole-in-the-middle stereo positioning.

Tonal balances vary so much in reality that the human voice is one
of the subjects most severely affected by reproduction at incorrect levels.
A perfectly recorded voice reproduced too loudly assumes a bass
stridence alien even to the most corpulent male.

Before leaving the subject of monitoring levels, a warning to
balancers with a taste for very high sound volumes. Apart from the
misleading lack of bass and treble which the quieter-level listener may
be left to endure, constant loud noise in any form can seriously harm
the hearing organs. If a sound balancer becomes deaf in middle or
later age, he is at least obliged to find another profession. But a
balancer with only partial deafness (restricted hearing spectrum) tends

to equalize his own hearing faults on to the recording itself, producing curious results for listeners with normal hearing.

One factor which audio balancers may cease to fear, if not disregard, is the gradual deterioration in hearing which occurs to almost all humans after the age of about eighteen. There is no doubt that, as humans progress in years, their sensitivity to extreme bass and treble diminishes. Oscillator tests show that many people can easily detect 16 kHz well into their forties although this ability is almost as variable as any other human characteristic. As humans progress into their fifties and sixties, so their maximum high frequency sensitivity declines to typical 10 or 12 kHz. Few experimenters seem to trouble over the actual level of tone pumped into their subjects and it seems that almost anyone can sense a sufficiently loud high-frequency tone (up to about 15 kHz), regardless of age. The tone may not be consciously audible; a vague region exists for most people where they are aware of the presence or cessation of a tone without being able to pitch it. This phenomenon may be verified by reproducing orchestral music to a listener whose hearing does not measurably function above 8 kHz. Many such souls will still sense the switching in of a filter acting above 10 or 12 kHz.

The overall performance of the auditory senses in a healthy human has little relevance to his or her abilities in sound recording and monitoring. What matters is not the absolute quality of sound signals reaching the consciousness; rather the ability to hear differences between original sound and the recorded copy. Practical experience is the only way in which to cultivate this ability, taking every possible opportunity to hear live instruments and avoiding the temptation to live among the shadows of artificial sound reproduction. As with any other art, careful analytical listening improves the auditory sense much more rapidly than mere ageing can detract from it.

Equipping a listening room

The guidelines relating to loudspeaker positioning are unambiguous. *Figure 3:8* (*a*) shows the most practical mono arrangement, a single loudspeaker aimed directly at the listener. Ideally, the cabinet should be positioned away from the wall and certainly away from any corner. Nearness to a wall creates a spurious increase in bass output, and a corner more so. This may actually improve the subjective quality of loudspeakers inherently inefficient in the bass region but all hope of a reliably flat frequency response will be lost.

In diagram (*b*), the same rules apply to stereo loudspeaker placement. Avoid walls if possible; avoid corners at all costs unless funds are available to meet the price of corner-resonance 'suckout' circuits. Optimum stereo effect is obtained when the two loudspeakers and the

Figure 3:8

listener form an equilateral triangle. The larger the listening room, the larger the available triangle area and thus the greater the usable listening area.

Quadraphonic listening demands an exceptionally large room if more than a single listener is to experience the surround-sound illusion. Again, suckout circuits are desirable if four sources of corner resonance are to be prevented from destroying this particularly fragile illusion. Tetrahedral ambiophony, a refined application of quadraphony, makes the further demand of a high ceiling in its effort to reproduce a vertical dimension. The 360 degrees horizontal soundstage is created by three loudspeakers facing up from floor level towards the listener. A further loudspeaker is suspended directly above the listener, from whom all four are ideally equidistant. The problems tetraphonic sound reproduction imposes in the average home are obvious and there is no sign, at the time of writing, of the format being adopted on a commercial basis.

Loudspeaker height, where mono and stereo and surround-quadraphony are concerned, is largely irrelevant. Provided the listener occupies a position in reasonably direct line of fire from all loudspeakers, the only problems likely to require attention are wall/floor and wall/ceiling resonances.

In home surroundings, and in control rooms suffering from sound leakage, some advantage may be obtained from mounting loudspeakers on flexible plastic foam. Neither the building structure nor the neighbours derive much benefit from vibrant floors and ceilings. Foam insulation beneath a loudspeaker ensures that little direct mechanical shock is transmitted. Any remaining floor or ceiling vibration will be a much smaller proportion, responding to the air vibration itself.

The acoustics of a control room should be as dead as possible, in other words adding no reverberation to the sound produced by the loudspeakers. If a customer shoots the sound balancer in the control room, the shock wave created by the explosion should be entirely absorbed by damping material on the walls, floor and ceiling. Any sound reflection from these surfaces will return the wave a second time to the culprit's ears. In a normal room this is not heard as a discrete echo but as one in a series of such reflections merging into a gradually fading reverberation. The dividing line between echo and reverberation is about 15 Hz. More than 15 echoes per second are merged by the brain into a single pitchable tone.

An inexpensive method of damping a control room is by cladding the walls with felt or a comparable commercial preparation. In addition, or alternatively, the boundary surfaces may be serrated to diffuse reflected sound. This is comparable with fogging the surface of a mirror to destroy optical reflection.

Yet another form of acoustic cladding involves perforated thin metal tiles mounted 1 cm or so from each wall. Air trapped within the tiles resists the incoming waves as air in a pneumatic tyre resists vibration from a passing road. The perforated tile arrangement is substantially more effective than common sense suggests it should be.

Floors are adequately damped by carpet and undercarpet felt. Cork tiles are sometimes employed for ceilings but, whatever material is chosen, dark colours should be avoided as these tend to be oppressive above eye level.

It is not usual to damp the highly reflective surfaces of control room equipment: loudspeakers, mixers and recorders. Even if thought necessary, this could lead to overheating; remember that many monitor loudspeakers possess internal power amplifiers.

The function of a microphone is to convert sound waves into corresponding electrical waves of a kind which can then be amplified and either relayed directly or recorded. There are several ways of achieving this conversion, perhaps the commonest microphone being the 'carbon' type used in most telephones. Its sound quality is so low, however, that it is never used in audio recording or public address.

Ceramic microphones

Before transistors replaced valves in recording equipment, ceramic microphones enjoyed wide popularity at the low-price end of the market. *Figure 4:1* shows a section through such a microphone, comprising no more than a flexible diaphragm, a piezoelectric crystal (typically Rochelle salt) and the signal feedout wires. Physical stress on the crystal at the diaphragm contact point generates an electrical signal within the crystal which may be extracted from appropriately positioned contact wires. The outgoing signal is of relatively high voltage, sufficient for an insensitive valve input circuit. Both valves and ceramic microphones, with their attendant deficiencies, have now departed from the audio scene. The predominant disadvantage concerned cable length. If more than 2 m of cable were used on a ceramic microphone

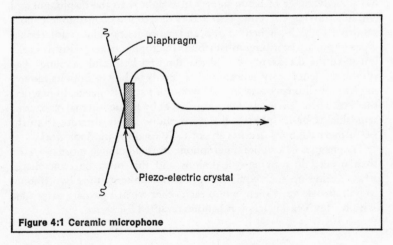

Figure 4:1 Ceramic microphone

line, signal quality was severely curtailed by the progressive introduction of hum and radio interference—depending on the locality and on the quality of cable employed.

Moving-coil microphones
Cheapness, robustness and reasonably high quality are the three reasons for the very wide use of moving-coil microphones. When a maker of domestic recorders chooses to supply microphones with his products, moving-coil units are almost always decided on. And when a studio prepares to record intensely loud drums or amplified guitars, a sturdy moving-coil is inevitably chosen. Wind and rain, which can seriously damage other forms of microphone, make the moving-coil the predominant choice of outdoor recordists and broadcasts.

The moving-coil principle is elegantly simple. Any electrical conductor (copper wire) moving in the region of a magnet generates an electric current. Air vibration, detected by a lightweight plastic or paper diaphragm, moves a wire coil to and fro through such a field at a frequency and level determined by the pitch and loudness of the sound. This motion produces corresponding electronic vibrations within the coil which can then be duly connected to an external amplifier.

Ribbon microphones
The principle of the ribbon microphone is similar to that of the moving coil. An electrical conductor is vibrated by sound waves within the field of a permanent magnet. *Figure 4:2* shows the assembly of a typical ribbon unit. The ribbon itself is made from very thin metal foil and has the advantage of being lighter in weight than the diaphragm and coil in a moving-coil unit. This makes the ribbon comparatively more sensitive to high-pitched sounds and hence its popularity for certain types of music recording. Most ribbon microphones are relatively cheap but have the disadvantage of demanding fairly careful handling. The ribbon element is very delicate and can easily be blown from its mounting by close human breathing or by outdoor air turbulence. In practice, the breath problem can be overcome either by fitting internal or external windshields or by placing the microphone a safe distance from the performer. Ribbons are never normally used for outdoor work.

The magnet in a ribbon microphone is usually much more powerful than needed in moving-coil designs and this must be remembered when setting up such equipment. It is not unknown for two ribbons to pull themselves violently into each other when a pair are suspended within a few centimetres—as is often required for stereo.

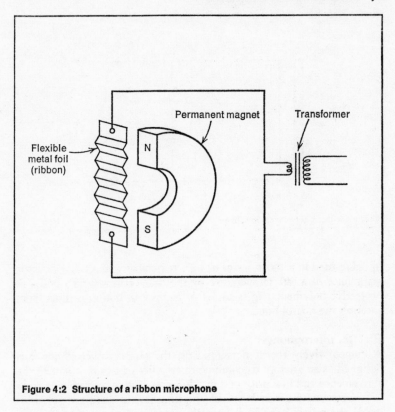

Figure 4:2 Structure of a ribbon microphone

Capacitor microphones

Undoubtedly the highest quality microphones, and indeed loudspeakers and headphones, at present available are those embodying capacitor transducers. Although more robust than ribbons, electrostatic microphones are unsuitable for working in very high sound levels such as in the immediate vicinity of a drum kit. They are also sensitive to moisture and therefore must be shielded from close breathing. Capacitor microphones should never be brought directly from a cold environment into a warm room as condensation can form between the diaphragm and backplate (*fig. 4:3*). Any such moisture will tend to produce background hiss and can sometimes be difficult to extract. A common cure is to place the offending microphone in the heat of a spotlamp, thus gently cooking it dry, but prevention is better than this 'kill or cure' approach.

If capacitor microphones are being carried along a cold road prior

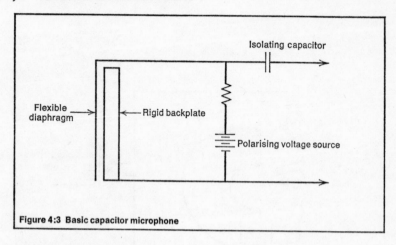

Figure 4:3 Basic capacitor microphone

to being used in a warm room or hall, remember that a coat pocket is maintained at a safe temperature by the heat of its wearer's body. A protective polythene bag is advisable to prevent cotton or dust from entering the microphone.

Electret microphones

A comparatively recent development, the electret microphone was designed as an attempt to combine the quality of a capacitor with the convenience and low price of a moving-coil. The output voltage from the electret element is low and amplification is therefore provided inside the microphone body, usually powered by a very small torch battery. The electret differs from the capacitor microphone in requiring no polarizing voltage. Theoretically at least, this polarization is inherent in the electret material—like the force field in a permanent magnet. In practice, the electret charge tends to vary in accordance with local humidity. This can produce minor or near-total fall in output level, depending on the individual sample. Considerable research has been undertaken in this field and in time the electret may live up to the original promise. Until then, electret microphones can be purchased at much lower prices than conventional capacitor units though they appear to have no other virtues.

Pickup patterns

An indirect advantage of having several forms of microphone construction to choose from is the resulting variety of sound pickup patterns. The most extreme example is the so-called 'rifle' microphone which has an extremely narrow pickup angle and can be aimed over

relatively long distances. Sounds arriving outside this angle are still picked up but are reduced in level by the microphone mechanism. This design must wait its turn, however, until more common patterns have been described.

Omnidirectional

The great majority of moving-coil and ceramic microphones have no significant directional properties whatever. They are therefore defined as omnidirectional since the alternative 'non-directional' would imply total deafness. In *fig. 4:4*, the circle surrounding the microphone portrays a line of equal sensitivity. A clockwork musical box carried round an omnidirectional microphone on a uniform radius would register the same signal level regardless of its angle. In other words, the microphone is uniformly sensitive in front, to the sides, and the rear. Further, the pattern of an omnidirectional microphone remains unchanged when the unit is pointed towards the ceiling.

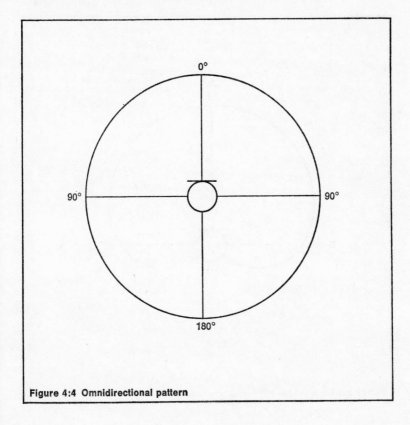

Figure 4:4 Omnidirectional pattern

Cardioid

There are many applications where omnidirectional microphones are undesirable, typically in a public address system. Here, a talker's voice is amplified and relayed through loudspeakers often in the same auditorium. If the talker's microphone picks up the amplified voice from the loudspeakers, this in turn is amplified again and again until the amplifier runs into wild distortion. This all too common experience is known as howlround. A cardioid microphone assists here in being relatively deaf to sounds arriving from its rear. *Figure 4:5* shows the theoretical pattern, again a line of equal sound sensitivity. Note the sensitivity to sound arriving from the 90 degrees sides. This feature makes the cardioid suitable for handling performers at locations B and C in addition to the obvious position A. In practice, however, some slight treble fall-off may be noticed in sounds reaching a cardioid from B and

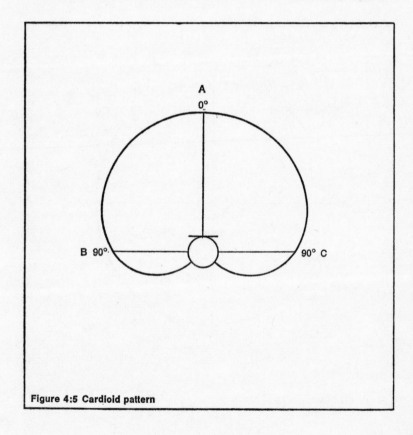

Figure 4:5 Cardioid pattern

C. This is because forward directionality becomes more pronounced as the subject pitch rises.

A cardioid microphone can be converted into a reasonably hemispherical omnidirectional pattern by the simple process of mounting it vertically. This has actual advantages over a true (spherical) omnidirectional pattern since the insensitive 'rear' hemisphere can be deployed to minimize the noise of scripts rustling on a desk.

The comparative forward and rear sensitivities of a cardioid are expressed by manufacturers as a 'front/back ratio' of so many decibels. A typical ratio is 12 dB though some microphones give as much as 20 dB differential. For the sake of standardization, front/back ratio is always measured using a 1 kHz sinewave. This easily generated tone is used for the great majority of audio measurements throughout the world and may be assumed to be the reference where no other is specified.

Hyper-cardioid
This pattern refers to nothing more than an exceptionally directional cardioid. The polar pattern is longer and narrower than that of a cardioid, showing some 90 degrees sensitivity and considerable 180 degrees attenuation.

Figure-of-eight
Equal sensitivity at front and rear (technically a front/back ratio of 0 dB) and extreme insensitivity to 90 degree sounds defines the figure-of-eight pattern, very appropriately named as *fig. 4:6* shows. The pattern is common to most ribbon microphones and reference back to *fig. 4:2* will show why. The ribbon element is affected equally by sounds arriving from front and rear. Sideways-on sounds impinge only against the razor-sharp ribbon edges and thus contribute virtually nothing to the foil's motion. Even the best figure-of-eight is not totally deaf to its sides, of course, since all sounds are to some extent reflected by local obstacles and in this way reach the sensitive ribbon faces. This roundabout route inevitably causes a severe reduction in sound level so the useful directionality is maintained.

Cottage loaf
If one face of a ribbon microphone is blocked off, the effect is to attenuate one lobe of the figure-of-eight pattern. The ensuing characteristic may be seen in *fig. 4:7*. There is invariably some slight pickup from the rear but the dominant sensitivity is to the front of the microphone. It is easy to mistake a cottage loaf for a cardioid and the result can be disastrous if attempts are made to use the non-existent side lobes.

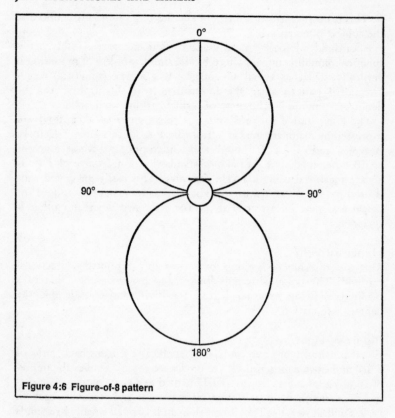

Figure 4:6 Figure-of-8 pattern

Unidirectional
Strictly speaking, this title should apply only to microphones sensitive along a single very narrow angle. Such devices are best known as 'gun' or 'rifle' microphones and are commonly used in television drama where microphones must not be visible on screen. Being severely deaf to sounds outside its narrow pickup angle (comparable with the beam of a pocket torch), the gun unit eliminates the 'noises-off' created by ventilation fans, camera squeaks and so on. The high directionality is achieved at the expense of sound quality, however, so only in exceptional circumstances would a gun microphone be used for music.

Radio microphones
The usefulness of any microphone may be extended considerably by working into a low power pocket radio transmitter, thence feeding a receiver in turn wired to a mixer or recorder. Although in no sense

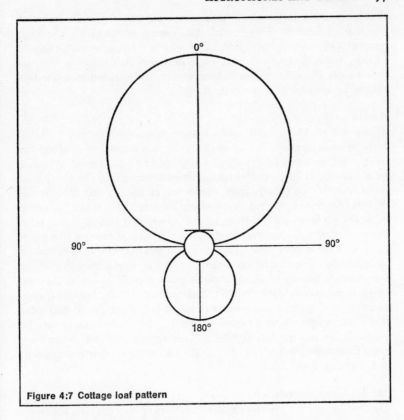

Figure 4:7 Cottage loaf pattern

a pickup pattern, the radiomicrophone technique increases the scope of available patterns in providing, for example, a remote localized cardioid capable of being carried through an audience or crowd. The system is more common in video than audio recording, providing freedom from unsightly and inconvenient microphone cables. It also offers a technically attractive means of recording stage artists and long-distance boat-bound or mountain-bound commentators. For purely audio applications, however, the increased risk of fading and electrostatic interference makes their use less appealing. There are now sound recorders small enough for even a mountaineer to carry.

Few nations permit the unlicensed operation even of low-power radio transmitters and many lay down a rigid design specification. In Britain, radio microphones have to meet strict Post Office standards before being allowed a licence. To prevent any drift in carrier frequency, the transmitter must employ a crystal stabilized reference,

thus preventing interference with transmissions on adjacent parts of the radio spectrum. This crystal stabilization accounts for the high price of radio microphones compared with the Japanese walkie-talkies sold by some disreputable retailers. There may be occasional temptation to use the latter form of inexpensive radio transmitter but this should be avoided as it is clearly illegal.

Audio cable

Figure 4:8 (a) shows side and cross sections through the 'coaxial' form of cable employed for audio lines. Signals are conveyed along the inner wire core and return along a tube of fine wire netting wrapped round the core. The outer screen is intended to shield the inner core from interference (mains hum, radio waves and so on) though the system is not very efficient. Very much more effective is the twin-core cable shown in *fig. 4:8 (b)*. Here, both the outgoing and returning sides of the circuit are protected by the outer screen. *Figure 4:9* illustrates the circuit of two-core microphone line, in this case of the form known as 'balanced'. The central earth tapping on the microphone side of the transformer has no effect on audio signals travelling round the two conducting cores (black arrows). Interference signals, however, tend to affect both cores equally and run in a single direction to disappear down the earth tapping (white arrows). The earth tapping can be omitted, leaving the interference signals simply to cancel when they meet from opposite ends of the transformer primary; this arrangement is known as 'floating'.

Microphone impedance

Discussing ceramic microphones at the start of this chapter, the point

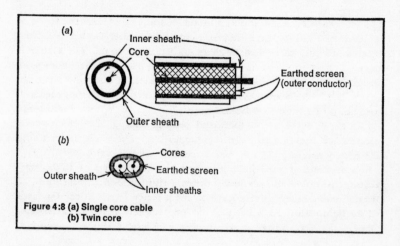

Figure 4:8 (a) Single core cable
(b) Twin core

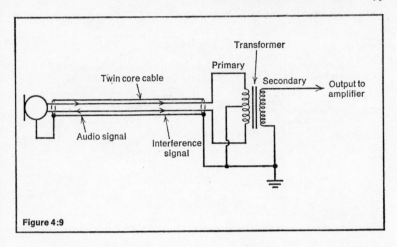

Figure 4:9

was made that they cannot be worked successfully through more than some 2 m of cable. While they are comparably efficient to a moving-coil or ribbon unit, ceramic transducers produce a relatively high voltage at low current. Moving-coil microphones, on the other hand, generate comparatively high current at low voltage. For our purposes, we may regard voltage as meaning the speed of electron flow through a conducting wire. Current may be modelled as the 'width of traffic'. Thus, if a bicycle travelling at 10 km/h constitutes 'one volt' (1V) raising its speed to 20 km/h lifts the voltage to 2V. If another cyclist rides beside the existing one, then we have doubled the current.

In essence, a high-voltage, low-current signal line constitutes a high impedance line. If a signal is to be conducted over fairly long distances, the impedance must be lowered by means of a transformer. This converts a proportion of the voltage into current, or vice versa, depending on the particular application. *Figure 4:10* shows the arrangement which would be necessary if a ceramic microphone were to be used over say the entire length of a concert hall. The physical length of high-impedance cable need be no more than 50 cm (the length of lead between the microphone and the output transformer). The reciprocal input transformer would normally be inside the chassis of a mixer or tape recorder.

In practice, virtually all serious recording is achieved using low impedance microphones since this eliminates the need for an extra transformer. The only important departures from this tendency are the capacitor and electret microphones; practically without exception, these operate at so high an impedance that a preamplifier has to be included in the microphone body itself. Such a preamplifier clearly requires a power supply but this is required anyway in a capacitor microphone

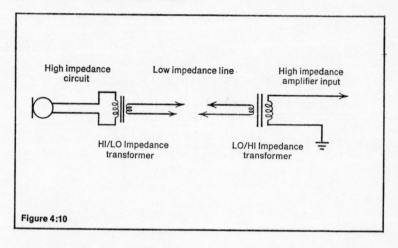

Figure 4:10

to polarize the capsule. The two power requirements are usually ful-filled by sending current along the cable connecting the microphone with the recorder. Although the power supply is sometimes allocated separate conducting wires, the technique of 'phantom' powering is more widely employed. Quite simply, the power supply goes out to the microphone along the audio core and returns on the earth braiding. Even in an unbalanced system, the 'direct current' (dc) power supply has no audible effect save for a 'plop' when the microphone is first switched on. Whether a battery or a mains conversion unit is used to feed the capacitor microphone is a choice left entirely to the operator. Batteries can be less cumbersome but are currently more expensive than mains-carried power.

Electret microphones generally require slightly less power than pure capacitor units since the electret element is permanently polarized—or so the makers claim. Virtually all electret microphones are therefore designed to work from miniature batteries (often a single 1·5 V cell) located inside the microphone case.

Noise-cancelling microphones
The easiest way for a commentator to minimize background noise is by turning down the recording level and placing the microphone very close to the mouth. A windshield is usually needed to combat breath popping and breath moisture. 'Lip' microphones are available for this specific application, the shielding materials being accommodated within the microphone case.

A specialized form of noise-cancelling microphone, for situations where a lip microphone would be artistically or technically unac-

ceptable, employs two physically close transducers wired out of phase.

Contact Microphones

The concept of a 'throat' microphone is fairly well known, being a means for communicating in conditions of extremely high noise: classically the cockpit of a poorly insulated aircraft. Instead of functioning via the mouth, such a microphone is held against the throat by a neckstrap. This produces voice qualities different from those normally associated with the speaker since the mouth and nose cavities no longer contribute substantially to the vocal tone.

Musical instruments may be recorded (or merely amplified) in the same way. The clavichord, one of the quietest musical instruments ever invented, is sometimes relayed through a contact microphone placed on the soundboard. Perhaps less legitimate is the occasional practice of recording entire groups of instruments (woodwind, percussion, strings and so on) by this means. The result can be interesting if unconventional tonal effects are appropriate to the composition.

At the risk of being momentarily deafened, the effect of a contact microphone in any location can be gauged by placing an ear hard against the soundboard or wherever the pickup would be placed. Incidentally, if placing contact microphones, care must be taken not to disturb the strings of multistrung instruments (piano, harpsichord, spinet) since any major tension change requires time to settle and may cause the instrument to detune during the performance.

Electronic pickups

The standard 'electric guitar' incorporates neither a soundbox nor a contact microphone. Instead, a wire coil more or less resembling that in a moving-coil microphone is placed beneath each string or group of strings. The string itself (steel) acts as a moving-magnet diaphragm whose motion generates a weak current in the nearby coil. A permanent magnet in or around the coil ensures that the string is sufficiently magnetized to produce a usable signal. Pickups of this kind (and others based on capacitor microphones) have been used in several types of instrument, notably the 'electric piano' and 'electric violin'. The tone only approximates that normally associated with the acoustic instrument since the pickup is usually unable to detect soundboard vibration or soundbox resonances, even when such features are present.

Recording from an electronic pickup is known as 'direct injection'. Some form of tone control is usually employed to counteract the essentially dull signal. The signal may even be increased in complexity (and therefore acoustic interest) by the simple process of deliberate distortion. Unfortunately, the pleasure derivable from these techniques tends at best to be transitory.

Audio mixers

Like a food mixer, an audio mixer combines a number of separate ingredients into a final composite. In the early years of tape recording, before transistors reduced construction costs, most amateurs and even a few studios employed 'passive' mixers: lowering the level of loud signals but incapable of amplifying the weak. Since noise (hiss caused by random electron motion, and interference caused by many other factors) is a problem in all communications systems, a more positive approach to sound mixing is essential. Virtually all modern mixers, regardless of price, now incorporate at least one amplification stage to raise the signal level fed to the recorder. Such a mixer may be defined as 'active' and requires a power supply.

Inputs and outputs

The simplest conceivable mixer (*fig. 4:11 (a)*) comprises two inputs passively mixing into one output, defined as a 2/1 (two into one). If it is desired to mix a larger number of inputs down to one output (typically for five participants in a panel game), (*b*) shows the extended 5/1 circuit requirement. Note the additional refinement of a master fader, allowing all five channels to be faded in or out by operating a single control.

An active mixer would in practice follow the basic scheme shown at (*c*). Each input is preamplified before being fed to two level controls. Why two? The first allows the operator to compensate for differing microphone sensitivities, different voice and instrument strengths. Once these are preset, each channel fader may be used as meaningfully as if each input channel had been of similar strength.

Multiple groups

No matter how many inputs are provided, a mixer with only one output is obviously restricted to mono operation. For stereo, at least two output groups are required. *Figure 4:12* shows the basic schematic of a 4/2 mixer: four inputs reducing to stereo. Note the addition of pan ('panoramic potentiometer') controls, allowing any input channel to be shifted from extreme left through middle to extreme right. Two master faders are incorporated in this unit, one governing each output group and normally referred to as 'group faders'.

Complexity does not stop here. For quadraphony, four output groups are the minimum requirement. Now the pan control is replaced by a four-way balance device, usually a joystick with backwards/forwards and leftwards/rightwards motion. The principle remains identical.

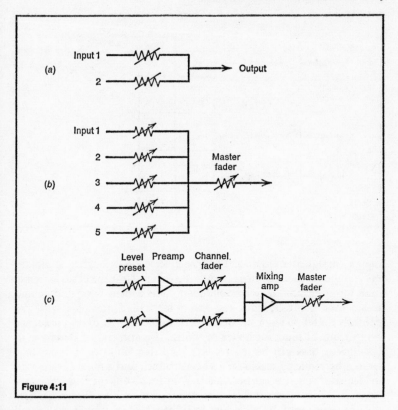

Figure 4:11

Control layout

At first glance, a large mixing desk appears fantastic in its complexity. The mystery soon clears when the onlooker recognizes a repeating pattern in the wide expanse of knobs, slides and switches. The controls relating to each input channel are by convention arranged in a strip stretching away from the front to the back of the mixer panel. A 24/8 desk, for example, will have twenty-four panel strips leading away side by side. To the right of these, perhaps separated by a vacant script panel, will be eight more or less elaborate output-group strips. A typical studio mixer is shown in *pl. 1*.

Equalization

However large or small the mixer, some form of equalization may usually be found either in the input or output channels. The very simplest equalizer is a bass-cut switch on one or more microphone

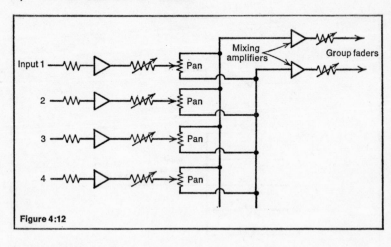

Figure 4:12

inputs, designed to reduce the 'chestiness' created when a ribbon microphone is used for close speech recording. Near the other extreme, each input channel may accommodate independent bass, middle and treble tone controls, hum and hiss filters, all comparable with the controls found on a normal domestic amplifier. Their overall influence on instrument tone, for better or worse, is considerable. Drums with insufficient bass can be 'corrected'; excessive sibilance is sometimes treated by reducing treble on a vocal channel; and a microphone with inadequate 'presence' can be 'equalized' by increasing the mid-frequency response. The operator does not necessarily wish to flatten the frequency response of the performer-to-listener system. Rather, the overall sound is being equated with the instrumental or vocal effect desired by the producer. A careful analysis of pop music recordings is the easiest way to an understanding of a large mixer's full capabilities.

At the farthest extreme of technical complexity, to date, is the 'voltage controlled' filter adopted by mixer designers from techniques developed for electronic music (and described on page 112).

Compressors and limiters
Although quite different in behaviour, these two devices are usually combined in a single unit—or merged on a mixer strip—which tends to blur their distinction. Both are designed to control signal dynamics or, in other words, volume level.

Solo singers, particularly female, are a classic subject for compression. Their vocal strength can vary so widely that a real danger of overload distortion exists if the initial recording level is set on the 'average' voice level. Conversely, severe underrecording may occur if

the level is preset to accommodate maximum singing strength. A compressor literally compresses the incoming signal strength to a more uniform output strength; the electronic equivalent of asking the performer to sing at more consistent levels.

Limiting is a less artificial facility, leaving the throughgoing signal level unaffected unless that signal exceeds a preselected maximum point. Beyond this point, the level is very severely compressed to prevent any further increase in input from overloading the recorder.

Echo send and return

While very few mixers have built-in echo generators, many make provision for the connection of external echo equipment. The term 'echo' is used in the recording industry to encompass both discrete echoes (mountain-top style) and the multitude of much faster echoes strictly called reverberation.

Each channel of a large mixer may carry two controls governing the level at which a signal is sent out to an echo unit (echo send) and the level at which the delayed signal returns (echo return). The main channel fader is used to mix the proportion of direct and delayed sound, depending on whether a natural or 'flooded' effect is required. The larger the mixer, the greater the chance that close microphones will be employed. While closely placed microphones give a greater stridence than is experienced at more natural listening/recording distances, they detect little or no room reverberation. Hence the widespread use of artificial reverberation generators even in orchestral recording.

Talkback

Most permanent recording installations, audio or video, are split into separate rooms with the maximum possible sound insulation between each. The performers sit or stand in the studio proper, often the largest of the rooms, while the mixer, tape equipment and non-performers occupy the control room. Loudspeakers in the control room allow the sound balancer to monitor any one or more microphone channels and to receive spoken communications from the music conductor. Short of gesticulating through an adjoining window (ideally double-glazed for audio insulation) the sound balancer requires additional means to convey messages back to the studio. This is provided in many mixers as a 'talkback' amplifier, fed by a microphone either hand-held or mounted in the structure of the mixer. The amplifier talkback signal may be relayed to loudspeakers or to individual earpieces or headphones for more discrete conversation.

Talkback has direct musical applications in specialized circumstances. When recording music for film, for example, each performer may play to earpiece-relayed ticks from an electronic metronome synchronized

F

to the film speed. In another case, where performers have been isolated in a series of acoustically insulated booths, the talkback channel is used to relay an approximate mix of the overall performance. Not surprisingly, many musicians intensely dislike the latter method of working. The isolation, incidentally, may be temporal as well as spatial. Multitrack tape recorders allow a musical work to be assembled instrument by instrument and this is particularly useful when practical difficulties prevent all the performers attending the same session.

Cueing
In addition to acoustic talkback (sometimes in place of it) many mixers incorporate a simple switching system which illuminates either of two cue lights in the main studio. By tradition, a glowing green lamp represents 'off air' (tape stationary) while red illuminates when the control room staff are actually geared for recording.

Line-up oscillator
A small panel on some of the larger mixers is allocated to a tone oscillator, the simplest form producing a 1 kHz tone when the appropriate switch is thrown. This constant signal may be routed through any desired channel and used in initial adjustments of mixing level and recording level. Like a tape recorder, all mixers offer a compromise between hiss (low-level working) and distortion (at high sound levels). The optimum meter settings of the mixer must therefore be adjusted to conform with the meters on the recorder. This is easily preset using a constant tone since the meters do not fluctuate wildly, rising instead as the relevant fader is opened.

Routing
Here lies the main ergonomic distinction between one mixer and another. A simple 4/2 mixer (four inputs reducing to stereo) may have no routing facilities whatever. Another will allow all four channels to be routed to one output group. The design combinations possible in larger mixers can be seen to be large, an extreme case being a 36/24 mixer allowing all thirty-six inputs to merge into one output channel. Although physical presentation varies from throw-switches through rotary selectors to plug-in pin matrices, the principle of routing remains similar in all mixers and requires only a brief introduction by the maker or the studio operator.

Access points
Like all other systems, mixers can develop faults which will require identification and repair. To assist in fault-finding, the most complex mixers incorporate a panel of sockets leading to and from the input

and output (respectively) of each mixing, amplifying or processing stage. The sockets also allow external-effects generators to be added temporarily to any part of the mixing chain. A series of socket rows is known as a jackfield, the Post Office 'jack' plug being widely used in audio.

Logic

Since it is fairly easy for an inexperienced sound balancer to become confused when handling a mixer in a hectic recording session, many of the larger designs include arrays of coloured lamps to show the state of individual channels and control settings. Coding is again in the 'beware red', 'go green' tradition though additional colours are used to show different control functions. The effect of so many lights on an already elegant design can be to increase its visual beauty. This alone is of benefit to the operator who may have little else to look at for hours on end.

Miniature mixers

Although the foregoing description has concentrated on the facilities offered by the most elaborate mixers, it is not assumed that the reader will either intend or need to use such equipment. Once the principle of the larger mixers has been understood, however, nothing on the smaller designs should present much difficulty. Being simpler, the smallest mixers (up to about 6/2) are sometimes afforded less thoughtful ergonomic design than large models. Instead of being arranged in separate channel strips, controls may be positioned more haphazardly, thus requiring more time for familiarization. The main fader on virtually all large mixers is a long flat slider no wider than the narrow panel strip. Some older desks employ 'quadrant' faders, comparable with a flat slider curved over the brow of a miniature hill. Many operators actually prefer the feel of the quadrant to that of a flat fader though quadrant faders are nevertheless going out of use. A third option is the rotary fader, raised in level by a clockwise turn and lowered by an anticlock twist. These are the least likely to be logically positioned, occasionally being placed on a panel almost at random.

Connecting sockets

Except in the very smallest mixers, signal inputs and outputs are kept clear of the main control panel and confined to the rear or the sides. This has the obvious advantage of leaving the controls uncluttered, and, in desk formats, ensuring adequate knee room. Permanent installations are sometimes wired out through a hollow section of one or more legs, the cables being ducted beneath the floor. In this situation, the choice of connecting sockets is relatively unimportant since there is little

danger of anyone tripping over a cable and tugging the plug from its socket. In semi-permanent and transportable systems, however, a lockable plug and socket in the Cannon (company name) range is widely employed. The precise type is model *XLR*.

Cable connectors are usually referred to by sex, a simple plug being 'male', a socket 'female'. Complications arise in the *XLR* family since this includes a connector with male pins recessed in an integral socket. Great care must therefore be taken in specifying items from this range. Cheaper, quicker to connect, and comparable in strength with the *XLR*, is the Post Office 6·25 mm diameter standard jack plug. This is a three-contact device also known as a 'tip, ring and sleeve' jack or 'balanced' jack. It should not be confused with, the 'tip and sleeve' or 'unbalanced' jack though some types of socket function successfully with both.

The preceding four chapters have dealt with equipment. Attention
is now turned to the use of these tools and in particular the use of
microphones.

What is meant by the term 'studio'? A permanent recording studio
comprises three basic areas: the studio proper in which the per-
formers function; the control room in which the performance is moni-
tored and recorded; and a service region providing reception, canteen,
minor-repair and tape-storage facilities. When recording at a remote
indoor location, the performer's hall becomes the temporary studio
and the nearest convenient room becomes the control room. The latter
must be far enough from the hall to provide high insulation from direct
sound, yet near enough for microphone cables to cover the intervening
distance.

An initial problem arises in communicating between performers
(represented by their conductor) and control room (represented by the
sound balancer or the producer). Permanent studios are usually con-
nected to the control room by a multiple-glazed window. In addition,
some form of audio talkback is always provided so that the control
room may talk to the studio. The same audio link is usually employed
on location though many balancers manage without an optical link.
If the latter is required, closed-circuit television can be incorporated
either by purchasing an inexpensive camera and monitor or hiring
something more elaborate.

A less obvious but important distinction between permanent and
location installations is the routing of microphone cables. Purpose-
built studios and some concert halls have audio cables built into the
wall or floor structure, connecting junction boxes in the studio to
similar boxes in the control room and thence to the mixer. If no such
plumbing is available, or the extant wiring is distrusted, separate
cables must be laid along the corridors connecting the control room
with the temporary studio. These introduce an immediate danger of
accidents, by tripping, and should be routed under carpet wherever
possible. There is much to be said for laying microphone cables along
the corner between floor and wall, provided careful listening prior
to recording ensures that no hum has been induced by nearly adjacent
mains wiring. Even away from wall skirtings, the chance of running
over, or close to, power cables must be guarded against. The amateur

is at greatest risk here, being the most likely to use unbalanced microphone leads over long distances. Balanced equipment, for reasons stated on page 58, is much less liable to hum pickup.

Either the mixer or the recorder (definitely not both or a hum loop may be formed) should be earthed to the mains as no amount of skill will eliminate the clicks and buzzes which may otherwise be detected on the microphone lines. Lastly, the mixer and recorder must themselves be kept apart from each other and from any equipment which could induce hum straight through the cabinet. Television monitors have some notoriety in this respect.

Once the cables are laid, and the control room is equipped, attention may finally be turned to the front end of the audio chain: the microphone.

Single-microphone technique

The simplest, cheapest and safest method of sound recording is by means of one microphone per audio channel: one for mono, two for stereo, four for quadraphony. Fairly strict rules of placement apply and any deviation usually causes disaster, a fact best confirmed by personal experiment. *Figure 5:1* shows a single microphone on the soundstage centre-line, set back approximately half the width of the orchestra. Optimum height for a stand-mounted microphone in this situation normally corresponds to the head height of seated performers. Where the artists are banked on a series of soundstage terraces, matching the midrow head-height usually provides optimum results.

The microphone pickup pattern in a mono system may be omni,

Figure 5:1

cardioid or figure-of-eight. All three will give satisfactory results though an omni may unduly emphasize reverberation from the sides, ceiling and rear of a concert hall. Many permanent studios are rendered as acoustically dead as possible on the principle that reverberation can later be added but cannot so easily be removed. A cardioid microphone in the *fig. 5:1* location has the considerable advantage of reducing audience noise and would therefore be the obvious choice when recording a public performance.

For stereo recording, the mono microphone is simply replaced by a stereo microphone or by two figure-of-eight or cardioid microphones mounted as a crossed-pair. *Plate 3* shows the distinction between typical stereo and paired microphones. A stereo microphone is little more than two separate microphone transducers in a single housing. Some of the most expensive designs have variable polar diagrams which can be switched from cardioid to figure-of-eight. This switching takes place either at the microphone itself or, depending on the design, from a selector unit in or near the control room. The sound balancer may in the latter case use this control to offset the failure of another microphone if conditions are appropriate. More important, the pattern may be varied while actually monitoring the microphone output through control-room loudspeakers.

The simplest and most reliable method of stereo recording is by means of a figure-of-eight pair. When two figure-of-eight microphones are placed side by side at a relative angle of 90 degrees, the combined sensitivity pattern is as *fig. 5:2*. The pair should ideally be spaced about 25 cm from each other, corresponding to the spacing of human ears. They are usually mounted on a crossbar supported from a single stand or suspension line. The optimum position is again more or less as *fig. 5:1*, back along a centre line of half the soundstage width.

The importance of monitoring in correct loudspeaker phase cannot be over-stressed. Accidental cross-wiring inevitably blurs the entire stereo image and can lead to disillusionment with the stereo concept. Microphones must similarly be kept in uniform phase or the stereo picture is again tarnished.

Ideally, an explosive sound which deflects left and right microphone transducers away from the soundstage should, on reproduction, deflect both loudspeaker cones towards the audience.

If the rear lobes of a figure-of-eight microphone are aimed at the soundstage, the two loudspeaker cones will suck when they should blow and vice versa. The human hearing system is insensitive to uniform phase changes and the stereo picture therefore remains intact. If the antiphase (side) lobes are aimed at the soundstage, however, the stereo effect is lost. In a practical recording session a figure-of-eight stereo pair detects the soundstage in its in-phase true polarity lobes

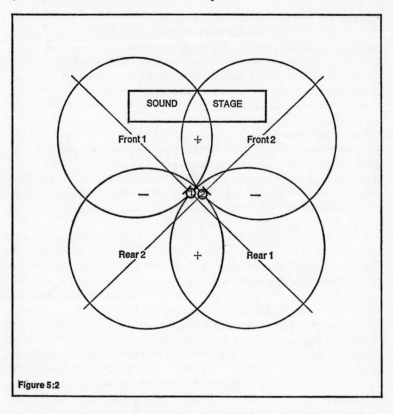

Figure 5:2

(+ +), rear reverberation and audience noise in its in-phase false polarity (— —), and side-coming reverberation in its out-phase (+ — and — +) lobes. The out-phase reverberation is of little consequence since, although its position may be confused in a stereo system, its arrival angle is usually vague even in reality.

Figure 5:3 shows the pattern produced by pairing cardioid microphones. The left and right lobes merge along their centre line to offset the falling treble sensitivity exhibited by most cardioid microphones towards sounds arriving well off each microphone axis. Once again, both microphones must be wired in identical phase. A well-organized recording team will in fact check the phase of every microphone in its possession, reversing cable polarities (in balanced lines at least) whereever necessary.

When recording in an unusually noisy environment, or excessively reverberant hall, twin cardioids generally give better results than twin figure-of-eight microphones. If the deaf rear lobes present no obvious

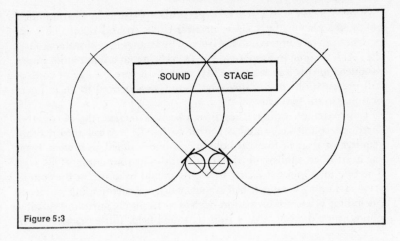

Figure 5:3

advantage, however, figures-of-eight will usually be found to give marginally better sound quality.

In quadraphonic recording, the balancer must decide between two quite dissimilar approaches. If the quadraphonic microphone (four cardioids) is positioned as in *fig. 5:4*, a normal quadraphonic loud-speaker arrangement will reproduce stereo in front and studio ambience at sides and rear. Since few listeners are conscious of hall ambience for more than a fraction of their attendance at a concert, the difference between stereo and this form of quadraphony is at best subtle and at worst (with the rear unnaturally loud) deplorable.

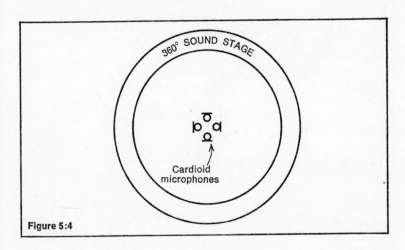

Figure 5:4

Some concert musicians take particular pleasure in hearing their colleagues playing in a circle or near-circle around them. This experience can be conveyed to the listener by arranging performers round the quadraphonic microphone. Far from being an adulteration, music produced in this way takes the listener back before the age of concert hall presentation to the 'surround sound' experienced in an intimate chamber music gathering.

Tetrahedral recording, using three channels to create the 360 degrees surround sound stage and a fourth to handle vertical information, requires an array of four cardioid microphones aimed, as it were, from the heart of an equilateral tri-pyramid out to its four corners (*fig. 5:5*). The two microphones facing forwards should be aimed at the soundstage, assuming a concert hall layout, when the surrounding ambience (including vertical information destroyed in purely surround quadraphony) should create a very realistic sound field. Little practical work

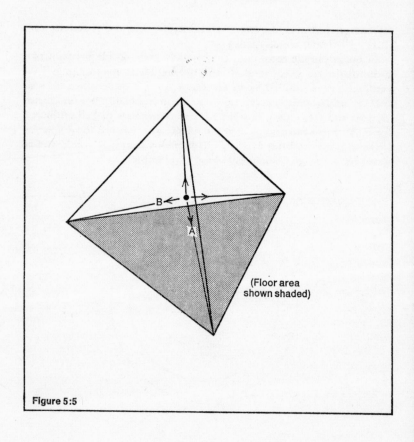

(Floor area shown shaded)

Figure 5:5

has been done with the technique, however, and at best it seems likely only to be adopted when the market has grown tired of horizontal quadraphony. In particular, the ability to place one or more performers above the listener seems unlikely to have other than curiosity value. When tetrahedral ambiophony was originally outlined by Granville Cooper, the suggested format involved pointing the A and B microphones straight towards the soundstage along axes parallel with the floor. Up-ending the 'pyramid' in this way places the remaining two loudspeakers one above the other at the rear of the listener. The aural and visual merits of this format compared with the foregoing are open to differing interpretation and present ideal material for experiment.

The term 'professional' applied to any individual does not necessarily imply the ability to execute consistently perfect work. In sound recording particularly, it pertains to experience in overcoming emergencies at short notice and minimal inconvenience to performers. Recording through a single microphone per channel, although theoretically the nearest to perfection, does not provide the degree of flexibility required by many recordists. If a basic stereo pair is set up for a rehearsal and reverberation or traffic noise found to be excessive, it is sometimes necessary to shift an entire orchestra closer together or even transport the performers to another part of the studio. Individual instruments may then need to be shifted forwards or backwards to retrieve a quiet harp solo, for example, or conceal an over-strident piano. Apart perhaps from being shifted forward, none of these actions is likely to please a performer. Yet it would be wrong to exaggerate these problems. Stereo pair recording (like its mono and quadraphonic equivalents) improves as a balancer gains experience. One of the first lessons learnt is that of visiting the chosen hall before even the rehearsal to ascertain the likely difficulties. If the performance is being planned solely for recording, the balancer can legitimately recommend a hall in preference to that suggested by the performers.

When a commercial recording unit is hired to cover a session, it usually finds itself working in totally unfamiliar premises. Multi-microphone recording (mixing more than one microphone per programme channel) is often employed either to complement or entirely supersede a stereo pair. In the former case, a stereo pair is positioned with the usual care and one or more 'spot' microphones are placed near important soloists. *Figure 5:6* shows a stereo pair being used to record a small chamber-music group. If the harpsichord is too quiet, perhaps being the 'bottomless' kind tolerated for a few decades in the early twentieth century, then it may require a spot microphone to remain audible behind the vocalist. A stereo pair can only capture actuality and in this situation even a live audience may be unable to hear the

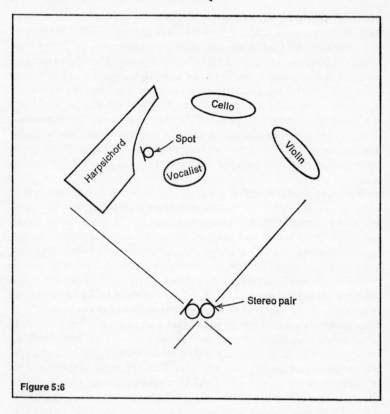

Figure 5:6

keyboard instrument. An experienced stereo-pair advocate would attempt to change the layout of the soundstage until both the recording and the audience were well served. Even then, however, a really badly made instrument could pose an acoustic nightmare.

A spot microphone gives the sound balancer (ideally the conductor but usually the recordist) considerable control over the amplitude, position and tone of the subject instrument. In *fig. 5:6*, the location of the harpsichord may be shifted from near left to middle or near right, though unnatural treatment can create some degree of dissatisfaction with the final recording. The instrument's tone will depend on the precise location of the spot and this facility can be used to offset inadequate treble output, for example, by aiming a cardioid towards the treble end of the soundboard.

The location of a spotted instrument will depend largely on where the spot microphone is panned (see page 62). In a reasonably elaborate

mixer, further tone control may be effected by altering the frequency response of the spot channel, leaving the stereo-pair channels 'flat'.

Particularly with the high sound levels in live pop music, it is sometimes considered necessary to record a vocalist through a spot microphone. Unfortunately, even the finest singers can sound coarse when recorded a few centimetres from the performer's mouth. While tone control offers little improvement in such cases, artificial reverberation is usually a successful cure.

The great majority of wind instruments benefit from local reverberation and if this is removed through spotting some attempt should be made to replace it. Like all rules, this recommendation may be ignored if a composition thus benefits.

In many fields of commercial recording, multimicrophone techniques have taken over almost entirely from 'stereo pair' operation. In effect, the spot microphones have been increased in number to the point where each instrument is recorded through its own microphone. More commonly, complex instruments such as drum sections are allocated several microphones, solo performers playing into at least one apiece, and supporting musicians are recorded through a stereo pair per group. *Figure 5:7* shows an orchestral layout on these lines.

Multimicrophone working introduces a host of minor problems (not to mention the capital outlay) in return for shifting audio-balancing functions out of the studio and into the control room where they belong. If the notion of laying down some thirty-six microphones on a large session appears formidable, experienced staff achieve it with little fuss.

Although publicly responsible for orchestral tone, a conductor becomes second to the sound balancer in this aspect of control during a multimicrophone session. Just as a misused public address system can spoil a live performance, so an orchestral recording may be improved, faithfully mirrored, or marred in the control room. Some conductors recognize this delegation of responsibility and co-operate with the balancer. Others ignore the control room until the tapes are replayed, only then passing comment on deviations from their planned interpretation.

Whether multimiking or spotting, each instrument raises marginal differences in terms of angular tone variation. Similar instruments (such as violin and viola) differ little, yet even instruments of the same type and make display some variation in tone. The general rules pertaining to popular modern instruments are classified below, not as rigid instructions but to show the lines of thought that can be followed in classic situations.

Human voice

Male or female, the human voice is one of the most common, most

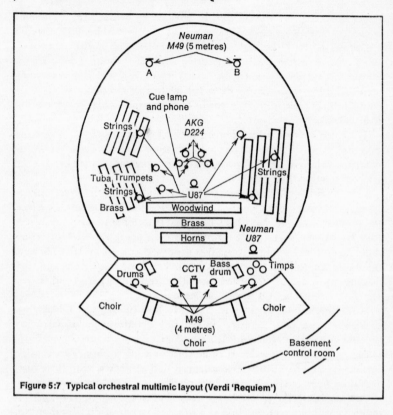

Figure 5:7 Typical orchestral multimic layout (Verdi 'Requiem')

versatile, structurally most complex, and most delightful of all musical instruments. It constitutes the first instrument ever applied to music yet is more versatile than the most modern electronic synthesizer. If an entire orchestra can be considered an instrument, then this alone may be compared in music value to the human voice. In both cases, needless to say, it depends upon how well the instrument is played for a badly controlled voice is a uniquely effective irritant.

Vocal sounds are generated when air is blown from the lungs through the vocal chords located at the top of the windpipe (*fig. 5:8*). The vocal chords resemble the reeds of an oboe or clarinet in behaviour, breaking a continuous air-flow into a pulsating flow. Pulsation frequencies (fundamental and harmonics) depend partly on the size and shape of the flexible mouth/nose cavity. The greater the inertia of the semi-enclosed air, the lower the resonant frequency of the pulsation. The fundamental itself depends primarily on the tension of the vocal chords, this being controlled by the brain. Phlegm resulting from a head cold, for

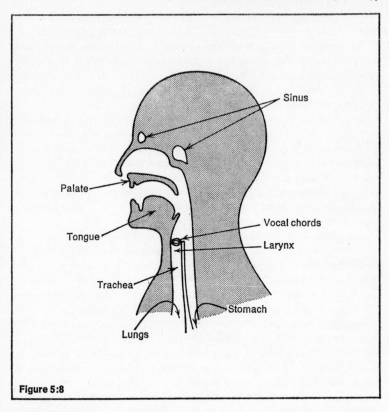

Figure 5:8

example, lines the vocal chords and so increases their weight. This has the effect of lowering the range of working fundamentals. Likewise, the vocal chords increase in weight during male adolescence and thus account for a deepening of the voice range. Further voice control, allowing a wide range of basic formats, is provided by the tongue and lips.

When recording speech or solo singing, the microphone must be protected from direct breath flow as any form of wind striking the transducer produces an audible 'pop'. Windshields, if found necessary, can be fitted inside or over a microphone casing and usually consist of materials such as stocking nylon. More elaborate shields provide additional protection against breath moisture.

Whenever possible, a talker or singer should be recorded through a ceiling-slung or stand-mounted microphone. Desk-top stands are more inclined to detect table thumps. Cable noise may be minimized

in hand-held microphones by looping cable round the hand such that shake is transmitted to the hand rather than to the microphone case. A few commercial microphones incorporate cable-noise dampers and the suitability of any one design is best checked by practical trial. High impedance microphone lines are out of the question in this application since the cable itself is then rendered microphonic.

When recording short programme links or long narratives, the spoken voice is normally most tolerable when accompanied by slight reverberation. A typical talks studio is treated with sound-absorbing material on the floor, walls and ceiling, reducing the ambient reverberation to that experienced in the dryest domestic lounge. Studio characteristics are not critical since a wide range of reverberation control is effected by altering the distance between microphone and subject. Even in highly reverberant conditions, a microphone held about 5 cm from the mouth produces a dry—almost open-air—recording.

It is generally advisable not to use ribbon microphones for speech, even though their usual figure-of-eight characteristic lends itself to across-the-table conversations. Adult male speech is particularly inclined to sound unnaturally bass heavy through a ribbon, due to sound waves being detected from the speaker's chest. Moving-coil and capacitor microphones are much more satisfactory in this respect.

Human speech characteristics can vary as wildly as the local pollen count and much trouble may be saved by recording a long narrative sequence in one session if the length makes this practical. Vocal tone can similarly alter during the course of each day, the daily patterns often being similar. Drinking water should be provided within reach of the narrator. Though perhaps less refreshing, this is a more efficient voice lubricant than fruit dilutions or milk, both of which leave solids in the mouth which can become abrasive and hasten the need for further drinking.

Many talks studios provide the narrator with an interruptor button which may be pressed during an uncontrollable cough or sneeze. This should be silent-acting down-off, release-on pushbutton, not to be confused with the highly audible click-switch incorporated on many public-address microphones.

More than one professional newsreader has been dismissed for being unable to control laughter, whether appropriate or merely a nervous reaction. This human fault may be cured by reading aloud a long and suitably provocative collection of giggles. Student 'rag week' publications are often appropriate for this purpose. If initially amusing when first narrated before a microphone, the publication should be recorded several times over until the reader becomes thoroughly bored. This technique is equally applicable to comedy scripts where 'straight' presentation may be essential to the subject.

When recording a solo singer from a close microphone, the subject must be firmly reminded not to stray from the standing position. Some balancers suspend the microphone above the artist, as in *fig. 5:9*, and this at least guarantees freedom from 'blasting'. A chair placed behind the performer is one method of preventing the subject shifting out of the microphone pickup area.

Figure 5:9

When recording a singer whose voice is simultaneously being rein-forced for public address (in pop presentation, for example), separate microphones may be used or a single microphone wired to the two channels (*fig. 5:10*). A distribution preamplifier or sub-mixer is best used unless the main mixer has a 'clean-feed' output from the relevant input channel. Complications can arise unless the public address level is independent of faders on the main mixer. If more than one per-former requires public address reinforcement, the latter is best left

G

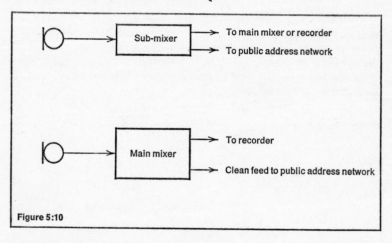

Figure 5:10

entirely to a separate operator. When close-miking a solo singer, only a thorough rehearsal of the loudest passages will allow confident adjustment of the recording level. Solo and small-group sopranos cover a particularly wide dynamic range. If an exceptionally loud note coincides with a resonance in the hall and/or in the microphone, even a carefully adjusted system can shoot into wild distortion. There are three other solutions: find another singer, use a dynamic limiter, or record at a distance—perhaps through the main stereo pair.

Woodwind

The basic woodwind family of instruments comprises the bassoon, cor anglais, oboe, clarinet, recorder, flute and piccolo. Other members include the accordion, bagpipes, pipe organ and harmonica. All at some time in their evolution were constructed essentially from wood. Many manufacturers have since adopted plastics to overcome the tendency of wood to change shape when subjected to (breath-carried) moisture. Others, notably with the flute and piccolo, have opted for metal though usually losing the warm tone of the wooden originals. And perhaps the harmonica should be termed 'metal wind' since the reeds used therein are never wood.

Two distinct methods of tone generation are employed among woodwind instruments. In the bassoon, clarinet and oboe, one or two reeds placed between the performer's lips perform the function of the vocal cords in human speech. Instead of varying the shape of the succeeding air cavity, the air capacity of a rigid tube is effectively altered by opening or closing air-inlets along a hollow pipe. With all gaps closed, the resonant frequency is low. If higher gaps are appropriately located during initial design, a musical scale may be generated.

In reedless instruments such as the recorder, flute and piccolo, tones of a simpler harmonic structure are obtained without need for a reed. *Figure 5:11* shows the mouthpiece of a recorder. Air is blown across the V wedge and almost instantly adopts a 'preferred' route from the initial random turbulence, perhaps down channel X. This leaves channel Y in partial vacuum, recognising Y as the easier route, the air flow duly flips across the wedge point. Now channel X becomes a vacuum, pulling the air-flow back from Y. The speed at which this oscillation occurs is determined as before by the effective capacity of the pipe cavity.

Figure 5:11 Recorder mouthpiece

In the accordion and harmonica, a third principle applies. A separate 'free reed' is incorporated for each note, the pitch being predetermined by the reed size. The greater the weight and flexibility of the vibrant element, the lower the fundamental frequency. If the bellows of an accordion are replaced by an electric fan, and the keyboard arranged horizontal with the flow, the result is virtually a harmonium.

The dynamic envelope of woodwind instruments presents no inherent recording problems. It is generally characterized as a fairly quick rise to a maximum-level plateau, sustained until concluded with a fairly quick decay. *Figure 5:12* shows this as a simple graph of loudness against time. The sustained level may of course be varied through the performer blowing harder or softer, or by an accordionist increasing pressure on the bellows.

Most woodwind instruments may be 'overblown' to raise their useful frequency range. The first few notes in the overblown range tend to

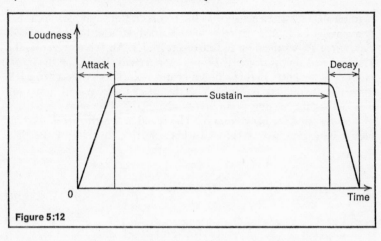

Figure 5:12

be louder than notes at the adjacent end of the bass-fingered group. When setting recording levels during a rehearsal, performers should be asked to play sections of the composition requiring overblowing. It is usually safer to overestimate programme level than to underestimate it.

When close recording a woodwind instrument, particularly if of metal construction (flute or piccolo), worn hinges and cover pads can generate a high level of action noise. Although some balancers take pains to exaggerate action noise in a variety of instruments, this constitutes a special effect (another word being 'gimmick') having little connection with concert hall or chamber reality.

The classic position for a woodwind spot is within 1 m of the seated or standing performer at middle-chest height. If a horizontal instrument such as a flute is recorded through a very close stereo pair, it can be spread across almost the entire soundstage as the sound source tends to follow the position of the lowest closed hole. It is difficult to imagine circumstances where so wide a flute would be desirable.

In virtually every situation and composition, woodwind instruments benefit from a fairly high degree of reverberation. Pairing, tripling or quadrupling instruments is the most effective alternative to high ambient reverberation since the main effect of reverberating a soloist is to provide a ghost accompanist. While any orchestral member may be raised in relative level by spotting, that member becomes detached from any natural reverberation which may be present. It is therefore often necessary to add artificial reverberation. Not too much, of course, for any sound flooded with reverberation becomes increasingly objectionable the more it is played.

With bagpipes, the tradition of open-air playing makes a 'dry' re-

cording generally preferable to one that is reverberant. The effect of many pipers playing in the open certainly cannot be synthesized by indoor or artificial reverberation. A reverberation-free orchestral church organ on the other hand, would tend to resemble a much less majestic fairground instrument. The organ is one instrument that should never need spotting since it can hold its own against even the most powerful orchestra. A fairly distant stereo pair is nevertheless sometimes employed to reinforce pipe organs. If positioning such a pair, the organ must be regarded almost as an independent orchestra occupying a comparably large amount of space. Organ pipes are usually installed well above head-level which many recordists overcome by using microphone stands capable of reaching some 10 m. Needless to say, every precaution must be taken against human injury when designing, assembling or using a high microphone suspension whether of the stand or cord kind. Similarly, microphones do not derive benefit in falling from a height.

For the reason already stated as applicable to bagpipes, fairground organs are traditionally heard in acoustically dry surroundings. The elaborate effects produced by many fairground organs, coupled with the desirability of freedom from reverberation and surrounding noise, make close-microphone recording particularly appropriate. A four-microphone arrangement of the kind shown in *fig. 5:13* allows a much closer approach to the soundstage than would be possible using a stereo pair. All four microphones should be cardioid since omni or figure-of-eight patterns anywhere in the group would raise the level of ambient noise it is designed to suppress. This arrangement can, of course, be applied in any circumstance where local noise or reverberation is excessive. Only the most basic 4/2 mixing facilities are required, there being no inherent need for pan controls. If any of the four microphones is out of phase relative to the other two or three, however, stereo anomalies may be expected.

Brass

Brass instruments differ from woodwind in one major respect having no immediate bearing on constructional materials: the performer's lips perform the function of reeds and air-flow wedges. In pronouncing the plosive 'pah', we force air from the lungs into the closed mouth cavity and suddenly release this pressure by opening our lips. If lip tension is carefully controlled, a series of short plosives may be generated with such rapidity that they merge into a buzz of the kind popularly termed a 'raspberry'. When this action is performed at one end of an air-filled tube, the entire air column tends to vibrate at the plosive frequency. The larger its bore and the greater its length, the lower its fundamental resonant frequency. Only a skilled performer

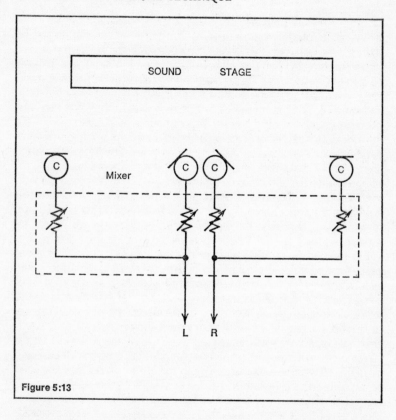

Figure 5:13

can produce more than two or three notes from such an instrument since the horn dimensions dictate pitch to the lips rather than vice versa. A horn can usually be activated at one or more harmonics of the fundamental but these are not necessarily on a useful point of the chromatic scale.

Although early horns were produced literally from animal horn, metals of one kind or another became increasingly adopted since they allowed almost complete freedom of shape and size. The next step in the evolution of 'brass' instruments was to curve the basic horn into whatever shape suited the length and bore. This had no significant effect on the horn's musical characteristics until instrument builders realized they could short-circuit some of the tube convolutions, using 'valve' switches to vary the horn's 'speaking length'. A modern trumpet is little more than a carefully designed horn, folded on itself and equipped with length-control valves.

In the trombone, an even simpler pitch-control system is employed.

The horn is again folded on itself, one section of the tube being telescopic in construction. Within a predetermined range, the pitch of a trombone is therefore continuously variable.

French horns possess the curious distinction of throwing their sound output away from the audience unless the performers sit back to front. Back spot microphones are consequently usually placed behind these instruments, if required at all, where they present not the slightest optical distraction to the player. This gives a more strident tone than the concert-goer might expect but this, in the guise of 'greater presence', has long been a major selling point of close-microphone recordings.

Few instruments in the brass family can be classed as among the quiet members of the orchestra and the necessity to close-record a single trumpet, trombone, horn, bugle or cornet is likely to be rare. A more homogeneous sound may be obtained by covering the brass group with a single stereo pair in the case of a well distributed orchestra multimiked in a dry studio. This arrangement is neither practical nor desirable in a concert hall, however, where a stereo pair plus (if really necessary) one or two spots gives the most pleasurable results.

Strings

The three most widely used methods of sound activation in stringed instruments are plucking, bowing and percussion. In almost all cases, the strings are connected to a reasonably flexible wooden panel which diffuses their vibration more efficiently into the surrounding air (*fig. 5:14*). A resonant air chamber, the soundbox, is usually incorporated beneath the soundboard to give the instrument a recognizable aural identity. The rose in a guitar or harpsichord and the 'f holes' in a

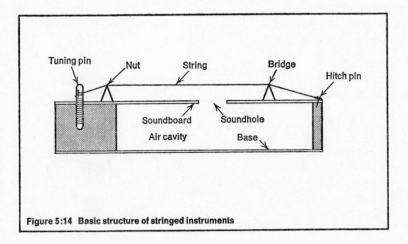

Figure 5:14 Basic structure of stringed instruments

cello are both examples of the air gap left to encourage resonance. String vibration rate, and therefore pitch, is determined by the weight and tension of wire or gut between bridge and nut or between two bridges. A nut is a 'bridge' mounted on an essentially non-vibrating section, usually the wrest plank.

The dynamic structure of a plucked string is typified in *fig. 5:15*. Compared with the woodwind structure, we find a very rapid attack and an exceedingly long decay. In reality, the decay time is often shortened by deliberate damping as occurs when a harpsichord key is released. Some stringed instruments, notably the piano, generate an extremely high attack transient which can easily overload a mixer (if the microphone is too sensitive) or a recorder (if the tape modulation level is too high). It is often wise to ignore a VU meter in such situations and adjust recording level by simultaneous off-tape monitoring.

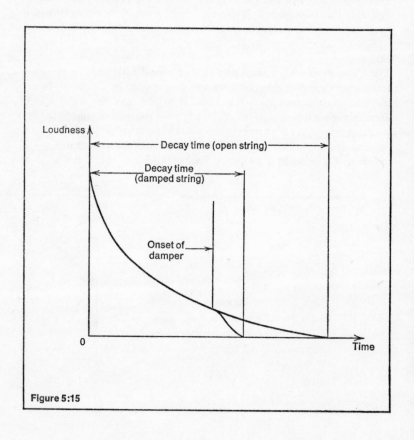

Figure 5:15

Harp

One of the very earliest musical instruments, the harp, almost certainly evolved from the hunting bow. Folk and concert harps operate on similar principles, generally using a separate string for each note of the diatonic scale. In a concert instrument, pedal mechanisms sharpen or flatten certain notes by altering the effective string' length and so achieve a chromatic scale. In the technically more elegant cross-strung concert harp, diatonic strings run from top left to soundboard-right with 'sharps' travelling top right to soundboard left. Purely diatonic harps are tuned to whichever mode is required for a particular composition. There is no bridge in a harp, the strings being anchored by the lower end. Usually, a knot is tied in the lower end and the string threaded up through an anchor hole to a nut pin and thence to the wrest pin.

At first sight, the obvious location for a spot microphone is off to one side of a harp. But this assumes that the strings emit the major proportion of sound when in fact the angled soundboard does so. *Figure 5:16* shows a more effective position for a cardioid spot microphone, looking down at the middle point of the soundboard (ideally 90 degrees to its surface as played). The microphone is best set slightly to left or right of the front pillar, not least to prevent accidents when a tilting instrument is returned to rest. It reflects badly on many composers that the harp is sometimes called into action during very loud orchestral passages where it is totally unable to compete with surrounding instruments. Talk of a carefully judged 'wash' of sound here is too often nonsense, though a more thoughtful orchestral layout sometimes rescues the harp. An additional problem is that concert harps have acquired a degenerate feature which goes back earlier than the pedal instrument: by placing the resonance holes at the back of the soundbox, the full force of sound is delivered to the performer's legs. Precisely who suggested this 'improvement' is a mystery but the motives are fairly obvious: the soundboard of a concert harp is stronger for the lack of up-facing soundholes and re-stringing from below is made possible.

In a folk harp, the soundholes are usually set in the soundboard. If a spot microphone is considered necessary, it should be placed at the angle applicable for a concert instrument.

Harpsichord

Many of the earliest harpsichords, so far as can be deduced, were upright instruments roughly resembling a harp with a horizontal keyboard. Instead of fingertip plucking, a mechanism was placed between the player and each string. This considerable disadvantage was considered offset by the ergonomic superiority of a keyboard over the many strings of a harp or psaltery. Upright harpsichords soon gave

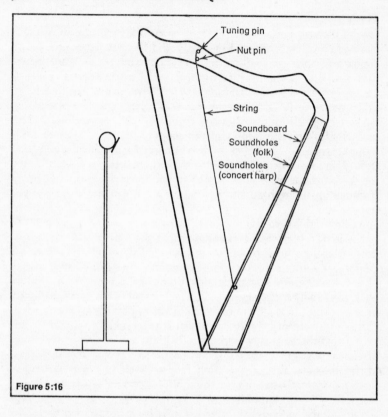

Figure 5:16

way almost entirely to horizontal designs, simplifying the mechanism to that shown in *fig. 5:17 (a)*. Pressing a key raises a wooden (nowadays sometimes plastic) jack from which a protruding 'quill' plucks the appropriate string. When the key is released, the jack falls back to rest and is prevented from audibly catching on the string by an escape mechanism detailed in *fig. 5:17 (b)*. The disadvantages of the system over finger plucking are obvious: the tone of each note is rendered much more uniform; dynamic control is almost lost; action noise and unreliability factors are introduced. Over the last few centuries, harpsichords have been rendered more versatile in several ways, each adding to the problems of maintenance. In a very elaborate instrument, each key may support three jacks, one quilled with leather (soft tone), and two with delrin. Of the latter pair, one jack plucking very close to the nut gives the thin sound designated 'lute' while the other, nearer midstring, produces a warmer full-bodied tone. A choir of strings an octave higher ('four foot') than the single or unison-paired standard

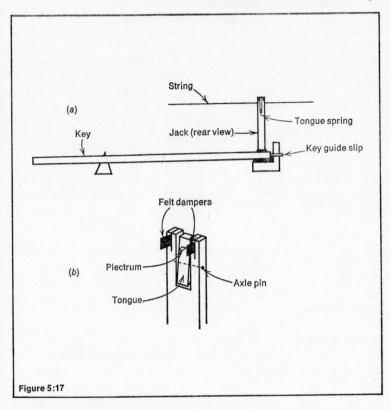

Figure 5:17

pitch ('eight foot') choir are often incorporated, either worked from a double manual keyboard or switch-coupled to a single keyboard. In the latter, jacks can be moved sideways to disengage the plectra when not required to sound. In some designs, this mechanism provides further dynamic control in the shape of the 'half stop'. Here, each plectrum is positioned to pluck at its extremity, giving a quieter pluck than when pushed further in to overlap the string. Yet another means of dynamic control is, or rather was, the 'Venetian swell'. This comprised a series of horizontal wooden shutters running parallel with, and just above, the strings. Worked from a pedal, the swell was fairly effective but is generally considered an excessive adulteration of a plucked instrument and was confined mainly to a single eighteenth-century manufacturer (Burkat Shudi).

When recording a solo harpsichord, a stereo pair set back 1–3 m gives generally the best results. Again, the precise distance depends on local reverberation and on the noise contributed by the key and jack

mechanisms. Traffic noise behind this instrument sounds particularly absurd, although at least one commercial harpsichord recording suffers from it. It can be overcome in all but mid-city locations by recording between the hours of 02.00 and 04.30. Any isolated noise heard during monitoring should be marked on the producer's or balancer's score.

Many harpsichords built during the early and mid twentieth century were copied on contemporary piano structures: heavily built and lacking a soundbox base. Spot microphones are often rendered essential due to the low volume resulting from poor design. An obvious spot location is underneath the soundboard where the microphone or microphones may be placed virtually out of sight. It is usually necessary to apply severe bass cut, however, since the proximity of keyboard, jacks and jack rail introduces very objectionable low-frequency action noise. Depending on the available equalizers, this bass cut may detract from the bass string tone in which case an additional spot above the soundboard, near the instrument tail, provides ample recovery. Alternatively, the recording can be made entirely from above the soundboard, the precise microphone position depending on the desired final tone. Too close a microphone gives an initially pleasant tone but this rapidly tires the senses as indeed applies to all but the very quietest musical instruments.

Spinet and virginal

The generic 'spinet' has been used to cover a variety of instruments more or less resembling the harpsichord. A convenient distinction is to classify a spinet as having strings at an acute angle to the keyboard, those of the harpsichord at 90 degrees, and those of the virginals parallel with the keyboard. Spinets come in two distinct shapes and sizes: the small triangular and the larger bentside. Each has a characteristic resonance, the triangular instrument having musical-box associations and the bentside spinet approximating to a lightly built Italian harpsichord. Spot microphones are unlikely to prove necessary in chamber performances of Renaissance music, for which the spinet is most appropriate, and the likelihood of a full orchestral accompaniment is clearly remote. Nothing is outside the interest of pop musicians, however, and in the event of its receiving a loud backing a spinet may be spotted most effectively by a cardioid aimed at the sound hole. Virginals may be treated in the same manner but, as with spinets, loud bass action noise must be anticipated if the instrument is more than a few decades old. Even a new specimen may give noise problems, depending on the care taken in design and construction.

Clavichord

Structurally resembling a virginal, the clavichord must surely be the

quietest musical instrument ever developed. It is generally assumed to have evolved from the monochord, a single-string tool employed many centuries ago for research into the foundations of musical scales. *Figure 5:18* shows the basic clavichord action. A metal tangent strikes a string and forms the nut until the key is released, whereupon the note is damped by felt at the distant string end. Pitch modulation can be effected by varying the pressure on the key. Clavichords are produced in various sizes, depending on the required compass, and construction varies from the original closed-bottom-plus-soundhole through totally closed to open-bottom and even open-bottom-plus-soundhole.

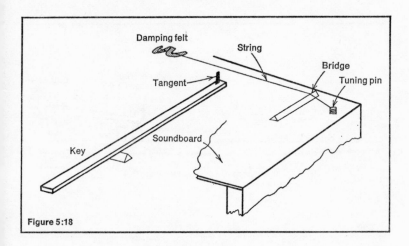

Figure 5:18

Due to the low sound output, this is one of the few instruments which cannot be recorded with a conventional (horizontal-aim) stereo pair. Since the sound from a clavichord travels predominantly upward, a spot or stereo microphone is best mounted above the soundboard. The effective soundstage width is determined by the bridge length, the overall instrument width being irrelevant. A reasonably even output spectrum is clearly ideal and this may prohibit placing a microphone too near the soundhole. In many instruments, such a location produces an excessively bass-heavy balance.

In public performance, the clavichord is invariably amplified from a very close or contact microphone. Almost any microphone can be employed as a contact device merely by placing the transducer shield firmly against the soundboard. Trial and error is the only way to determine the most suitable contact point as invisible soundboard ribs, for example, can strongly affect local tone.

Piano

Although strictly a member of the percussion family, the piano has more in common with plucked-string keyboard instruments. Early pianos were essentially modified harpsichords—each jack rising to strike a string and then bounce rapidly back to the key. From the harpsichord evolved the grand piano and from the virginals came the 'square' which later gave way to the upright. *Figure 5:19* shows the hammer structure and escapement of an early Viennese piano, a system which became very much more complex during the eighteenth and nineteenth centuries.

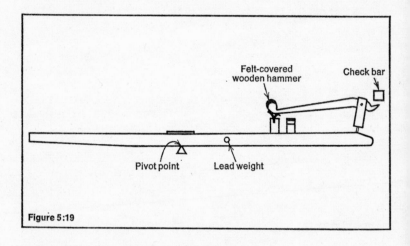

Figure 5:19

As the piano evolved into its twentieth-century form, cabinets became heavier to compensate for higher string tension (caused in turn by a desire for greater dynamic range). Metal frames were eventually required as tensions approached the 30 tonnes of a modern concert instrument. The characteristic tone of a piano now bears little resemblance to that of an early grand or square and the unique charm of the latter instruments is almost entirely neglected at the time of writing.

A fairly reverberant hall and a distant stereo pair produce the finest piano balance for many types of music. Assuming the performer to be facing north, the microphone pair should aim in from the north-east. Unless the instrument is fiercely strident, the reflector should be raised at 45 degrees and the microphones aimed in at about head height from 1 to 4 m depending on the desired reverberation.

Much closer locations are often employed for jazz and pop, where a drier or more strident tone may be more appropriate to the composi-

tion. Piano tone varies widely from one instrument to another, perhaps the ideal for intimate jazz being the soft quality of thick hammer felt. If extremely close microphone locations are preferred, key and pedal actions should be checked for silent operations and any excessive mechanical noise eliminated.

Not all compositions require a well-tuned instrument and some studios retain an upright piano in deliberate rough tuning. Metal chains, drawing pins and blotting paper between the strings provide a substantial extension in the tone of an upright instrument where a jangle effect, for example, is desired.

For visual aesthetic reasons, upright pianos are usually placed against a wall even though a substantial volume of sound would otherwise emerge from the rear. If an upright is reasonably strident, it may be recorded from a stereo pair located as shown in *fig. 5:20*. The tendency for excessive bass pickup is offset by this microphone location. If the tone of an upright is insufficiently strident, this may be improved by turning the instrument away from the wall and recording from behind. It is often better, and more convenient, simply to remove the casework until the desired tone is obtained. The top lid, upper and lower face boards may all be removed with much less exertion than bodily shifting the instrument.

Dulcimer
A true dulcimer, large or small, comprises a wooden soundbox with groups of unison cross-strings running parallel to the 'keyboard' edge. There is, however, no keyboard for the instrument is played in the manner of a xylophone with wooden or felt-covered hammers held in

Figure 5:20

the performer's hands. A spot microphone, if needed, can most usefully be suspended above the soundboard at a height of about 1 m. Recording level should be set for wooden hammers since any adjustments made for felt may prove disastrously over-sensitive in later sequences.

Guitar

The guitar, mandoline, ukelele and banjo can each be recorded at close quarters without unduly fatiguing the listener's ears provided the instrument is sufficiently well made to have no bass honk—a common fault in the cheaper guitars. A seated performer can be covered from a spot or stereo pair facing towards the soundholes and offset slightly to the instrument neck. Some balancers try to capture finger-action noise even though the performer may be trying harder to eliminate it. Pulling a spot or pair back from the instrument is the only satisfactory way to reduce this noise, short of destroying the music itself with treble attenuation.

Electrically amplified guitars can usually be recorded either by direct injection (to the mixer from the pickup coils) or through a microphone near the guitar loudspeaker. While direct injection gives the purest sound, the ear is in many cases offended by the simplicity of the waveform—an analogue of the string vibration relatively unaffected by instrument case vibration or soundbox cavity resonance. In live performance of amplified-guitar music, loudspeaker colouration improvises the missing soundbox characteristics. There is no technical objection, of course, to mixing the microphone and direct injection channels if this is found to produce preferable results.

Violin family

The violin, viola, cello and double-bass amount to little more than the same instrument in several sizes. All are primarily bowed rather than plucked and normally produce a dynamic transient similar to that associated with wind instruments. Although the sound produced by a violin travels predominantly upwards (90 degrees to the soundboard plane), this is one instrument which does not benefit from a microphone placed on that axis as the resultant sound is too shrill. Some degree of reverberation is essential to a violin solo, duo or trio and is desirable even when these instruments are played in larger numbers. This applies to a smaller extent with the viola. Cello and double-bass, however, are anything but shrill under normal circumstances and may be recorded through as close a microphone as the performer will tolerate. It is not uncommon to wedge a small microphone in the f-hole of a double-bass and this might similarly be applied to a cello. Such practices should only be adopted to overcome specific problems, however, not applied merely at casual whim.

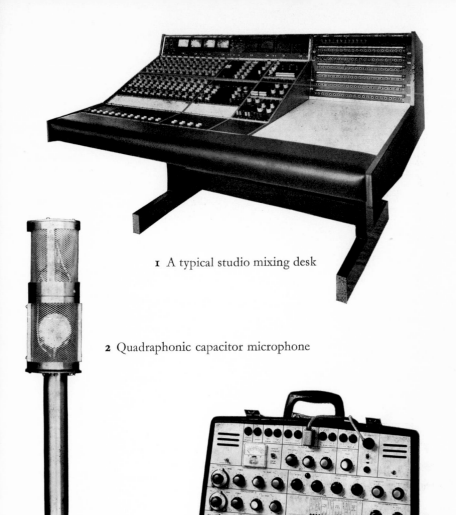

1 A typical studio mixing desk

2 Quadraphonic capacitor microphone

3 Compact electronic
music synthesizer

4 Tape path of an omega-wrap helical scan video tape recorder

5 Monitor controls of a Sony monochrome television camera

6 Control panel of a Sony monochrome television camera

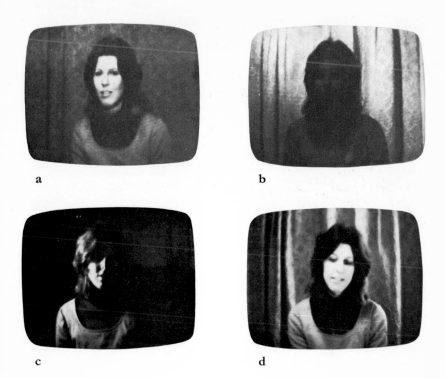

a b

c d

8 Various approaches to lighting a head-and-shoulders subject. **a** Insufficient overall light creates a flat picture of poor contrast. **b** Excessive rear light causes concentration on background rather than on subject. **c** Subject highlit from one side, leaving background relatively dark. Creates asymmetrical features. **d** Preferred method. Two side lights for subject and (if desired) a third for the background. As *fig.* **10:10**

7 Input and output connectors of a television monitor

9a Telephotomicrograph equipment set-up

9b The resultant image

Percussion

Percussion instruments are simultaneously the easiest and the most difficult to record. The percussion section of a large orchestra or dance band is normally perfectly audible above the companion instruments, at least when the composer consciously wishes them to be, and this family should rarely need a spot. In pop, however, it is not uncommon to close-record a drumkit by treating each component as a separate instrument. Here, the aim is usually to record the kit in a totally non-reverberant acoustic. The dominant consideration is no fine point of balance but that of keeping microphone transducers intact. Most studios handling pop soon find a moving-coil microphone capable of withstanding the high-sound pressure levels inside a bass drum: ribbons are invariably too weak and capacitors too expensive for this application.

The best angle from which to cover the main items of a pop or jazz drumkit is directly above the player at 2 or 3 m from the ground. A capacitor may safely be used at this distance, mixed with the signal from a moving-coil microphone suspended up to 1 m in front of the bass drum but shielded from floor-transmitted mechanical shock.

Magnetic tape is by no means the only medium capable of recording sound. Other possible storage forms include mechanically, optically or magnetically modulated discs, drums, mats and ribbons. Even in computer systems, however, magnetic tape remains the most popular medium for long-term storage. In computing, as in audio, the advantages are economy, easy reloading, easy labelling, and the facility of total or partial erasure and rerecording.

Audio tape possesses an additional major advantage over all other contemporary stores. Sound may be cut, transposed, spliced and inverted as easily as the recording medium itself. This process is termed 'tape editing' and is invaluable both in recording short sequences and in programme production.

The basic tools of tape editing are simple and inexpensive. *Figure 6:1* shows an editing block in top and side section. Even with so elementary a device careful choice is essential. The block should be of metal rather than plastic and should incorporate the slight lips visible in the diagram. Without these, there is little to prevent the tape from slipping along the block or falling to the floor.

Additional requirements are single-edged razor blades and hard-glue jointing tape of just less than the true tape width. Double-edged razor

Figure 6:1

blades are too flexible for safety and household adhesive tape a similarly troublesome improvisation since the glue tends to ooze out on to the tape surface, causing the edit to catch on each pass through a playback machine.

The problems which may be solved by tape editing are numerous. An elementary task is tidying up a series of recordings interspersed with false starts, long passages of tuning up, or just plain silence. It is not normal practice to store separate sequences on individual spools since this can rapidly absorb all available shelf space. Instead, recordings are grouped on one or more spools beginning with white leader tape and ending with red trailer. Yellow is usually employed as a spacer between items. These colours are obviously an arbitrary choice, those named being in accordance with BBC practice.

Editing techniques vary from one operator to another and to some extent from one tape machine to another. When tidying up a series of musical items, the opening bars of the first item are played and checked against a handwritten record of the tape's content. A record of this kind can eliminate the risk of confusing a false take with a complete take, provided a tape timer or spool rotation counter is employed as an additional reference.

Once the opening bars have been found, the tape should be stopped and rocked back across the replay head by hand. The ability to reproduce a tape under these circumstances represents a fairly clear division between purely domestic and semi-industrial machines though even an unobliging domestic can be rocked if the tape is threaded outside the capstan and pinch wheel. Assuming 38 or 19 cm/s recording speed, there is no need to cut the tape hard against the opening note, an error margin of 1–3 cm being acceptable except when trimming a cough or click just before the desired opening.

If time is at a premium, the cut itself can be made with scissors (provided these are degaussed before each session, using a tape head demagnetizer). With practice, a 90 degree cut can be approximated sufficiently well for direct butting to a 90 degree leader or spacer edge. Perfectionists go several stages further. Instead of scissoring the edit point, this is marked with a chinagraph pencil using the replay head as a back rest. Alternatively, the mark is made against a guide to the right or left of the replay head with the stagger distance (typically some 3 cm) calibrated on the edit block. Many editors prefer consistent use of a 45 degree cutting angle since this provides a relatively slow build-up of tape hiss as the leader or spacer gives way to magnetic material. The sudden introduction of background hiss produced by a 90 degree joint in these circumstances can create the illusion of a 'click' though the blame may equally be attributed to a noisy recording.

Whether or not an editing block is used for the initial cut, it is

practically essential during the jointing process. Suitably angled leader tape is butted against the opening transient and a 3 cm adhesive strip pressed carefully over the join. Slight overlap of the two tapes need not be feared though there must be no sign of the jointing strip when the tapes are peeled from the block and inspected from reverse. It is usually necessary, always advisable, to press the jointing tape with the back of a fingernail to ensure a tight bond otherwise the splice may break during subsequent playback.

There is no need to remove the feed reel from the tape machine when editing, except for the obvious purpose of changing spools, provided the block can be brought reasonably near the tape heads. A few recorders leave space for permanent mounting of a splicing block while still fewer have a usable block built in.

Finding the end of a sequence is simply a back to front version of the foregoing with the added complication that decay transients are generally longer and less well defined than the opening attack. Cutting instrumental or reverberant decay before it has really died is among the worst errors that can be perpetrated in audio. It is nevertheless an easy mistake if the editor is tired or if the decay is masked by noise in the replay equipment.

In-programme editing is both more satisfying and more difficult than tidying up with leaders, spaces and trailers. Before about 1945, most commercial recordings were cut direct on to disc and any serious mistake meant starting once more from the beginning. With tape, it is usually possible to remove unwanted gaps and interruptions—if necessary recording the faulty few bars again for reinsertion.

Speech is generally easier to edit than music, particularly when manipulating distinct phrases. Individual words require more careful treatment as many run into each other, notably when one closing vowel meets a succeeding opening vowel. 'She is' is often merged into a continuous 'Shee-yis', 'Why are' into 'Wyar', 'This station' into 'Thistation' and so on. With practice, most such combinations can be split though it is clearly easier to cut before or after a plosive. It is even possible to manipulate syllables, a classic conversion being that from 'This is BBC Radio Newsreel' into 'This is BBC Rewdio Nasreel'. Editing with this precision is most easily undertaken at 38 cm/s since the error margin becomes small at 19 and absurd at 9·5 cm/s. Attention to detail is essential. Does one, for example, really wish to assemble 'Rewdio' (ree-oo-dio) or is it better to chop the *ee* during transposition and insert merely the *oo* to produce 'Roodio'?

In reality, as distinct from amusement, a major consideration in speech editing is to avoid changes of meaning. The editor may be faced with a rambling five-minute interview to be condensed into a tight one-minute. It is often desirable to cut some or all of the inter-

viewer's questions, provided this can be achieved without making nonsense of the replies:

'What is your job here?'

'I am the chief executive.'

'And what do you actually do?'

'I am responsible to the chairman for the efficient running of the company.'

This specimen could be shortened by cutting out the second question and coupling the two replies. On paper, the second 'I am' would be probably eliminated but on tape this might involve shaving 'mresponsible'. And beware the obvious alternative of linking the first question direct to the second reply as this can lead to angry communications from an interviewee who feels he appears downgraded to the role of general manager.

Very fine editing sometimes demands the use of 90 degree joints and here the chinagraph mark is usually more precise than scissoring near the heads. Whichever technique is adopted, any razor employed should also be demagnetized at frequent intervals until such time as razor-edged plastics are developed. Plastic scissors, incidentally, have hitherto not been found sharp enough for repetitive tape editing.

One irritating mistake which can occur when splicing tape is to join a portion upside down or, if the editor is near the end of his tether, inside-out. The former causes track reversal (full-track mono or two-track stereo) or programme disappearance (half-track mono or quarter-track), while the latter causes a fall in signal level, particularly bad at high frequencies. Another error is to try editing thinner than standard-play tape. Long play is manageable, double play difficult, triple play extremely difficult and quadruple play (rare specimen) almost unworkable.

There is little danger of a splice catching as it passes through a tape machine, unless the adhesive material is accidentally applied at an angle. Some editors habitually trim a slight concave in the tape edges above and below the splice but this is really only necessary where adhesive tape has overlapped the magnetic tape backing.

Do not always assume the matt side of a tape to be the oxide coating. Many modern tapes have a polished oxide surface and matt backing, the former minimizing head wear (in theory at least) and the latter maintaining neat spooling. A splice on the coating side can register as a gigantic dropout.

Acoustic Effects

There are two distinct forms of tape recording: one in which the sole motive is to capture reality as near perfectly as possible, the other in which recording equipment is used as part of the programme origina-

tion chain. In the latter situation, the sound balancer is expected to understand the more obvious acoustic treatments which may be used to doctor sound. Since originality is the usual motive for such treatments, there is little point in trying to list every permutation of effects. Instead, a basic guide should enable balancers to develop entirely original techniques of their own. In pop music particularly, nothing is 'against the rules' short of actually damaging studio equipment.

The most common acoustic effect is chamber-reverberation. *Figure 6:2* shows a studio microphone (A) connected through fader F1 to a recorder. A parallel line feeds from the studio microphone via an amplifier to a loudspeaker situated in a convenient live room. At the opposite end of this room is another microphone (B) routed through fader F2 back to the direct signal channel. In practical location sessions, it is not unusual for a reasonably large public convenience to be commandeered as a reverberation chamber since the traditional wall tiling gives almost ideal acoustics for this purpose. Alternatively, any room or ante-chamber will serve if reasonably free from sound-absorbant soft furniture, thick carpet and curtaining. Such a room must be totally free from outside noise although slight breakthrough from the performance hall is usually tolerable.

Many recording studios equip a permanent reverberation chamber if the space is available, since the result is generally superior to electromechanical artifices. All floor, wall and ceiling covering is removed and hard curved-surface sound reflectors are installed to randomize the reverberation patterns. These reflectors usually take the form of concrete drainage pipes distributed fairly casually around the chamber.

Figure 6:3 shows a reverberation chamber being used to derive a

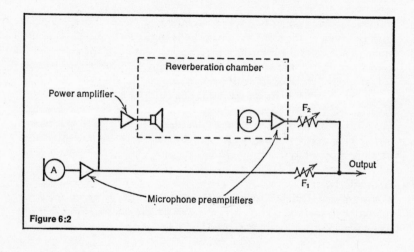

Figure 6:2

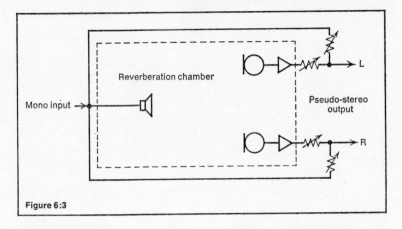

Figure 6:3

stereo effect from a mono source. It is only really effective when applied
to highly localized sounds such as a solo instrumentalist but can be
used reasonably successfully with more elaborate sources. Few mixer
manufacturers distinguish between reverberation and echo in captioning
the 'echo send' and 'echo return' controls of their products. Any sound
reflections occurring slower than about 15 per second may be heard
as individual echoes and are termed thus. Reflections faster than 15 Hz
tend to merge into a continuous wash of reverberation. An interesting
parallel exists in optics, the human eye merging projected cine film
into a continuous picture when shown above 15 frames per second;
when shown below, these split into discrete flashes.

Electromagnetic effects
A classic electromagnetic treatment applied to audio is in generating
reverberation and echo without resort to any acoustic chamber. Note
the similarity between *figs. 6:3* and *6:4*, the latter showing a reverbera-
tion plate. Instead of a loudspeaker activating multiple reflections of
air-carried sound waves, the sound travels along a thin metal plate
and reflects off each edge in a similar manner to air-motion reflection
from a wall. Early reverberation plates were bulky and not really
suitable for location work. These are now being superseded to some
extent by compact units employing metal foil. In both systems, the
acoustic wave conductor is suspended fairly freely to encourage
reasonably sustained vibration. Precise control of reverberation time
is obtained by applying damping material to a progressive area of the
plate, often by electric motor remote controlled from the mixing desk.
 Cheaper and simpler than plate devices are reverberation springs.
These comprise little more than a moving-coil driver coupled by a

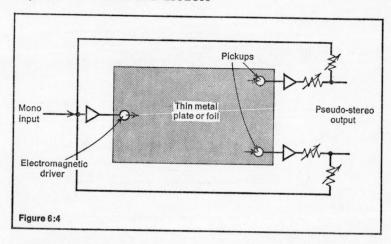

Figure 6:4

spring to a pickup (*fig. 6:5*). Any such device, spring, plate, or indeed chamber, must be designed in such a manner that no severe resonances are detectable. A simple practical test involves recording noise (an FM radio receiver off-station provides a useful source). The noise tape is then formed into a short tape loop of which perhaps 10 per cent is modulated and 90 per cent spacer tape. This produces repeated noise pulses which quickly reveal any potentially troublesome ringing in the reverberation chain.

Echo

Rather than employ gigantic plates, springs or chambers, echo is

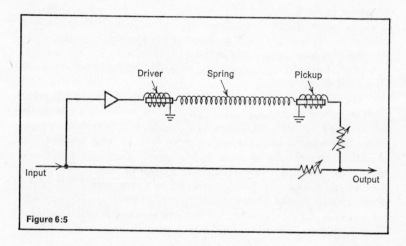

Figure 6:5

usually derived from one or more staggered tape playback heads. Any recorder with separate record and play heads will provide a single echo when connected as in *fig. 6:6*, the echo time being the period taken for any point on the tape to travel between (a) and (b). Many studios feed reverberation plates from single-delay systems of this type to synthesize bounce-back from the rear of a concert hall.

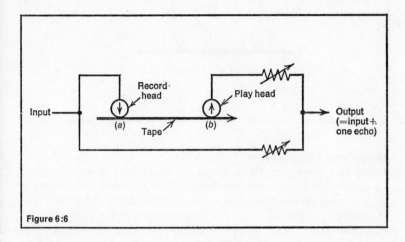

Figure 6:6

Recycling echo (*fig. 6:7*) is obtained by feeding the delayed signal back to the record head at a level suitably lower than the main input. Some form of echo-level control (represented by fader F) is essential to prevent accumulating howlround. Yet another means of echo generation (*fig. 6:8*) involves the use of several playback heads, the delay medium being a tape loop or a rotating drum with a peripheral magnetic coating—the latter eliminating the nuisance of loop breakages. The stagger distances are made dissimilar to give a more complex echo formation than is available with the simple recycling technique.

Pre-echo

Having no existence in natural acoustics, pre-echo is a highly unusual and effective treatment for certain types of experimental music. The sound to be processed is first recorded on a full-track or two-track machine and the tape reversed for backward reproduction into a second recorder. Echo, reverberation, or both, are added to the signal before being copied. The second tape is then reversed, returning the programme to its original temporal direction but converting the delay treatment into acoustic precession.

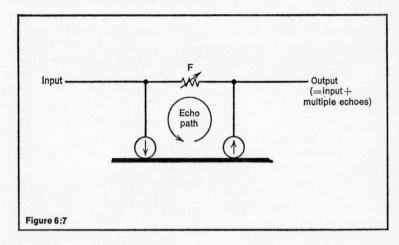

Figure 6:7

Instrument modification

In pop and programme theme music at least, highly original effects can be obtained by temporarily modifying existing musical instruments or by inventing more-or-less new ones. Upright and grand pianos lend themselves particularly well to such alterations, in the form of metal chain placed across the strings, drawing-pins in the hammer felts, or paper between the strings and hammers. Guitars can be muted by placing the ball of the hand across the bridge, as most performers know, or more dramatically altered by entwining metal springs round the strings to encourage buzzing.

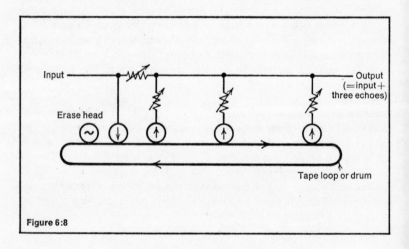

Figure 6:8

Pitch bending

Many electric guitars incorporate a pitch-bending arm which allows the tension of all six strings to be uniformly varied in mid performance. It is sometimes desired to pitch-bend instruments that are mechanically quite incapable of such a characteristic. A simple method of achieving this is shown in *fig. 6:9*. A continuously variable speed tape transport is useful in this application but by no means essential. More interesting results can sometimes be produced simply by pinching the tape where indicated to alter its speed. The effect is rendered more unusual by adding recycled echo (completing the circuit broken by switch S). This creates complex interference between notes of similar pitch though too high an echo setting can spoil the resultant tone. Like all gimmicks, this should be used with discretion.

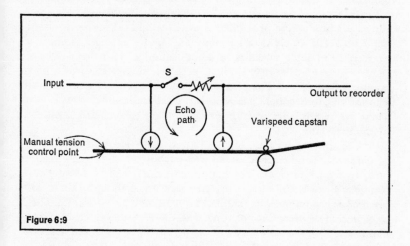

Figure 6:9

Though hardly an instrument, a wooden or plastic ruler can be used as a unique form of percussion. The ruler is held at the edge of a hard table top, substantially overlapping, and the free end flicked down with a finger. This simple device has been used in several successful music productions.

Glass bottles, tuned by progressive water filling, make an inexpensive and unusual form of xylophone though less conventional sounds are obtained by recording the bottles being shattered. One, two or three such sequences, upspeeded, downspeeded, reversed or otherwise processed, can form the basis of an edited tape loop suitable as a backing for almost any melody. Here, the experimenter is entering the realms of *musique concrète*, an art form which at one time appeared to have a

promising future. Unfortunately, intensive tape editing can fatigue and even permanently injure the editor in requiring long periods leaning over a splicing block. Solid-state, rapid-access memories may eventually supersede magnetic tape, in which case *musique concrète* should become a more practical art form.

Multitrack assembly

Many major recording studios, faced with arrays of twenty-four or more microphones in a complex session, route these to a comparable number of tape tracks. It is not unusual for a multitrack tape to be partially recorded in one studio, completed in a second (typically by adding vocals to the previously recorded backing tracks), then reduced to stereo or mono in a third premises. One legendary tape was so heavily modified that only the audience-reaction tracks reached the reduction stage, all other original tracks having been rerecorded.

Quite apart from its practical convenience, multitrack recording allows the production of sequences which would otherwise be almost impossible. Extremely close harmony singing, for example, is obtained by recording single vocalists in accompaniment with themselves. A single instrumentalist may similarly assemble many tracks of a polyphonic composition for simultaneous playback. Most electronic music synthesizers, for example, are essentially monotonic and also expensive. These are two reasons in favour of compiling an orchestral synthesis by multitracking.

At the time of writing, eight-, sixteen- and twenty-four-track recorders are beyond reach of all but well-established studios and wealthy (usually pop) musicians. The high cost is due to the provision of a complete record and replay chain for each track though this is only essential for simultaneous multitrack recording (*fig. 6:10 (a)*). There is no technical objection to using a single record/play chain with a multitrack tape transport, switching the circuitry from one track to another as each is recorded. Multitrack playback facilities can be arranged relatively easily with appropriate switching and mixing of the replay head outputs (*fig. 6:10 (b)*). A further price saving can be effected, at some compromise in quality, by using a single multitrack head for both recording and reproduction. Virtually all studio multitrack recorders incorporate a selsync facility, allowing one or more tracks to be monitored from the record head. This is obviously necessary when recording a track in accompaniment to previously recorded tape tracks as the staggered replay head would create a timing problem.

An altogether cheaper form of multiple assembly involves using a suitably designed stereo recorder. The technique is elaborate and lacks the versatility of discrete multitracking but is none the less practical. Assume a flautist wishes to perform the function of first, second, third

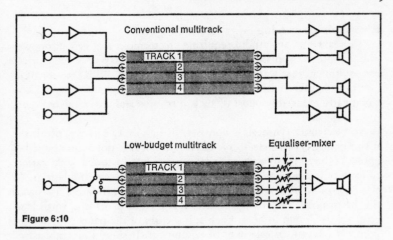

Figure 6:10

and fourth flute. The flute 1 track is laid on top track of the stereo recorder. This is next replayed (from the top track playback head segment) and dubbed on to the bottom track, accompanied by the mixed-in flute 2 (*fig. 6:11*). Now the process is reversed, the content of the bottom track being replayed on to the top track intermixed with flute 3. Finally, flute 4 is mixed with the top track content on to the bottom track. The process is essentially mono since simultaneous playback of the top and bottom tracks reveals the time delay caused by the spaced record and play heads. Very occasionally, this delay may be appropriate to a composition.

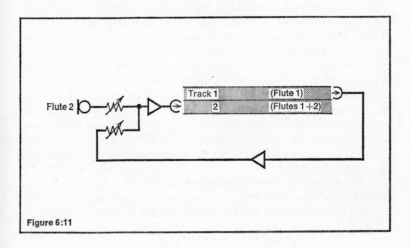

Figure 6:11

Electronic processing

A few years ago, any studio requiring electronic effects generators was obliged either to make them for themselves or pay very high prices for equipment that was clearly not mass-produced. With the advent of electronic audio synthesizers, however, small-scale mass production has greatly reduced the cost of such apparatus and also rendered them more compact.

An electronic synthesizer consists, in one or two racks, of all the major contents of an electronic music studio. It is not an instrumental entity in the hitherto accepted sense, providing instead a wide variety of tone generators and processors for use in selective permutations. At the time of writing, all commercially available synthesizers are based on the principle of 'voltage control'. The front panel of a small low-cost unit is shown in *pl. 3*. Each sub-section of the panel contains the controls relevant to one item of equipment. It should be emphasized that each section of a well-designed synthesizer can be used entirely independently of the rest. There follows an itemized description of the most common sections.

Vc oscillator

The functions of a voltage-controlled oscillator are to provide audio frequency tones suitable for direct music production plus (usually lower frequency) voltage wave-forms to control the parameters of other sections of the synthesizer. A vc oscillator can be arranged to frequency-modulate a second oscillator, for example, or even to control its own frequency. In a conventional vc oscillator, one input and one output are usually provided. The input accepts an externally generated voltage which may be used to modulate the output frequency. For example, a one-volt swing may be used to provide a one-octave frequency shift. By adjusting either the external voltage or an internal attenuator, the swing may be reduced to a slight *vibrato* or increased to encompass many octaves. The *vibrato* speed depends on the control voltage fluctuation frequency; a constant voltage produces a constant tone, a 1 Hz voltage fluctuation a 1 Hz *vibrato*, and so on. At least three basic wave-forms are usually available from the oscillator output. Illustrated as a graphic or oscilloscope display in *fig. 6:12*, these are sine, square and triangular. All three shapes may be available on separate outputs of identical frequency or, in simpler instruments, one or another is selected by a multiway switch.

A vc oscillator is essentially a signal source rather than a processor of existing audio. However, the vco plays an important role in controlling true processors so its value should not be underestimated.

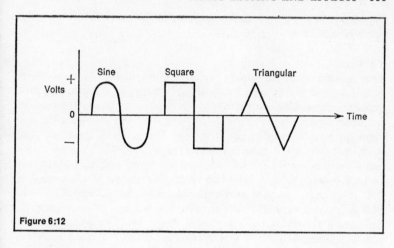

Figure 6:12

Vc amplifier

A voltage-controlled amplifier, in the context of a synthesizer, has two inputs and one output (*fig. 6:13*). Audio signals from the microphone are routed to the programme input and fed out to loudspeakers (unless being further processed or recorded). The amplifier gain (that is the degree of amplification) depends on the voltage level applied to the control input. A high voltage may give a high gain; low voltage a low gain; and fluctuating voltage a *tremolo* affect. At least one commercial record includes a piano treated with slow *tremolo* by means of a vca. There is nothing to prevent one programme signal being ampli-

Figure 6:13

tude-modulated by another though careful choice is necessary if the result is to be worth the effort.

Vc filter

There are two standard forms of vc filter, most common being the low-pass. Like a vca, this has a programme input, control input, and programme output. The control input voltage governs the low-pass cut-off frequency and, if this is modulated by a sinewave around 2 Hz, the effect on programme can be intriguing. Alternatively, a square wave (rich in harmonics) can be fed through a vcf with both the oscillator and filter frequencies modulated from the same keyboard-controlled voltage source. With appropriate tuning, each note of the keyboard can be arranged to give conventional semi-tone spacing. The low-pass filter ensures that a similar harmonic balance ('tone colour') is maintained throughout the keyboard range. Most vc filters have an additional manual control governing the shape of a resonant boost just below the cut-off frequency. This is a highly effective means of adding a formant to a non-acoustic (or indeed acoustic, if desired) programme source.

Envelope generator

A specialized form of vca, the envelope generator is designed to convert continuous tones (usually from a vco) into discrete notes. The generator is usually triggered from a keyboard—the same keyboard modulating the vco pitch—and in its simplest form incorporates three manual controls. These govern attack, sustain and decay times. With all three controls at their zero positions, the synthesizer behaves like an electronic organ—emitting a continuous note when a key is pressed and cutting that note instantly the key is released. An 'on-off' envelope of this type is illustrated in *fig. 6:14*.

The dynamic envelope of a plucked instrument may be synthesized by increasing the decay time control position and telling the performer not to hold any key down for more than a brief moment. The resulting envelope is shown in *fig. 6:15 (a)*. In *(b)* the attack (short) and decay (long) times are unchanged from *(a)* but the sustain time control has been raised. This facility is only really of value if an elaborate processing cycle has been prepared for each note. Lastly *(c)* shows the dynamic envelope produced when the attack and decay times are set to about mid position and the sustain time control to zero. This produces the dynamic characteristics associated with an accordion.

Noise generator

Whereas an oscillator produces a tone of one (variable) pitch, albeit with harmonics, a noise generator produces sound at all audio fre-

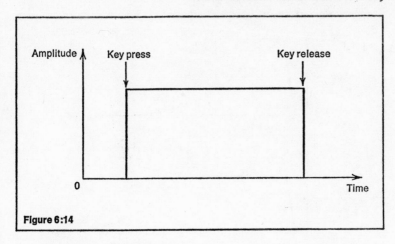

Figure 6:14

quencies simultaneously. The effect is of pure and simple hiss, nominally 'white' (equal frequency distribution) but may be modified to 'light' (treble heavy) or 'dark' (bass heavy) by means of internal or external filters. Hiss may not seem a particularly useful basic signal, since much of a recordist's time is spent in trying to eliminate it. In practice, however, its applications range from generating seashore, steam engine, percussion, wind, breath, explosive and richochet effects to synthesizing musical sounds of a kind beyond the capacity of existing acoustical instruments.

Sampling

Excluding the very simplest models, most synthesizers incorporate some form of sampling facility by which the level of noise or programme signals may be sensed a fixed number of times per second. If noise is sampled once per second, the output voltage is an endless chain of one-second-long plateaux varying entirely randomly in level. A regular wave-form such as a fixed-frequency sinewave sampled in the same manner produces a correspondingly regular chain of plateaux. This device has been little explored by commercial exponents of the synthesizer, its value being limited only by the user's imagination.

The foregoing is by no means an exhaustive list of the facilities available in electronic synthesizers. Many incorporate simple spring reverberation devices, while a smaller number incorporate solid-state memories ('sequencers') capable of storing musical sequences (even entire tunes) until such time as the mains supply is disconnected. Although the smaller sequencers are arguably not worth their price, being equivalent to very short tape loops, larger models offer both much

I

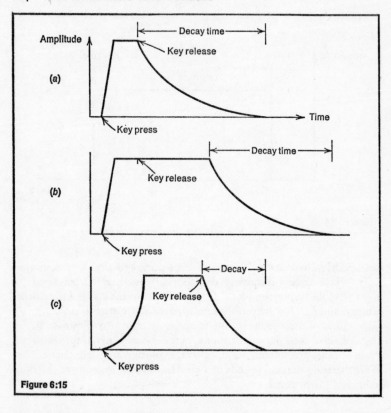

Figure 6:15

greater storage capacity and the ability to add and remove individual notes at will.

It should be obvious, however, that any studio requiring electronic processing facilities can most economically and conveniently obtain them in the shape of a small or large audio synthesizer, even if no plans exist for actually producing purely electronic music.

Few commercial recording studios have much more than a passing interest in the techniques and problems of mass duplication beyond the few tape or disc copies they produce for the convenience of their clients. One of the largest London studios installed a cassette recorder in their control desk to provide visiting producers with a convenient, if very token, copy of the day's work. Smaller organizations, however, often find themselves more closely involved in the mechanics of dubbing and distribution. In either situation, some basic knowledge of the processes involved is of benefit to the recordist, to the copier, and ultimately to the audience.

Copying a master
The high cost of producing master recordings often makes the owner unwilling to part with the ('first generation') original. A second generation copy is required, leaving the master tape for careful storage as an insurance against loss or accidental damage. This is a wise precaution since mechanical failure during fastwind, although a remote possibility, can stretch several metres of a tape into crumpled ribbon.

In multitrack studios, even the master may be a copy since much of the multitrack art is in mixing the final mono, stereo or quadraphonic reduction. Since every copy is marginally noisier than the preceding generation, fairly widespread use is made of noise-reduction devices. In their simplest form these resemble the automatic gain control described on page 7, Chapter One. A basic compressor amplifies low-level signals and attenuates those of high level, thus substantially narrowing the dynamic range. Unfortunately, very low level or completely silent passages cause such severe amplification that background hiss comes well to the foreground, only to fade again when high-level programme signals turn down the amplification. The rise and fall in hiss sounds like, and is termed, 'breathing' and was one reason for the development of the Dolby A system. Named after its inventor and manufacturer, Ray Dolby, this comprises essentially four separate compressors each handling a nominal quarter of the audio frequency spectrum. An additional disadvantage of conventional compressors is that they destroy the dynamic information present during the original performance. On playback, therefore, Dolby compressed material is reciprocally expanded back to its former state. A simpler single-band

system, treating only the treble portion of the spectrum, has since been developed for domestic applications in the shape of the Dolby *B*.

It is fairly common studio practice to Dolby *A* process each group output of a mixer before it is recorded. When copying such a master tape, therefore, it is usual to leave it in a processed state and use de-processors only to monitor the programme quality.

A major factor contributing to high background hiss is the failure of commercial studios to standardize on a single preferred tape. Most recorders are initially adjusted to suit a reliable brand and can give quite acceptable results with other tapes *if* their electromagnetic characteristics are similar. A casual approach to brand selection can lead to the unpleasant experience, however, of finding recordings very much noisier than normal. This can be particularly distressing on location, where there may be no facilities for rapid realignment of the recorder or for the immediate acquisition of appropriate tape.

Two major characteristics of magnetic tape are coercivity and oxide particle size. A low coercivity object or oxide is one that may be almost fully magnetized at the expenditure of relatively little power. Low coercivity tapes therefore allow a tape recorder manufacturer to save money by incorporating a low-power recording amplifier and bias oscillator.

High coercivity tapes require correspondingly more powerful recording circuitry but offer the advantage of higher tape remanence—high resistance to gradual erasure from (for example) accidentally magnetized playback heads.

When a high coercivity tape is used on a recorder designed (or adjusted) for low coercivity oxide, the tape may be severely under-modulated which usually leads directly to high background noise. Merely increasing the recording level does not usually help since the recorder is then likely to run into distortion—amplifier overmodulation, not to be confused with tape overmodulation.

A few manufacturers produce recorders with instant-access presets that allow rapid adjustment of bias power to meet the requirements of different tapes. In most studio machines, the audio level meter can be switched to read bias level as a percentage of the maximum available level or in any other nominal units appealing to the individual designer. Manufacturers and/or users then note the bias level appropriate to the tapes presently in circulation: 80 per cent for Brand *S*, 85 per cent for Brand *T*, and so on. This is something of a compromise, however, since it takes little account of frequency response and distortion variables.

The detailed procedure in setting up a recorder to suit a new brand of tape varies between one design and another. In some situations, a recorder may be unable to stretch to the characteristics required by a

particular brand. Although most studio recorders incorporate play-back equalization adjustments, this is by no means universal and complications may be introduced by worn record or playback heads. Most manufacturers supply on request, if not in their standard handbook, a line-up schedule appropriate to their particular design. The apparatus essential to this schedule normally comprises a variable-frequency low-distortion sinewave generator, a distortion meter (fundamental frequency filter), a millivoltmeter and an appropriate test tape. The better the recorder, the better the test equipment required to derive optimum performance. Test tapes are something of a sore point since they are recorded to equalization standards determined by European and American committees. In addition to differing between continents, these 'standards' are changed with unhealthy rapidity, to the distress of studios and individuals faced with purchasing expensive replacements.

In addition to electronic adjustments, most recorders require occasional inspection of record and replay head azimuth and this again requires a test tape. The tape in question may be recorded on any known satisfactory machine, however, and merely comprises a 1 kHz continuous tone at reasonably high modulation level. *Figure 7:1* shows an off-azimuth head, much exaggerated. If the exaggeration were taken to its extreme and the normally 90 degree head gap placed at 180 degrees (parallel with the tape edges) the linearly effective gap would be increased from the usual few microns to perhaps several millimetres, in other words to the entire length of the segment. With a full track 6·25 mm head, this would allow no more than 380 ÷ 6·25 Hz (60·8 Hz) to be recorded at 38 cm/s compared with the 380 ÷ 0·004 Hz (95 kHz)

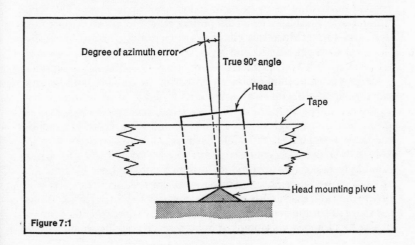

Degree of azimuth error

True 90° angle

Head

Tape

Head mounting pivot

Figure 7:1

theoretically obtainable from a properly aligned 4 μm gap. The minor azimuth errors occurring in practice do not cause such absurd bandwidth reduction but a worse problem can be incurred. If the record and replay heads are even slightly off azimuth with each other, phase errors can lead to blurring of a stereo image and to cancellation of signals at certain frequencies, the latter depending on the degree of error. If a master tape is found to be curiously lacking in treble, therefore, it may be considered worthwhile to adjust the azimuth of the replay head employed in the hope of compensating for an error in record azimuth on the original tape machine. If the tape commences with a 1 kHz reference tone this is the easiest portion on which to adjust replay head azimuth.

It should not normally be necessary to adjust the frequency balance of a master recording when preparing a copy since any treble boost, for example, tends to increase tape hiss and should have been introduced during the original mixing stage. Most important, a Dolby encoded tape must not be altered in frequency balance unless first decoded since the programme would be affected in an entirely unnatural manner.

High-speed tape duplication
As a commercial medium for recorded entertainment, open-reel magnetic tape is generally unpopular. Perhaps the prime reason for this is the ease with which such tape may be erased. An additional reason may be comparison by the customer of the cost of virgin and recorded tape, giving an immediate indication of the recording company's apparent profit margin.

In education, notably linguistics, open-reel audio tape is employed on a large scale. Likewise, it provides an inexpensive, reliable and convenient medium in many fields of industry and commerce. The background music industry generally prefers closed-loop cartridges to the open-reel format since this eliminates (practically if not aesthetically) the need to change or rewind tapes. Even cartridge tapes, however, are often recorded on open reels before being wound into their capsules.

Large-scale tape duplication is undertaken by running both 'master' player and 'slave' copies at substantially higher than normal speed. *Figure 7:2* shows a typical duplicating bank, several of which may be incorporated in a single copying room though not necessarily handling the same programme. A simple example of high-speed copying involves the reproduction of a 9·5 cm/s 'master' at 38 cm/s into correspondingly fast slaves to produce 9·5 cm/s copies. Less obviously, a 19 cm/s master may be reproduced at 38 cm/s into 19 cm/s slaves in order to produce 4·75 cm/s copies. There are many such permutations, the more so for the very high speeds reached by some copying systems.

The bias frequencies employed in high-speed copying should always

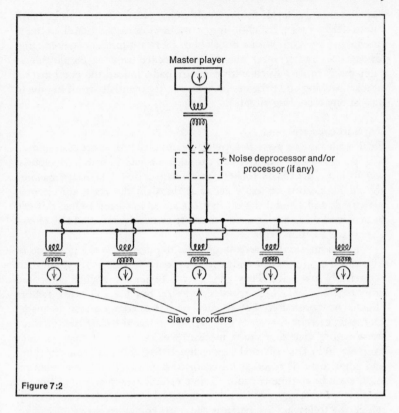

Master player

Noise deprocessor and/or processor (if any)

Slave recorders

Figure 7:2

be at least double the highest frequency in the audio spectrum, ideally greater, and at high copying speeds this can involve quite extraordinary figures. If the treble cut-off of 9·5 cm/s tape is around 10 kHz, duplicating this at 76 cm/s raises the cut-off by the same factor to 80 kHz. Treble this for a realistic bias frequency and one incurs 240 kHz which, at practical power levels, can generate sufficiently high temperatures to burn the record head coil. The designers of tape duplicators must contend with this and with achieving minimal scrape. This form of flutter can be irritating with conventional recorders but is more so when the high-frequency tape-speed fluctuations are reduced to wow or near-wow frequencies by the high-speed process. Scrape flutter generally does not come from the drive system. Rather, it is caused by very rapid catch-slip-catch action of the tape against one or more tape guides, against the head faces, pressure pads or pins. This action closely resembles that of a violin bow except that the 'bow' (tape) receives virtually all the oscillatory motion instead of sharing it with the string

(tape head or guide). If found troublesome, scrape flutter can be mini-
mized fairly easily by choosing a more compatible brand of tape;
possibly of the kind with a polished or lubricant-impregnated coating.
Under no circumstances should matt-backed tape be employed on
high-speed copiers fitted with pressure pads, indeed the combination
of matt backing and pressure pads or pins is potentially troublesome in
almost any recording situation.

Tape to cassette

Small-scale tape-to-cassette copying can involve little more than finding
a working cassette recorder and producing a lead to match its input—
usually a multipin DIN socket or a miniature jack. The latter machine
should be cleaned of oxide accumulations on the erase and record/
play heads and around the capstan. As stated in Chapter One, this can
be achieved using a proprietary cleaning accessory or—if all else fails—
a moistened handkerchief.

An obvious step towards large-scale duplication is the purchase of
five or ten 4·75 cm/s domestic cassette recorders, bearing in mind their
remarkably low price. They appear even better value when compared
with the cost of a high-speed duplicator but the following factors
should be considered before any purchase commitment is made.
Domestic cassette machines can only be expected to last two or three
years before incurring faults more expensive to repair than the (ad-
mittedly low) cost of total replacement. Secondly, routine checking
and adjustment of speed stability, distortion, noise and frequency re-
sponse can be so time-consuming that a studio may tend not to bother.

High-speed cassette copiers are produced in a variety of formats of
which the following are perhaps the most common: cassette to slave,
cassette to four slaves, and tape to four (or multiples of four) slaves.
This is further complicated by mono and stereo considerations though
cassettes have the advantage over tape of being completely mono/
stereo compatible. No commercially available cassette recorder is
capable of recording, or indeed erasing, four independent mono tracks
so the problem of interprogramme crosstalk should not arise.

At the moment of writing, one of the cheapest high-speed cassette-
to-cassette copiers is more than 15 times dearer than a pair of domestic
cassette recorders but this is balanced by much sturdier construction
and a sixteen-fold higher duplication speed. Several such copiers in-
corporate compressors but, while an aid to the intelligibility of re-
corded speech, these cause contractions in dynamic range which may
be objectionable with certain types of music.

The quality of cassettes (more precisely, of cassettes to the Philips
C60, *C90* and *C120* formats) is restricted by the low tape speed and
narrow track width and, at the present state of the art, the medium is

inferior to its immediate competitor: the gramophone record. For this reason, the Dolby B single-band noise reduction system has been fairly widely adopted in the distribution of musical entertainment on cassette. A typical master recording may therefore be produced to Dolby A and copied to slaves through an A-decoder and B-encoder. The precise customer requirements in this respect must clearly be checked before duplication commences. Further, B-encoded copies must be acknowledged as such when the cassette labels and container 'sleeve' are prepared or the resulting confusion will undermine the image of the issuing company. Lastly, unless otherwise instructed, it is usual to remove the erase-pins from commercial cassette records to prevent accidental obliteration.

Tape to disc

Despite ten years' competition from the cassettes, and longer from open-reel tape, the disc remains by far the most popular medium for audio record distribution. There are many reasons, notably the virtually instantaneous time required to stamp a gramophone record compared with that involved in even high-speed cassette copying. Secondly, portions of a disc may be selected and reproduced merely by shifting the position of a pickup arm without need for time-consuming 'fast' spooling. Thirdly, the relatively large area of a disc sleeve permits both attractive and informative overprinting which renders the final product more easily saleable yet without incurring storage problems. Whether a disc wears out faster than a cassette record depends largely on the care exercised in maintaining the player; certainly a disc requires greater protection from dust and fingermarks

The success or failure of a disc recording is largely decided during the original recording or, where relevant, subsequent reduction session. Few discs will sell unless the programme content is capable of attracting purchases. Less obviously, consideration must be given to the practical capabilities of the average disc reproducing pickup. Many inexperienced sound balancers prove so fond of high-level bass that they produce tapes that will be virtually unplayable by the time they reach the disc format. Others pay insufficient attention to signal levels, allowing occasional peaks to shoot into distortion, while yet others are blissfully unaware of the difficulties created by high levels of stereo difference information. The best equipped studio mixing desks incorporate sum and difference meters indicating the relative degrees of horizontal and vertical stylus movement incurred by the stereo disc cutter. A virgin disc comprises a circular metal plate (usually aluminium) with a surface coating of plastic. This coating rotates beneath a heated cutting stylus which is driven in a manner comparable with that of a moving-coil loudspeaker core. A heavy turntable drives the disc and is

linked to a tracking device governing the speed of radial stylus travel. The turntable is commonly driven at 33 or 45 rpm, namely the rate at which the disc will be reproduced. Some disc-cutting lathes permit half-speed transfer, however, reducing the effective inertia of the stylus system if the master tape is similarly halved in speed. In such situations, a 38 cm/s master would be reproduced at 19 cm/s but the replay tape equalization would need to remain at the 38 cm/s standard. If this is overlooked, the resultant disc will sound treble heavy as the hf programme component then receives an unnecessary boost.

It will be seen from the foregoing that excessive vertical motion of the cutter stylus can cause the latter to penetrate the full depth of the plastic coating and strike the aluminium beneath. This usually causes such severe distortion that the 'disc blank' is removed and replaced with another.

At the beginning of many discs, a pre-echo of the opening programme transient can be heard one revolution away from the true start. This is not master tape print-through (the tape at this point being leader or spacer) but adjacent-groove crosstalk. Modern disc-cutting systems minimize such crosstalk by means of the 'varigroove' technique in which the space between grooves is automatically increased before an unusually high-level signal reaches the master tape playback head. This requires the fitting of a 'pre-read' head well in advance of the playback head, indeed usually before the erase head. Once the high-level passage has passed, the groove spacing is automatically returned to its former size.

Discs containing a series of independent programme items are often divided into separate bands. The intervening very wide gaps are termed 'scrolls' and are the disc equivalent of tape spacers.

For many purposes such as private copying and performer-demonstration discs, only one or two records may be required. In these cases, the disc blank itself forms the playable end-product once the cutting has been completed. Records of this kind are not expensive to produce but should be treated even more carefully than a pressed disc since the surface material is comparatively soft. There is no technical advantage in producing one-off discs, despite their reasonably low price. The only appeal of such recordings is to customers lacking any form of tape reproducer, plus the psychological reward of being 'on disc'.

Disc pressing

In commercial record production, the newly cut blank becomes the disc master and in theory is immediately used to mould a 'mother', rather as a Plasticine imprint might be taken of the record surface. In fact the master is first plated with a thin protective layer of metal. The mother is in turn plated and used to press the end product copies when

only 100 or so are required. If large-scale production is planned (disc sales frequently run to hundreds of thousands), several copy-masters may be stamped from the mother for simultaneous or series duplication. Until the introduction of Value Added Tax in Britain, there was some financial advantage in producing below 100 discs. This is mentioned merely to point out that it no longer applies.

Disc to tape

The occasions when discs are transferred to tape prior to being mass copied are rare since, when preparing disc re-issues for example, it is usual to work from the original master tape. This is impossible if the discs were cut before the introduction of studio tape recorders since in those days the performers played straight into a cutting lathe. The discs in question are usually of premicrogroove vintage, namely 78s. Such recordings can only be re-issued by copying from an extant pressing—hopefully an unplayed (or at least unscratched) copy. As is well known, 78 rpm gramophone records were almost without exception much noisier than later microgroove discs, largely due to the brittle plastic from which 78s were made. Many electronic devices have been schemed with the aim of improving the signal-to-noise ratio of existing recordings, the classic being the 'expander'. This increases the level of loud signals and correspondingly reduces that of soft sequences. A fast-acting expander can sound odd but the subjective noise level is unquestionably lowered. Similar devices are employed by radio news reporters on noisy telephone lines. These so effectively cut background noise between phrases that the programme line appears temporarily broken. Such extreme degrees of expansion are a mistake.

In radio broadcasting, the need to copy from disc to tape arises fairly frequently since long or short sequences can then be spliced into a close-knit programme. There are two methods of integrating disc extracts with, for example, a record reviewer's linking commentary. One is by recording a spoken introduction, stopping the tape machine and roughly cueing the disc extract, stopping the tape again in order to reload the gram turntable, and so on. Alternatively the programme can be mixed straight on to tape as though it were being produced live. The former method is perfectly practical, allowing very close cutting from disc to speech (if so desired) but generally requires a tedious splicing session to remove starting and stopping noise, gaps and unwanted sections of programme.

True disc 'jockeying' is an easily acquired skill demanding no special accessories beyond two gram turntables and elementary mixing facilities. *Figure 7:3* illustrates the basic equipment required for the efficient production of disc-plus-commentary programmes. This comprises a microphone and two gram units connected to a 3/1 mixer, all shown

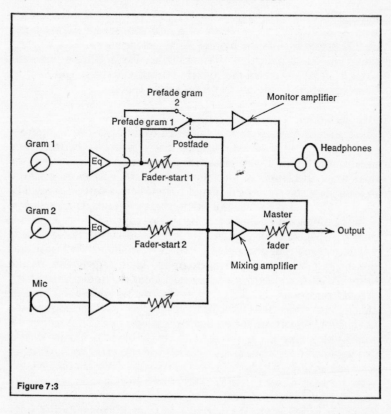

Figure 7:3

in mono for simplicity. Headphones are connected through a switch to monitor either the gram output 1, gram 2, or the final output from the mixer. No gram turntables accelerate to standard speed instantly, the majority taking about 1 second. Each gram fader is therefore coupled to the appropriate turntable start circuit, ideally operating a solenoid to engage a drive wheel between the motor and rotating platter. Provided the fader is operated intelligently, starting 'wow' is thereby rendered inaudible. Equally important, the 'fader-start' system allows the use of a single hand where (for stereo) three hands might be required simultaneously.

Practical application of the *fig. 7:3* equipment is as follows. The discs to be played are arranged before any recording or broadcasting commences, side or band titles and playing times being noted. A linking commentary is then prepared unless the disc jockey is sufficiently immersed in the programme subject to risk working *ad lib*. With these points arranged, the discs are positioned such that they come to hand

in the desired order. The first disc is placed on turntable 1 and moni-
tored through headphones switched to pre-fade listen (pfl). Lowering
the pickup near the desired starting point (in for example, the preceding
scroll), the operator drives the turntable using the normal manual-start
control—*not* the fader start. Once the opening bars are heard, the motor
is disengaged and the turntable swung gently backwards by hand. This
is the disc equivalent of tape 'rocking' and entails some concentration
on the opening transient. Once this point has been identified, the
platter is reversed through 180 or 360 degrees for the impending run-up
to speed. With the pickup still seated in the appropriate groove and
the headphones switched over to post-fade monitoring, the operator
is now ready to open the vocal fader and deliver an introductory
commentary. Immediately the impending disc has been announced,
the turntable 1 fader-start is opened, the vocal fader closed, and the
operator switches to monitor turntable 2. The relevant band of the
second disc is cued in a manner identical to that followed for the first
record and the monitor channel reverted to post fade. By now, the
disc presently playing may be approaching its end. At the appropriate
moment it is faded down and the vocal channel faded up. When the
linking commentary ends, fader-start switch 2 is raised and the second
disc emerges. This process can be repeated for an indefinite period
and is a technique popular among radio broadcasters for filling the
moonlight hours.

Since there is no such animal as a clean gramophone record, all
forms of transcription from disc require a Dust Bug (trade mark,
Cecil Watts & Co.) or similar device to brush the grooves as they are
played. The mere act of pulling a disc from its sleeve usually charges
the record sufficiently to attract any dust floating locally in the air. A
Dust Bug may be regarded as a miniature broom assembly attached to
a swivelling arm resembling the pickup arm. Merely brushing a disc
prior to playback is sometimes adequate but does not cope with such
irregularities as powdered tobacco ash falling on a record during
transcription.

The need for severe bass-emphasis in microgroove disc reproduction
tends to accentuate the sound of mechanical vibration from the turn-
table drive. Known as rumble, this is additionally caused by structural
inconsistencies in the disc itself and hence the considerable variation
between records from different companies. Fortunately, much of this
rumble is down at the almost subsonic end of the spectrum and only
becomes obviously loud if a tape of disc material is fast wound while
still in contact with the replay head face. Little can be done to reduce
inherent surface rumble, short of careful filtering in the extreme bass,
but noise contributed by the turntable can indeed be minimized. In
many turntables employing idler wheel drive (*fig. 7:4*), a high propor-

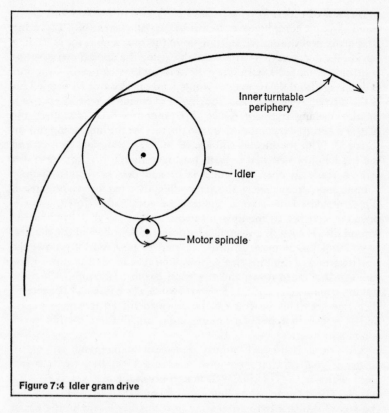

Figure 7:4 Idler gram drive

tion of noise is generated by defects in the idler periphery. A typical defect is the localised compression and deformation caused when a turntable is switched to play while electrically unpowered. The idler is forced hard against the motor spindle by a spring system, incurring damage which with many idler materials is practically permanent. Inexperienced operators should be firmly instructed in this detail since this kind of control setting may appear to be innocuous. Belt-driven turntables are less prone to rumble and less likely to be damaged by mishandling in the manner described. Nevertheless, this form of drive is not popular in studios as belts are generally considered more likely to fail outright than an idler system. While the latter can deteriorate, it is rare indeed for an idler to 'snap'. Even belts can be deformed by prolonged storage under tension. A turntable belt left unused for a long period may be stretched from its nominal circular relaxed shape into an ellipse. This can lead to very low frequency 'wow'.

Until the introduction of servo-controlled dc motors, most turntables

were driven by simple induction motors powered direct from the mains. These motors tend to vary in speed if fluctuations occur in the mains supply voltage which in turn tends to fall when a nation switches on its electric cookers in the early evening. Tape recorder manufacturers obtained independence of voltage fluctuations by using a synchronous motor locked to the mains alternation frequency (in Europe, 50 Hz). Gram designers, however, preferred the induction motor since it allowed the easy provision of a small-scale continuously variable speed facility by which means slightly off-tune performances could be reverted to a more acceptable pitch. Turntables of this type usually incorporate, or are at least supplied with, a stroboscope allowing easy reference to the mains supply frequency through the medium of ac-powered electric lighting. At least one commercial turntable carries appropriate metal engravings on the platter periphery, corresponding to 33, 45 and 78 rpm. A gram operator with 'perfect pitch' is a decided advantage in an organization using variable-speed turntables.

Several record publishing companies have marketed what they describe as quadraphonic discs but the only specimens really justified in these claims are those employing supersonic multiplexing. Just as a mono channel may be multiplexed into a stereo channel by very high-speed left-right switching, so the two channels of a stereo disc may be multiplexed into four.

Multiplexed four-channel discs should be copied on four discrete tape channels unless being deliberately reduced to stereo or mono. The presence and condition of a multiplex tone can be checked most easily by reflected-light microscopic examination. A small general-purpose microscope can be purchased quite cheaply and is a useful asset in examining pickup stylus and tape head wear.

Storage

Almost every organization involved in recording, duplicating or broadcasting requires a reliable means of storing tapes and discs. The enemies of both media are dust, heat and mechanical stress. Dust is a minor concern with tapes, provided the latter are returned to plastic or cardboard containers immediately after use. If allowed to settle on the upper surface of a tape—the effective edges—dust can fall on to the oxide coating and cause signal dropout. The effect of dust on discs has already been discussed in this chapter.

Heat presents difficulties only when substantially above 20°C room temperature. A tape left in fierce sunlight, say on the rear shelf of a car, may appear none the worse for the ordeal apart from possible warping of a plastic spool. Under similar conditions, a disc may warp more severely especially if compressed over an irregular car-seat contour by a book or other overlaid weight.

Mechanical stress can affect a tape in two significant respects. If a reel is loosely spooled, frequent packslips will be observed—some only the width of two or three tape thicknesses. If a metal or plastic spool is unevenly compressed during storage, many sections of the tape become vulnerable to damage. Half- or full-track 6·25 mm 38 cm/s working is not unduly affected by this edge-curling but recordings made on four tracks across 6·25 mm can indeed be so harmed. Less common, but much more serious, is the damage caused by tapes rubbing against a badly warped spool on each spool resolution. Fortunately, tape-manufacturing processes have improved considerably over the past decade and modern Polyester backing materials are much more stretch-resistant than earlier polyvinyl chloride (pvc).

Strong magnetism from loudspeaker magnets, electric train motors, head degaussers and even the recorder can affect a taped programme by causing print-through though in fact a properly modulated tape is as permanent a medium as any other, showing no significant tendency to fade with time. Perhaps the earliest surviving magnetic records are the geological specimens, many thousands of years old, that demonstrate occasional reversals in the Earth's magnetic polarity.

Little research has been published concerning the viability of magnetic tape as a very long-term information store. It is fairly widely known that very much more compact storage media are being developed using microelectronic, optoelectronic, optochemical and electrochemical technologies, with the ultimate aim of achieving storage densities comparable with an existing electrochemical system: the human brain. There is no doubt that tape, disc and photographic media will survive with their contents well into the next two or three centuries, thus ensuring the safe transfer of worthwhile material to less bulky and less vulnerable stores.

For the present, both tapes and discs are best stored upright on library shelves. Each recording should be protected by its own dust-resistant container. A tape store is useless without a simple and efficient reference system, nothing being simpler than labelling a first tape 1, and second 2, and so on up to infinity. Alphabetical and numero-alphabetical coding can be a cause of confusion if a library becomes larger than expected. Confusion between tapes and other media (discs, cartridges, cassettes) can be avoided by t, d, r or s prefixes, for example, or by allocating a block of say zero to 999 for tapes, 1,000 to 1,999 for discs, and so on.

Audio line distribution

Increasingly wide use is being made of audio line distribution in educational establishments, hotels, residential flats, factories and offices. Even in aircraft, piped entertainment is sometimes available through a

panel in front of each traveller. Wired broadcasting on this relatively small scale has in fact been commonplace for several decades though only recently has it been put forward as an alternative to radio. There is nothing in theory to prevent local broadcasting stations from using wired programme distribution and this has already been employed in Britain for small-scale transmission of television productions—not to be confused with 'community aerials'. In practice, the high cost of wiring individual homes prevents any widespread application of such systems though by the end of this century almost every house in Britain will probably have been wired to some form of information supply.

For the present, a typical application may involve connecting anything from one to 100 classrooms to a central studio or 100 hotel rooms to a central bank of entertainment channels. In the latter case, two or three radio networks may be supported by one or two background music sources from tape players in the hotel basement.

Figure 7:5 shows a single-channel wired broadcasting system feeding three separate locations. Note the use of balanced line distribution, a low-impedance transformer output feeding relatively high-impedance transformer inputs. Any deviation to unbalanced line working may prove satisfactory for very local distribution but will almost inevitably incur interference problems in large installations. It is essential to provide each listening station with an independent volume control and of course an on/off facility or a hotel may suddenly find it has no guests.

The foregoing is the only proper method of local audio relay guaranteed to work effectively. There are several improper methods, notably attempting to transmit across the neutral and earth lines of a

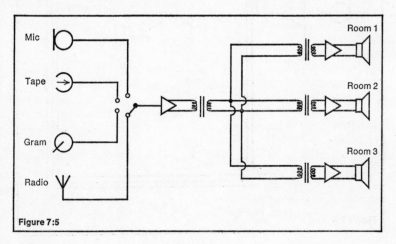

Figure 7:5

K

mains power supply. The short-term convenience offered by this system is entirely outweighed by the cost of replacing a complete chain of equipment if an electrical fault or lightning upsets the electrical status quo. This system is in fact downright dangerous.

Induction-loop transmission (*fig. 7:6*) is a technically elegant method of not-quite-wireless audio relay. While its practical applications would appear limited, it nevertheless offers scope for interesting experiments. Essentially, the audio output from a power amplifier is fed to a coil of wire running round the entire desired reception area—a room, an entire premises or even a sportsfield. If a smaller wire coil is placed anywhere within the reception area, the transmitted programme is induced within it and may be amplified as though received by more conventional methods. Reception is also possible on floors immediately above and below the transmission coil level but interference

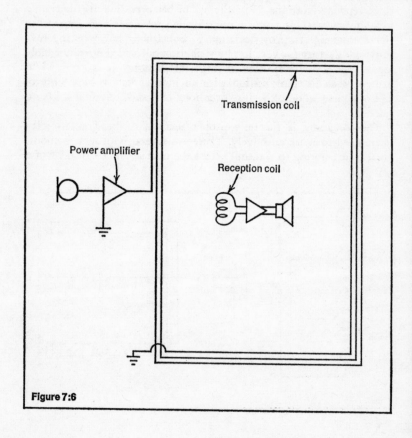

Figure 7:6

with other amplifiers, in for example deaf aids and radio receivers, renders the technique less than ideal. One detail: the resistance of the transmission coil should match the specified output load impedance of the amplifier or distortion will occur at unnecessarily low programme levels.

Sooner or later, everyone involved in sound recording or broadcasting is faced with an unexpected equipment failure. If operators are spared such occurrences in the first year or two of their involvement, hard experience should carry them over such troubles in later years. This chapter attempts to provide a substitute for such experience, illustrating the most common difficulties and trying to predict the less common.

Like everything else, electronic devices deteriorate with age. Valves, the few that are left, literally burn themselves out. Capacitors (some types more than others) are subject to chemical degeneration. Resistors and transistors may be destroyed by signal surges, solder joints dry out and cease to conduct efficiently, while even plain conducting wire can become brittle and disintegrate. Fortunately, these processes occur over a very long period if equipment is well designed, well manufactured and respectfully treated.

The greatest causes of trouble are dust and self-generated heat. A glance in the back of a table radio or television receiver shows the thick layer of dust and grime that collects from the surrounding air of a normal household or studio environment. This airborne dust can be seen clearly when illuminated by a suitably local beam of sunlight. Cigarette ash is another offender, clothing fluff yet another. These materials can make their presence known even in equipment normally considered new, namely in its first two or three months of service.

Cheap linear-travel slide-faders are without doubt the most vulnerable components, being in many mixers under the direct dropping zone of cigarette ash and jacket-sleeve fluff. Coffee, tea, carbonic-acid based ('fizzy') drinks and plain rainwater have similarly harmful effects on these faders and result in intermittent changes in resistance. An elegant rise or fall in signal level thus becomes a series of wretched jumps accompanied by more or less severe crackling, depending on the degree of fader deterioration. Similar troubles beset rotary potentiometers, though the dust entry path into these components is thankfully smaller. Whether linear or rotary, whether controlling volume, tone, balance, metering level luminance or any other facility, the effect is easily identified and the faulty component fairly easily replaced. Space permitting, there is often some advantage in purchasing better quality replacements since some brands of potentiometer are substantially better than others in terms of dust exclusion.

But we should really begin at the front of the programme chain—with the performance itself. In a permanent studio, it should be possible to commence recording without worrying about noisy clocks, background traffic, grumbling water systems, and the host of comparable factors usually ignored by the uninitiated. On location, however, noises of this kind can threaten to ruin a recording before even the first note is played. No recordist should promise a good tape, therefore, until the chosen location has been inspected. The writer once agreed to record a demonstration tape for a talented jazz group in their hired 'practice rooms' near London's Victoria railway station. The rooms in question barely justified their plurality, comprising a small basement, a tiny cloakroom and a still tinier loo. These were employed as studio, control room and vocal booth respectively but space constraints proved so absurd that the entire exercise was a waste of time. Further, the writer's ears took several hours to recover from the extremely high sound levels which the performers considered desirable.

Public concerts are a common subject for location recordings and even in these situations the hall should be inspected at least a few days before the performance is scheduled. Electrical wiring standards vary widely from one hall to another and even a satisfactory earth cannot be taken for granted. Without such an earth, electrical clicks and buzzes and AM radio interference may be detected on the microphone lines.

Concert presentation itself varies according to the professionalism of the artists and organizers. Inexperience shows itself as a grand piano out of tune, its spine to the audience and its lid down. The remedy: insist that it be tuned, turn it and open the lid.

By tradition, the highlight of an evening concert comes immediately after the intermission. The same tradition dictates that beverages shall be served during this interval and that cups shall be washed immediately afterwards. In a small hall, the clatter of dish-washing can easily leak through to the main hall, not least in dedicated amateur circles where the dishwashers may leave the kitchen doors open to hear the music. This is no imaginative fabrication, it really happens, unless pre-empted by an offer to do the dishes oneself if the organizers will not co-operate. Under these circumstances, the recordist might eventually be forgiven for an unannounced disappearance at the end of the concert.

With aircraft one can do nothing. There are many parts of the world, more specifically of Britain, which suffer relatively little from the low-flying jets that cause so much noise in London and south-east England. In recent years, several commercial recording companies have chosen the solitude of, for example, Kent and Oxfordshire in preference to the superficial convenience of central London. For total insulation

against aircraft noise, however, it is generally necessary to go under-
ground. Many London studios occupy the very large basements of
unrelated commercial premises to escape all forms of traffic noise. It
is a sad irony that at least one BBC studio in the basement of Broad-
casting House is troubled by Underground trains on the nearby
Bakerloo line.

When a recordist is asked or allowed to choose a location, this should
be selected both for its acoustics and for its freedom from noise. Quite
obviously, aircraft will inevitably intrude occasionally but the affected
bars may be rerecorded and edited in substitution. It is better to insert
an entire musical phrase than shorter items as changes in tempo may
otherwise by audible.

If a concert is recorded in the presence of a large audience, re-
recording ought in theory to be contrived before the auditorium is
emptied since a sudden change in hall acoustics may otherwise be
caused through the removal of large quantities of damping material.
In practice, this may not be possible and a case arises for the precise
substitution of perhaps the single offending bar.

Clicks can be very depressing to anyone monitoring off tape while
recording though even in this condition the noise may not necessarily
have reached the tape, perhaps coming instead direct from the power
supply to the monitor amplifier. The occasional switch click can be
edited from a tape surprisingly easily since the transient is very short
lived and any decaying residue may fairly safely be ignored. Click
locations are easily found by tape rocking. The affected portion may
amount only to 1–2 mm and these may be extracted without noticeably
affecting the programme tempo. It is easy to calculate the timing error
caused by a 2 mm extraction as 1/140 second at 38 cm/s and a similarly
minute 1/70 second at 19 cm/s.

If the programme is in order, can the microphones be trusted?
Short of blowing a ribbon from its mounting or dropping a micro-
phone to the floor, electromagnetic transducers will function reliably
for many years. Capacitor and electret units should be protected from
moisture, as described in Chapter Four, or background hiss may rise to
an unnecessarily high level.

When a microphone suddenly goes dead, and it is no rare experience,
blame may usually be placed upon the mic/line connector (if any),
on the line/mixer or line/recorder connector, or even on the cable itself.
The connectors in question receive more physical handling than any
others in the audio chain and are therefore understandably the most
inclined to work loose. The greatest advantage of multimicrophone
working is that a dead line can be replaced merely by substituting
another channel if time and conditions permit. This is also one of the
beauties of stereo: whatever goes wrong, the second channel stands

a reasonable chance of being unaffected. If a microphone line is in perfectly reliable condition, it should be possible to vibrate the plug or plugs fairly strongly without causing any break in signal. This could be argued to encourage later failure, however, wherein lies the fault of all 'soak testing' processes.

A cable that breaks inside its plastic sheath can be difficult to locate since it is usually the least suspected cause of discontinuity. Once identified, the cable should be destroyed as it would be prone to another failure if found to have decayed and/or snapped. Beware, when buying cable, of material having very coarse ('transparent') braiding as its screening properties are substantially worse than those of blanket-cover braids.

From the microphone through the lead to the first active part of the chain (excluding capacitor microphone preamplifiers): the mixer. The sudden total failure of a small mixer may sometimes be cured by a considered thump, from the palm, on the side of the chassis. Failing this, it may be practical to disconnect the ingoing audio lines and connect one or more direct to the recorder. Partial failure—of one input or output channel—is easily overcome in a reasonably large mixer simply by switching to a spare channel if one is available or reconsidering channel priorities if one is not. Most mixers, large or small, provide at least one additional feed for monitoring and this may be found a working alternative to a suddenly dead output. Where a mixer incorporates more output groups than the programme requires, such as a quadraphonic desk used for stereo, there is clearly no problem beyond the immediate task of channel switching.

Audio level meters of the electromagnetic variety occasionally stick at one or other scale extremity, a condition attributable to poor design, poor assembly, mechanical shock, high humidity or extreme cold. Mechanical shock can occur through careless transportation of the equipment incorporating the meter or through drastically overloading the instrument. Whatever the cause, a sticking meter can usually be reactivated by gently tapping the transparent face. If this fails, the meter movement may be beyond hope of functioning or the fault may be outside the instrument. It remains to be proved that LED meters are more reliable than electromagnetic devices though this appears probable.

The importance of good earthing has already been stressed. Whether the mixer or the recorder be earthed is largely immaterial but under no circumstances should more than one point in the audio chain be connected to ground. Since tape machines are sometimes used on location without additional equipment (mixers rarely so) there is a good argument in favour of earthing the recorder. All other earthing is then to the recorder chassis via the cable screen. Grounding elsewhere in the

signal chain—usually through misplaced caution—can easily result in induced hum as the physical gap between earth and the programme line then forms a very large electromagnetic pickup coil.

Radio frequency detection, manifesting itself as one or more locally strong AM programmes simultaneously, can fairly easily be cured in an emergency by soldering a low-value capacitor (around 400 pF) in parallel with the microphone at the input to the mixer or (if no mixer) recorder.

Considering their complexity and heavy dependence on mechanical engineering, tape recorders are generally much more reliable than it is reasonable to expect. Machine A may perform much better than design B when both are new but, if A's improvements result from greater complexity, machine B may be the longer lasting. It is a curious fact that most tape machines 'run in', actually improving in terms of speed constancy and recordable bandwidth as the capstan system and head faces respectively settle into use.

Although some organizations—notably the large multitrack studios —monitor the before-tape mixer output, it is wiser to monitor off tape to ensure that the desired signal is actually being recorded. Rapid comparison of line and recorded signals can usually be made through a before/after switch on the recorder. Only by constant off-tape monitoring can the sudden failure of a bias oscillator, for example, be detected in sufficient time to permit evasive action. Similarly, the popularity of matt-back tape makes it even easier than usual to lace a tape inside out; without off-tape monitoring, precious performers' time may be wasted before the mistake is discovered.

Sudden failures are a comparative rarity in well-designed (synonymous here with simple and robust) tape machines though it is nevertheless common practice to carry a backup recorder on location sessions. For many enthusiastic amateurs, providing such a backup to a semi-professional recordist presents an early opportunity to practise with competent performers.

More distressing on a location session is the realization that a tape is going to end before the work presently being recorded. Unless the conductor is prepared to co-operate through a cue light link, a backup machine is almost essential. Many musical works can be captured complete, or in complete sections, on 18 cm diameter reels of long-play tape running at the assumed norm of 38 cm/s but the practice is not guaranteed to improve the recordist's sanity. In such a situation, a ready supply of empty spools allows previously recorded tapes to be removed without rewinding and so takes full advantage of gaps between musical works.

Cue lights, if used, must be simple or the conductor will ignore or at best misread them. *Figure 8:1* illustrates a trouble-free system which

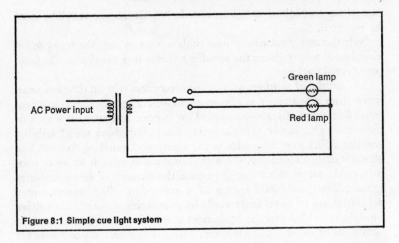

Figure 8:1 Simple cue light system

can be constructed from almost any battery eliminator. The latter connects ac mains to low voltage dc which is routed through a single-pole two-way switch to a pair of bulbs. Bulb selection may involve some trial and error before an appropriately rated specimen is found capable of giving the desired luminance. Red- and green-coloured bulbs are generally preferable to coloured plastic coverings but this will depend on local construction facilities. Provided reasonably low-voltage dc is employed, balanced microphone cable will be found a neat power carrier. If hum is found to be induced from this line into neighbouring microphone cables, high-value smoothing capacitors should be wired across the nominally dc output from the power unit.

Failure to clean indented tape guides can lead to severe 'wow' as the clogged deck components catch at the tape edges. Dirty tape transports are also the most likely to catch and break poor splices; domestic transports with a low reserve of mechanical power have even been known to stop completely.

Perhaps once each year, fate decides to jam the takeup motor. This results in tape spilling apparently at random straight on to the adjacent bench or—more alarming—to the floor. Happily, there is rarely any effect on the recording as the heads are isolated from the subsequent turmoil by the capstan and pinch wheel. Check immediately that the tape is falling cleanly from the recorder, indeed encourage it to fall to the floor, as any tendency to ride up or behind the capstan will indeed result in disaster. Under no circumstances should the tape be trodden on or otherwise disturbed. At the end of the performance, the loosely heaped material should be rewound slowly back to the original feed spool—pinching between thumb and forefinger if necessary to main-

tain close control of spooling speed. No significant tangling need
be expected.

Only the true professional uses rimless hubs so only the true profes-
sional need worry about the appalling tangle that usually results from
unexpected packslip.

At the time of writing, most studio recorders rely on direct capstan
drive from a hysteresis synchronous motor. There has been a recent
trend in favour of servo-controlled dc motors, however, in search of
lighter weight, lower manufacturing costs, improved speed stability
and the ability to synchronize to the speed of external equipment. For
all their design ingenuity, these are not quite as reliable as more con-
ventional motors since they introduce the element of servo-amplifier
failure. The pessimistic owner of a servo-controlled recorder may
achieve peace of mind fairly easily by purchasing a spare motor-drive
module, provided that the equipment in question conforms to modern
standards of rapid-access circuitry. There is similarly a good case for
holding a spare record amplifier module as an insurance against sudden
failure.

Tape breakage is more often the result of human mishandling during
fast spooling than of malfunctioning equipment. The single most
common cause is selecting record or playback before a tape has de-
celerated from fastwind, particularly from fast forward wind. Delay
logic prevents this form of careless mode selection in many studio
recorders though it is by no means a universal feature.

Tape itself, like any other manufactured product, can display faults
in more ways than one. A BBC operative asked to record an important
programme on two machines simultaneously, for safety, fell foul of an
ironic but predictable tape fault. Playing back the first copy, she found
a prolonged silent patch where no oxide coating had been applied to
the plastic base. To her distress, the second copy displayed the same
blank in the same position. They had, of course, come from the same
production batch and this giant dropout had occurred before the tape
was slit.

Excessive tape hiss may be caused by one or more of several factors.
The tape itself may not match the recorder's preset bias, record level,
and equalization settings in which case the tape should be changed or
the presets adjusted.

Accumulated oxide on the record or replay head surfaces may con-
tribute hiss though permanent magnetization should not be overlooked.
This may be eliminated using a low power head degausser—approaching
the target head as quickly as desired but withdrawing slowly and
steadily over several seconds before switching off the de- gausser.
Unless this is observed, the heads may be left more highly magnetized
than they were before. Both the record and playback heads should ideally

be treated each day—as should metal guides and the capstan.

Great use is made in budget-conscious studios of recorders basically designed for the domestic consumer and therefore equipped with such sales features as intertrack copying, superimposition (erase cut-out), and echo. Before any major exercise, check that these facilities are inoperative. Check also, before taking such a machine on location, that the hub-locking devices (if any) are fitted. At least two designs incorporating such locks spool badly if the reels are not held captive.

Avoid using any recorder with its desk plate off horizontal as this accentuates motor and capstan bearing wear. Further, it takes little engineering experience to realize that a poorly balanced flywheel will be more stable in a horizontal than a vertical rotation plane. Incredibly, some manufacturers have actually produced designs employing angled decks though their poor reputation perhaps speaks for itself.

One factor distinguishing industrial from domestic recorders is connector accessibility. If problems occur, it should not be necessary to lift a recorder from its base in order to change input or output connections. Console recorders are generally more accessible in all respects than transportable models.

Belt failure is almost unknown in mains-powered industrial recorders for the simple reason that very few machines use them. The problem is not uncommon in battery portable recorders, however, where the necessity to squeeze a litre into a half-litre has incurred many mechanical curiosities. Elaborate location recording projects, overseas filming for example, should always be supported by spare belts in addition to spare circuit modules, unless finances permit one or two spare recorders.

Occasionally, a studio possessing an elderly recorder will learn that spare parts are no longer available. The situation arises even more frequently in domestic circles. In both instances, the obvious solution of replacing the recorder with a new model may be postponed by purchasing nominally second-hand versions of the original solely as a source of spares. If the buyer recognizes the components in urgent need of replacement, these can be checked on the 'spares' model before the latter is purchased.

Replay faults

Equipment failure in monitor channels is rarely as irksome as in recording or live broadcast systems, especially since an entire monitor chain can be improvised by a pair of headphones if really necessary. More troublesome than a total breakdown is a monitor system with a restricted audio passband which may conceal from the sound balancer hum, hiss, distortion or other faults that may be intolerable to the listener. For this reason, great care should be exercised in selecting

monitor equipment—amplifiers, loudspeakers and headphones. The notion that high price implies high quality is by no means universally true and is indeed misleading where loudspeakers are concerned. Nearer the truth would be the claim that high price implies high sound level but very few loudspeaker manufacturers have succeeded in combining high sound level capability with good audio quality.

At one time, loudspeaker choice was largely a matter of individual preference; virtually all loudspeakers suffered from some form of colouration and one could only opt for the specimen least objectionable to one's own ears. In recent years, however, several loudspeaker designs based closely on BBC monitors have become available from commercial manufacturers and may be recommended with only one reservation. They are not at their best when driven at the ear-splitting levels enjoyed by many young pop balancers. Monitors specially for high-level working are available from many manufacturers though only one can be considered acceptably free from colouration. This design is normally tailored in frequency balance approximately to match the control room acoustics and, unlike the BBC monitors, is very expensive and too large for use on location.

When a loudspeaker develops a fault, the inevitable first reaction is to suspect preceding parts of the signal chain. The trouble can easily be isolated, however, by reproducing the noxious channel through another loudspeaker. If the fault is still audible, the two loudspeakers are probably not responsible. Fairly high-level piano transients provide a severe test for rattles in the cone structure or casework. Moderately loud transients from an electric bass guitar, on the other hand, may be more than many loudspeakers can tolerate and any consequent distortion is as likely to be inherent in the design as an isolated fault. Any studio expecting to handle such instruments should ensure that its chosen monitors can cope before committing itself to buying any particular loudspeakers.

Monitor amplifiers fail with tiresome regularity though there are, of course, exceptions. This month a blown fuse, next month perhaps a blown transistor, next year a new amplifier. One London studio became so tired of their amplifiers that they sold them and bought replacements from another company; sadly for the studio, both designs were manufactured under the same roof and only the external finish differed.

Power amplifiers do not 'blow' without reason. Either they are being driven too hard or they are overheating. The latter may be overcome in some situations by improving ventilation around the heat sinks even if this involves the expense of an electric fan. Only as a very last resort should the fuses be replaced with others of higher rating as the transistors themselves are the next weakest links in the chain.

It is not unknown even for headphones to fail, though the most common fault, a fractured lead to one of the transducers, is fairly easy to repair. Great ingenuity has been devoted to headphone (and indeed microphone) assembly, a puzzle-solving mind being required to open some designs. If all else proves unsuccessful and the headphones appear to be permanently bonded, check with the manufacturers before taking the drastic step of sawing the earpieces open. Regardless of the neatness with which sawn-open headphones are repaired, plastic dust may find its way into the transducer and cause audible grating.

Undoubtedly the most absurd disaster when recording on location is to run out of tape. It might be added that confusing a newly recorded tape with a virgin reel invites disaster but mistakes of this kind are easily eliminated by thoughtful planning.

Most location recordists prepare themselves for almost every eventuality by carrying the following accessories to all sessions:

One reasonably heavy-duty extension mains lead not shorter than 8 m.

One 13A square to local mains adaptor. (Some individuals and organizations tolerate 'universal plugs' at the mains end of the extension lead. Others carry a set of plugs to match several 'standards'. Still others refuse to work in locations not equipped with safe modern wiring.)

One set of cue lights with power unit and spare bulbs.

One small soldering iron, core-fluxed solder, cleaning rag, penknife, wire stripper/cutter, and assorted sizes of screwdriver.

One small metal file.

One assortment of audio connectors and short lengths of screened and unscreened wire.

High-grade string or nylon cord (for emergency microphone suspensions) and one reel of adhesive plastic tape for this and other improvisations.

One tape editing block, cutting blade and small scissors (both recently degaussed), editing tape and leader.

One head degausser and supply of head and transport cleaners.

One set of anti-vibration microphone stand mats, easily produced from plastic foam of at least 25 mm uncompressed thickness.

One torch.

Two writing implements, a notepad and a watch or stopwatch for sequence titling and timing.

One reel of electrical insulating tape.

Spare drive belts (if relevant) and a few less specialized elastic bands.

Spare circuit boards and batteries, if appropriate to the circumstances and to the equipment.

One might almost add to the list a spare human being though few

paid or unpaid recording units operate single-handed. There is no shortage of young souls prepared to help on location sessions in return for experience in the techniques of sound recording. Help of this kind is invaluable in preventing stray individuals from falling over cables or colliding with microphone stands.

Routing microphone cables safely and covertly is an art in itself, the approach varying widely from one hall to another. There is much to be said for running cables overhead rather than risking them underfoot, even though the microphones themselves may be mounted on floor stands. If the underfoot approach proves inevitable for practical or aesthetic reasons, endeavour to cover cables with some form of carpet at least where it crosses a major aisle. This, and coping with tight-fitting doors, is the grubby reality of location recording. The occasional temptation to chisel a route where no route exists must be avoided outside one's own studio.

Recording in the open air presents an entirely different set of problems, chief of which is the maintenance of adequate battery power. The days of clockwork tape transports have fortunately gone but the resultant strain on batteries and accumulators is heavy. The Ever Ready *HP2* and its equivalents of other makes are without doubt the most popular dry batteries among manufacturers of high-quality portable recorders. Finances often dictate the use of mains-rechargeable accumulators, however, and it is essential to remember that these decay if stored in a no-charge or low-charge state.

Although the quality of 4·75 cm/s cassette recorders is barely suitable for music and sound effects, the simplest battery models are so cheap and so compact that they merit serious consideration for outdoor interviewing and reportage. They are in fact so inexpensive that little strain is made on any economy by carrying a spare machine to guard against mechanical, electronic or battery failure. These machines are also capable of operating for very long periods on a single set of batteries. It is worth noting, incidentally, that batteries generally last longer when used intermittently than when employed for continuous sessions lasting several hours. A minor detail not widely appreciated is that almost any dry battery can be recharged in precisely the same way as a commercial accumulator though the number of successful charging cycles depends on totally random electrochemical factors so this should be regarded rather as an emergency measure.

Nothing has yet been written about service-bench repair techniques in this chapter. The subject is so vast as to be completely beyond the fundamentally non-technical equipment operator though interested readers will find many useful titles in the bibliography at the rear of this book.

There has been much talk in the broadcasting industry of adopting a three-line service system similar to that employed in the British armed

services. The principle is sound enough. Equipment operators (line 1) report system failures to on-site maintenance engineers (line 2) who trace the offending module and insert a replacement. They then forward the faulty item to the manufacturers whose service department (line 3) repair it and (hopefully) suggest to the designers methods of preventing any recurrence of the trouble. In practice this arrangement has been known to erect barriers against, instead of promoting, communication from consumer to designer.

The advent of transistors encouraged the widespread use of modular electronics which has tended to make servicing easier for the first- and second-service lines even if the third-line engineer is left with much trickier desoldering than arose in pre-module days. It is within the capabilities of almost all reasonably competent sound recordists to be their own 'line 2', particularly if they are prepared to invest in a sine/square signal generator, distortion meter, millivoltmeter and flutter-meter, all of which are in any case practically essential in lining up a tape recorder.

In many stereo recorders of modular circuit construction, a suspected faulty board can be unplugged and transposed to the other channel. If the fault is then observed on the formerly good channel, the board in question is almost certainly responsible. Where a fault applies to two channels, the cause probably exists in circuitry serving both. Examples here are failure of the erase/bias oscillator (causing un-mistakably severe distortion) or power-supply problems (causing background noise, distortion or total nonfunction).

The progressive shift to integrated circuit (ic) electronics is allowing miniaturization as dramatic as that accomplished when transistor technology ousted thermionic valves. It is also changing the nature of on-site servicing since the failure of an ic requires the replacement of the entire subsystem represented by that component. Given the system diagram and circuits of a transistor or ic-hybrid audio device, it is not unduly difficult to trace a suspect component and if necessary to insert a replacement.

When soldering transistors or ics, precautions against static leakage and component overheating should be taken. Extremely high-voltage charges can be acquired by the human body in the everyday motions of hair combing, walking on certain types of carpet, or taking a water shower. Though never dangerous, the momentary current being so low, these charges can produce a noticeable electric shock if suddenly released via contact with an earthed tap for example. This phenomenon ceases to be of mere academic interest when, in the course of replacing certain types of transistor or integrated circuit, electrical leakage from a badly earthed soldering iron or from a charge in the repairer's body destroys the component before it has even been fitted.

In engineering terms, the prime difference between sound and vision (audio and video) is that the latter involves a much faster rate of information handling than the former. Faced with the option of deafness or blindness, most living beings would prefer to retain their visual sense, since almost every object important to daily living reflects or emits light waves whereas only a few emit sound. A few creatures, notably in the bat family, 'see' by means of reflected sound and most humans possess this ability in an undeveloped form.

Whereas a really good audio system can reproduce sound well enough to deceive an audience into thinking they are hearing a live performance, nobody could confuse even the best conventional television with reality. The small screen and enclosing box eliminate any such illusion. Projection colour television is a definite improvement but even then the eye is fully aware of an unnatural picture coarseness. In Britain, the move from 405 to 625 line produced some improvement in definition but many years of development will still be needed before television systems approach the standard required to match the human eye.

John Logie Baird is credited with having produced the first practical television system and for this he employed an earlier invention, the Nipkow (after Paul Nipkow) disc. The mechanism of his system is irrelevant to this chapter but some value may be derived from studying its theoretical limitations.

Baird chose to work within the bounds of 1930s audio technology, restricting himself to the 10 kHz frequency bandwidth that he knew could be transmitted (via AM radio) or stored (on 78 rpm gramophone record). Whereas sound can easily be captured through a motionless point-source transducer (the microphone), visual images cover a finite area. In cine photography, this area is simply reduced in size and later magnified by projection. But in television the picture area is scanned in a series of parallel lines to produce a single chain of luminance (brightness) information. (Colour system complicates matters by requiring a separate 'chrominance' information channel.)

From established cinema practice, Baird knew that moving picture systems should ideally be transmitted at not less than 15 frames per second. Around and above this rate, human persistence of vision merges discrete flashes into a fairly stable picture.

Elementary arithmetic shows that 15 frames per second carried on 10 kHz (10,000 cycles per second) allows (10,000 ÷ 15) 666⅔ scan units per frame. When these are distributed over a nominally square picture area, the result is an image of about 25 lines with up to 25 'dots' per line. Compared with so-called high-definition television, this is very poor quality indeed though the subjective quality improves when the screen is viewed from a distance. The first regular BBC television broadcasts employed this system but in the longer term there was clearly no competition between the Nipkow mechanical scanner and the soon-perfected cathode ray tube electronic scanner.

Which brings us to the television of today. Instead of a mere 10,000 'dots' per second allocation, some 6,000,000 dots are handled. Picture stability is improved by communicating 25 frames per second, leaving a nominal 240,000-dot element per frame. When these are distributed over 625 lines, the number of resolvable dots per line is some 380. As stated earlier, nobody pretends this represents perfection but it is at least a far better cost/convenience compromise than the Baird system. In practice, a two-fold improvement in picture stability is obtained through splitting each frame into two separate 'fields', the field rate therefore being 50 per second. During the first field, alternate lines 1, 3, 5, 7 to 625 are scanned while the second field fills in 2, 4, 6, 8 to 624— a technique known as 'interlacing'.

Although the radio transmission of some 6 MHz presented no major design problems, the only method of high-definition video recording prior to 1950 was optical cine photography. Before long, however, the obvious solution of running magnetic tape at very high speed was developed by the BBC into VERA (video electronic recording apparatus). This equipment, and similar devices produced in the USA, left much to be desired and ways were sought of reducing the colossal tape speed. In Japan, a system later to be known as 'helical scan' was under development when an American company, Ampex, demonstrated a system which won immediate approval from television broadcasters throughout the world.

The Ampex Quadruplex video tape recorder overcame the need for rapid tape movement by moving the *heads* rapidly instead. Four heads were mounted at 90 degrees to each other round the edge of a metal wheel (*fig. 9:1*). The tape itself, 50 mm wide, was cupped against the wheel periphery by a vacuum device and moved at the respectably low speed of 38 cm/s. By driving the video head wheel or 'scanner' at a suitably rapid rate (250 Hz), an affective recording speed of 38·1 m/s was obtained—entirely sufficient for very high-quality video recording. The Ampex Quadruplex system is used by virtually all television broadcasting organizations at the time of writing, and has been so for many years, though its total domination of that market is now being

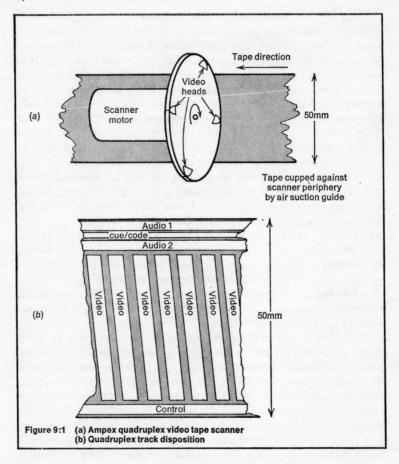

Figure 9:1 (a) Ampex quadruplex video tape scanner
(b) Quadruplex track disposition

increasingly threatened by recorders employing helical scan. This exists in many forms though *fig. 9:2* serves to illustrate the basic concept. Instead of scanning the tape straight across its width, this is accomplished along a relatively long length thereby greatly reducing tape stress and eliminating the need for vacuum guides. The tape is wound in a helix round a usually horizontal drum incorporating a single scanning head. In many designs, the scanner rotates at 50 Hz and therefore records or reproduces a complete video field on each rotation, allowing 'stop motion'. Helical scan further lends itself to much narrower tape widths than are practical in a transverse-scan system such as the Ampex. Early helical recorders employed 50 mm tape, 12·5 mm later establishing itself as something of a standard among closed-circuit

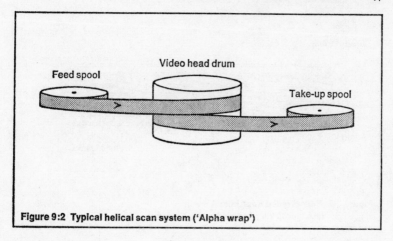

Figure 9:2 Typical helical scan system ('Alpha wrap')

operators though at least one manufacturer markets an elegant little recorder using 6·25 mm.

In essence, therefore, rotating-head video tape recorders are not unduly more complex than the familiar fixed-head audio machines. Only when one comes down to details can one realize the considerable research that was necessary to convert drawing-board theory into solid engineering.

The first problem in designing a vtr is to overcome the drag imposed on the tape by the scanner. This is particularly acute in helical recorders where the tape may be required to slide some 360 degrees round a fixed metal drum. Clearly a powerful capstan motor and slip-free pinch wheel are required.

Secondly, it is necessary to synchronize the playback scanning speed within tight limits so that the rotating head travels down the centre of each track. This is achieved by allocating a separate fixed-head 'control track' to record field pulses (*fig. 9:3*). Any deviation from the nominal 50 Hz, on playback, electronically induces a corresponding rise or fall in scanner speed. The circuitry employed here is similar to that used to control the speed of servo-capstan audio recorders.

Thirdly, some means of sound recording must obviously be provided and this usually takes the form of at least one fixed-head audio track running parallel to the sync track. For practical purposes, a second audio track is sometimes provided to carry spoken programme cues. In other formats, the second audio track is intended for bilingual commentaries or to permit stereo. If the latter application seems absurd in relation to small-screen television, it is at least wise in anticipating the general introduction of large-screen (possibly projection) television.

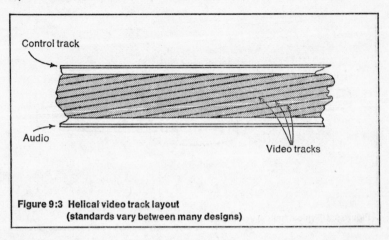

Figure 9:3 Helical video track layout
(standards vary between many designs)

Fourth, the very high head-speed demanded for video results almost inevitably in very rapid wear—of the head, of the tape, or of both. Many manufacturers have solved the head problem, at least, by employing very hard ferrite material for the gap structure. Video tape in turn has improved immensely over the past few years to the point where a single field may be reproduced for several minutes without undue degradation of the oxide coating. Today this is taken for granted but earlier tapes disintegrated after a mere few seconds of such treatment (equivalent, incidentally, to some 500 rapid head passes). Stronger tapes than this tended to cause excessive head wear so ferrite video heads should be considered an essential feature of any purchased vtr.

Fifth, most single-head videotape scanners incur a programme break between each track sweep. This takes place during the crossover from the end of one track to the start of another and amounts to the loss of several screen lines. An obvious solution is to employ two heads at 180 degree intervals on the scanner so that one can be switched into circuit before the other cuts out. This doubles the initial head cost, however, and causes curious visual effects where one head becomes (for whatever reason) substantially more worn than the other. In single-head vtrs, the dead lines are quite easily hidden above and below the nominal picture area. When the stop motion (or 'freeze') facility is employed, however, careful tape rocking becomes necessary to shift this interference at least nominally out of sight. If stop motion or slow motion are an important requirement, therefore, a multiple-head vtr is generally preferable despite the head-matching considerations.

Until quite recently, single-head helical-scan recorders were totally unsuitable for broadcast applications as the break in video information

between scans created difficulties in synchronizing with external equipment. Even this problem has now been overcome, the missing signals being replaced from a separate generator.

A sixth design feature, unhappily missing in many helical-scan vtrs, concerns the treatment of short-term dropout. In audio, dropout is heard only indirectly as an absence of sound. In untreated video, however, any sudden absence of signal causes bright white dots or streaks. The precise white area depends on the duration of the signal break but even shortlived dropouts can be objectionable; in many vtrs they offer the first indication of whether a screened programme is live or taped.

Ampex were one of the first companies to tackle dropout by other means than simply trying to improve the tape. They developed an elegant electronic circuit which differentiates between low signal (naturally white) and no signal (dropout) states. When dropout was identified, the luminance signal was automatically raised to 'grey', reverting to normal when signals reappearing at the playback amplifier input showed that the dropout had passed. Still less detectable devices largely replaced this technique in broadcast and less expensive closed-circuit vtrs alike. Instead of reverting to a predetermined grey, signal levels immediately preceding a dropout were averaged and this average luminance substituted where necessary. Recently has come the use of short-term delay devices to store the content of the line preceding that actually being reproduced. Where a line drops out in whole or in part, the adjacent line in that field is substituted. This system has the remarkable ability to improve poor original recordings in a way that has never been accomplished for audio.

A sixth complication in video tape recording is how to capture chrominance. A monochrome television system senses overall brightness (luminance) and reproduces a correspondingly light or dark pattern. Yellow is interpreted merely as being lighter than mid green, green lighter than deep red, and so on, converting respectively into white, mid grey and dark grey. Curiously, the deep black seen on a well-adjusted monochrome receiver is in reality no darker than the mid grey observed on most screens before the set is switched on. This grey is easily mistaken for true black when viewed in contrast with high-luminance picture areas, the human brain being more concerned with relative than absolute values.

The electronic coding of colour information is quite easily accomplished in theory. Taking the colour spectrum as it occurs in nature, one observes that red runs into orange and thence via yellow, green and blue to violet. If colour variations are arranged to produce analogous voltage changes, the latter may be communicated or recorded as chrominance information. In fixed-head high-speed recording, the chrominance and luminance bands might be allocated separate tracks

in the manner of left and right stereo signals. The technique actually used in rotary-head vtrs is rather more elegant. Luminance information is normally recorded by modulating the *frequency* of a carrier while chrominance simultaneously modulates the carrier *amplitude*. It is in fact possible to modify almost any helical-scan vtr to accommodate colour.

Videotape formats
Some forty years of technical development were needed before magnetic audio recording had evolved far enough for development to slow down and standards to be agreed. Since about 1950, it has been possible to take a 6·25 mm 38 cm/s tape into almost any studio in the world and be confident that some means of reproducing it will be to hand. Video tape recording has thus far had only 20 to 25 years of serious development and manufacturers have been understandably reluctant to standardize on one format when so many remained unexplored. The broadcast television industry alone demanded—and received—total compatibility between video recorders in one country and another.

Among helical-scan machines, the lack of compatibility even between recorders of superficially identical design soon led to improved production techniques. At the same time, prices fell more than tenfold between 1960 and 1970 as the benefits of mass-production began to take effect. Much more recently, several Japanese manufacturers agreed to support recommendation EIAJ/1 laid down by the Electrical Industries Association of Japan. This specifies a 12·5 mm tape width and dictates tape speed, scanner diameter, track widths, video track angle and so on within sufficiently tight tolerances that tapes recorded on equipment of one make can be reproduced without difficulty on that of another.

Compared with audio recorders or Quadruplex vtrs, most helical-scan designs are tricky to thread up when reloading tapes. The difficulty should not be exaggerated, however, for even the most tortuous vtr is more accommodating than the average cine projector. *Plate 4* shows the intricate tape path of a typical vtr. Failure to thread correctly round the tension servo can result in picture instability while a misplaced autostop spring can cause temporarily mystifying transport failure. *No vtr should ever be loaded while the scanner is running* as ferrite heads, being very hard, are so brittle that they can be chipped and so rendered inoperative.

Aware of the foregoing limitations, several manufacturers have developed cassette systems (alas, by no means all compatible) which eliminate the need for human handling of the magnetic medium. 'Lacing up' becomes a simple matter of 'dropping in' a plastic container to an appropriate receptacle. Incidental to the ergonomic ad-

vantage, but even more important, the cassette protects its contents from dust, sweat, and direct mechanical deterioration. Regrettably, the mechanism required to pull tape from the cassette and round the scanner adds substantially to the overall cost of the vtr and a video cassette recorder is generally inferior to a comparably priced open-reel machine. As time progresses, experience will show whether cassette vtrs are really mechanically reliable though in ten or twenty years we may not be using magnetic recording means at all.

It would be wrong to give the impression that video tape recorders are beset by faults, though careless purchase can easily result in such a state of affairs. A well-designed vtr, not necessarily expensive, will repay reasonably careful treatment with many years' useful life. Anyone who has had occasion to instal or adjust a television aerial may share the writer's one-time trepidation that videotape would involve similar pandering to picture ghosts and their like.

One major disappointment experienced with many vtrs concerns the picture breakup that occurs when a recording is stopped and later restored. When an audio recorder is held at 'pause', the resultant break in programme may be almost completely undetectable. Most vtrs require between 3 and 10 seconds to stabilize when a recording is interrupted, while the scanner servo fights to overcome headwheel momentum. Compromise is possible here. If the scanner is manufactured as a very lightweight assembly, momentum plays a much smaller role and near-perfect record-stop-record scene changes can be accomplished. Against this, any reduction in scanner momentum tends to cause field instability for the same reason that many lightweight gramophone turntables suffer from flutter.

Even the foregoing problem can be overcome, given an intelligently designed recorder. Instead of merely restarting the tape to record sequence B after the conclusion of sequence A, the tape is reverse wound and sequence A played back. When the desired changeover point is reached, the performers are cued and the vtr switched straight from play into record. In this way, the scanner settles into synchronization long before recording commences and picture instability is thus minimized.

Some designers provide one or both of the following additional facilities. 'Sound dubbing' allows an audio track to be erased and re-corded while playing back an existing video track. 'Video dubbing' allows a video recording to be erased and replaced without affecting the audio. The latter may seem an unlikely requirement though it is useful in allowing fairly clean cuts to a diagram or cine film in the course of a lecture tape.

Fastwind searching, a common feature on audio recorders, is at least partially available on some video machines. If the winding speed is

fairly slow (as is usually the situation where the effective takeup reel diameter is small), then the vtr may well be seen to reproduce a reasonably stable speeded-up picture. Even when the picture breaks up, it can be temporarily restored by adjusting the horizontal scan frequency ('horizontal hold') of the video monitor. This can hardly be considered a practical facility, however, and an alternative means of simplifying searching may be employed on most recorders incorporating a stop-motion facility. In all helical vtrs, the scanner ceases rotation when the transport is switched to stop. A separate switch usually allows the scanner to be driven with the tape stationary and this is a major timesaver as it gives an immediate display of local programme content when a tape is stopped from fastwind.

At the time of writing, two television line standards are in common broadcast use in Britain: 405 and 625 lines per frame. The former is due eventually to be replaced by the latter and virtually all video recorders presently available, new or secondhand, have sufficient band width to cope with either standard. Were a new standard of 500 or 600 lines to be announced, this would require no vtr modification—line standards being a function essentially of camera and monitor.

Before purchasing a video recorder, it is most important to ensure that it will accomplish all that is required of it. There is in circulation one design employing 'skip-field' scanning, an ingenious tape saver for budget-conscious operators but one which might be considered unsuitable for use with existing television equipment. The scanner in a skip-field helical vtr incorporates two heads spaced 180 degrees from each other. In the record mode, one head is left out of circuit while the other records alternate video fields (25 per second). On playback, both heads are switched into action with the result that each field is scanned twice, producing the desired 50 fields per second output. This ingenious system effectively halves the linear tape speed but also halves the vertical definition from 405 to 202·5 lines. Since it functions at 405 lines, however, the observed definition is more tolerable than it would be if true 202·5-line scanning were employed.

In selecting an audio recorder, it is wise to consider the ease with which the design lends itself to tape marking, rocking and editing. With videotape, however, this is almost entirely irrelevant. Any programme producer relying on videotape cutting and splicing will find such joints distressingly obvious, disregarding the comparatively high cost of the record medium. A 90 degree or 45 degree videotape edit can take several seconds to pass the scanner, during which time the new scene will displace the old as a slow vertical wipe. The precise duration of this wipe may be calculated by dividing the scanner circumference by the linear tape speed. Typical figures are 60 cm circumference divided by 22 cm/s tape speed: 2·73 seconds. Even this assumes that the picture

holds steady during the wipe, which is by no means certain. Hence the importance of the video insert facility described earlier. More elaborate programme production techniques are described in Chapter Eleven.

Weight is an important consideration to educational establishments where a vtr may be transported from one classroom to another. Even the smallest mains-powered helical recorders are generally heavy enough to present the risk of injury to anyone carrying such equipment more than a few metres. Some form of trolley is therefore essential, as is a clear instruction to any staff involved that careless lifting may damage both the individual and the recorder.

A fairly wide choice of monochrome battery vtrs exists for outdoor operation though even these are best transported by car and carried only when actual recording is to take place. The camera alone is usually indecently heavy though very much lighter, and hopefully cheaper, designs are expected to be available in the latter half of the 1970s.

Most battery vtrs are supplied with a shoulder strap, one exception being a Quadruplex portable produced by Ampex and arranged as a back pack. It amused the writer, so very expensive is this recorder and its ancillaries, that in many countries an operator would require substantial police protection against thieves. Battery helical recorders are now available at prices not much higher than those of mains models, no mean achievement considering the mechanical and electronic complexity of this equipment. Controls have been reduced to their barest minimum: record, pause, stop and rewind.

An increasing number of battery vtrs now incorporate play-back monitor facilities. Early designs omitted this feature on the assumption that tapes would in due course be played on a mains vtr.

As in mains recorders, so in battery equipment attention must be paid to tape modulation levels. Ideally, separate meters are provided for audio and video signal strengths with optional manual and automatic gain control on both channels. Agc presents a variety of problems, notably raising to audibility any field sync noise present in the system, but solves more than it creates for the solo operator. Some battery designs contain no agc override though in practice this is rarely found to be a significant limitation.

Power consumption in battery vtrs is high and rechargeable accumulators are much more economical than dry cells. The latter only merit serious consideration if working in locations where no alternative power source is available.

In comparing the specification of different video tape recorders, it is easy to overlook the most important factor of all. If the equipment develops a fault in the coming five years or so, will the manufacturers or their local agents be able to supply (and, if necessary, fit) replacement components? Virtually all electromechanical devices are supported by

some kind of guarantee but the mortality rate of import agencies representing Japanese manufacturers is exceptionally high. This is the more disconcerting in that helical-scan vtr technology has largely been pioneered in Japan. Distance alone is probably to blame for highly respected Far Eastern manufacturers granting distribution concessions to inefficient and even disreputable agent companies. Several leading manufacturers have overcome the problem by establishing a branch of the parent organization in the host country and there can be no doubt that this improves the supply of service, spares and technical information.

Modern 'high-definition' television cameras vary in size and complexity from broadcast colour units down to compact 'electronic eyes', the latter used for various kinds of industrial and commercial surveillance and for traffic control. Large or small, all these devices operate on similar principles. Before considering these, however, there is some advantage in examining a much simpler optoelectric transducer: a photographic lightmeter. *Figure 10:1* shows the components of a simple specimen. Light impinging on certain materials creates electric energy which may be fed to a voltmeter calibrated to measure relative light levels. The system is particularly elegant in requiring no additional power source.

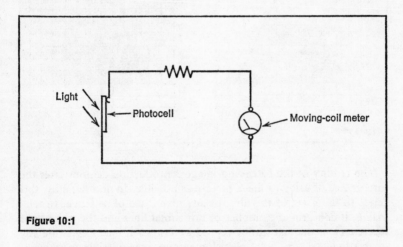

Figure 10:1

There is nothing theoretically difficult about transmitting pictorial images over a single communication line. Many people do this, perhaps unconsciously, when telephoning the shape and colour of a newly purchased coat, for example. The transmitted information tends to be very basic, however. The mere word 'coat' conjures a shape in the listener's memory (invariably wrong), while even a detailed colour description would leave the recipient in no position to sketch or paint a copy.

A substantial improvement in image transmission, albeit laborious on a human scale, is obtained by splitting the picture into a matrix of discrete elements and transmitting each element in turn. *Figure 10:2 (a)* shows a simple triangular shape overlaid by a 12 × 12 matrix, the equivalent of a 12-line television system. The original can now be 'scanned' precisely as one scans the text of a book. Elements 1A to 1L are all white, as are 2A to 2E. Elements 2F and 2G are both partially white and each is therefore transmitted as grey; 2H to 2L are white. In line 3, F and G are almost entirely black. Line 4 is white from A to D, grey at E, black at F and G, grey at H, and so the description proceeds until the end of line 12. Anyone listening to the breakdown could reproduce the image in the form of (*b*).

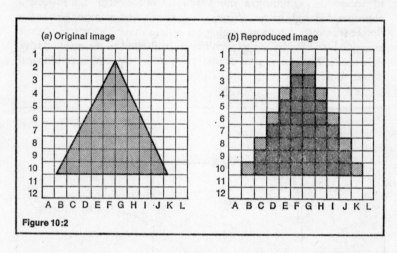

Figure 10:2

The crudity of the foregoing image reproduction demonstrates the importance of using as fine a picture as possible. In photography, this refers to the grain of the film for any given size of negative. In television, it concerns the number of horizontal lines and the number of discrete elements that can be reproduced on each line. Given the 405 or 625 lines of a modern television system, it is possible to transmit quite reasonable pictures. And, in handling 25 picture frames per second, the chain is capable of reproducing animate movement.

One of the finest television camera systems ever developed, the *image orthicon*, employs a principle remotely comparable with the photoelectric lightmeter. The image to be televized is focused on to the flat face of a glass tube. On the inner side of the glass is a thin coating of photosensitive material which produces an electrical charge pattern corresponding to the optical image. It is no simple matter to

convert this pattern into a video signal but we may spare ourselves
detailed description of the image orthicon as it is hardly ever employed
for non-broadcast productions.

Structurally simpler, cheaper and slower to age than the foregoing
is the vidicon camera. Since this type of unit is employed for virtually
all educational and commercial closed-circuit television, it merits careful
study. A vidicon camera tube can be compared with a closed glass
bottle from which the internal air has been extracted, so leaving a
vacuum. The bottle is set on its side and a convex lens mounted between
the picture subject and what was the base of the bottle. On the inside
base surface is a very thin metallic plate. This must be capable of con-
ducting electricity yet should not impede the passage of light images
to yet another layer: of photoresistive material. The sandwich formed
by these layers is illustrated in *fig. 10:3*. When the camera is switched
on, a steady beam of electrons travels through the vacuum from the
cathode to the photoresistive layer. A battery or mains-derived dc
power supply endeavours to maintain a steady current flow. Clearly,
any resistor placed in this circuit will cause a reduction in the electron
flow. If a large amount of light falls on the tiny photoresistive area at
which the beam is aimed, the layer will exhibit much higher resistance
than if little or no light were present. Consequently, relatively little
electricity will flow round the circuit. This lack of electron flow can
itself be used as a television signal, provided both the camera and the
receiver know which part of the picture the beam is aimed at.

From transmitting the 'light or dark' nature of a single point on the
camera tube face, it is a small step to transmitting the nature of an entire
image area.

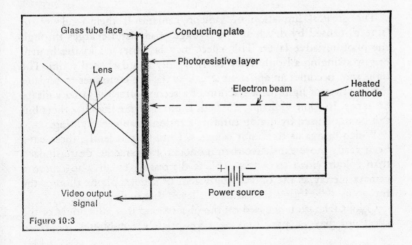

Figure 10:3

The electron beam may be deflected from its *fig. 10:3* straight line by an electromagnet placed at V in *fig. 10:4*. Depending on the direction of current flow, this will deflect the beam towards or away from the coil and thereby cause vertical scanning. If a slow sawtooth signal of alternating voltage is applied to the vertical coil and a many times faster sawtooth to the horizontal coil, the result is a scanned area resembling the exaggerated tube face diagram. No small part of television technology is dedicated to ensuring that horizontal and vertical synchronization remain uniform between camera and receiver since any deviation results in picture unsteadiness.

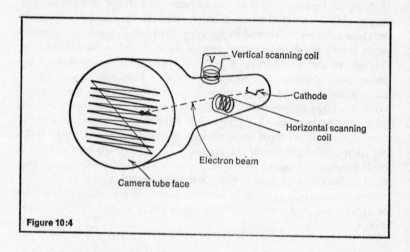

Figure 10:4

The greatest limitation of vidicon cameras is their tendency to 'smear', caused by delays in the passage of electron charges through the photoresistive layer. This effect may be observed in the human eye by swinging a bright lamp fairly rapidly in a darkened room. The light spot becomes an apparent streak as the eye continues to register the presence of light for a fraction of a second after the latter's disappearance. In some vidicons, the fault is more severe than in others but can be minimised by giving careful attention to subject lighting.

Which brings us to colour cameras. Until very recently, these have been vastly more expensive than monochrome cameras, dearer indeed than colour video recorders. This is distressing to all who regard a camera merely as the optical equivalent of a microphone though the foregoing description should have allayed that notion.

Colour television is based on the observation that all colours of the spectrum may be produced by appropriately combining the three

primary colours: red, green and blue. When these are mixed by optical projection, their respective spectral frequencies *add*. Quite different results are obtained by *subtractive* mixing, as occurs on a painter's palette, in printing and in some forms of photography. Here, the nominal primaries are red, yellow and blue.

The simplest form of colour television is accomplished by means of a three-colour (red, green, blue) transparent wheel rotating at a steady speed in front of the camera. If the same wheel is arranged in front of the reproducing screen and rotated at the same speed and colour phase, the result is a moving colour image. Rotating wheels went out with Baird, however, and nobody is keen to see them return. Instead, early colour cameras employed three separate tubes to handle each primary colour independently. A mirror structure splits the ingoing image between each tube (*fig. 10:5*), leaving only the task of recombining the three at the receiver.

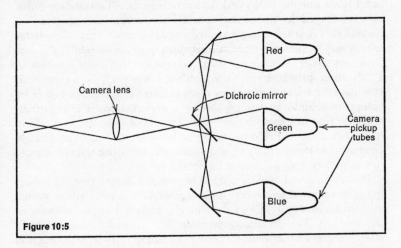

Red

Camera lens

Dichroic mirror

Green

Camera
pickup
tubes

Blue

Figure 10:5

A much simpler approach to colour image pickup (potentially simpler at least) involves painting alternate primary colours in a grating over the face of a single vidicon. This, ignoring the resultant electronic complications, is essentially what occurs in the Sony Trinitron system.

Plate 5 shows a typical fairly low-price monochrome vidicon camera produced by Sony for use with their vtrs and vcrs (video cassette recorders). The lower and upper units are detachable from each other and comprise the camera proper and video monitor respectively. Four monitor controls may be seen on the near (right) side of the upper unit. These govern brightness, contrast, horizontal hold and vertical hold but have no influence on the camera line output.

Two coaxial controls in front of the camera provide adjustable focus (nominally 1 m to infinity) and aperture (f2·8 closing to f16). The latter is intended to reduce excessively bright subject lighting, as in any photographic camera. This is an appropriate moment for a stern caution: under no circumstances should a television camera be aimed directly at the sun as this can cause permanent severe damage to the photoconductive tube layer. It is similarly advisable, though less essential, to avoid direct pickup of high intensity artificial lighting, whether car headlights, street lights, domestic lamp bulbs or studio floodlights. These warnings apply both to powered and unpowered cameras.

Many television cameras, especially battery models, are supplied with a lens hood. In the absence of such a hood, any camera left unattended should be covered across the lens by some kind of lightshield.

Plate 6 shows the control panel of the same Sony vidicon. For ordinary one-camera one-vtr working, a DIN socket to the left of the panel feeds out the video and field sync signals. The standard video connector used in closed-circuit television is the 'uhf plug' and a parallel socket is therefore provided to match this format. The latter output may be switched from normal video to a video-modulated radio-frequency carrier suitable for direct connection to the aerial socket of a television broadcast receiver. Below this switch is an internal/external sync selector. If two or more cameras are mixed (whether by fading or straight switching) during a presentation, it is important that they scan in step with each other. Instead of each camera working to its own internal field-sync oscillator, they are all locked to a single external sync signal. Only by this means can a smooth transition from one camera output to another be obtained.

Battery-powered mobile television cameras depart from the foregoing description in several major respects. A remote pause switch set into a pistol grip allows the shoulder-strapped vtr to be more or less ignored. The camera-to-vtr cable link is usually rendered lockable to eliminate the possibility of a plug falling from its socket in mid recording. Audio may similarly be taken more or less for granted as a forward-facing microphone is usually built into the front panel of the camera. In early models, the microphone clipped to the camera casing.

A miniature electronic viewfinder incorporated in the majority of battery cameras (at least, those supplied with battery vtrs) makes the unit as easy to use as a through-lens reflex cine camera. In many designs, a 'tape running' warning light is also visible in the viewfinder. No viewfinder quality controls are normally provided, these being preset by the manufacturers. Nor is any provision normally made for manual control of audio or video recording level, these being determined by automatic gain controls.

Virtually all mains-powered television cameras are intended to

operate from a tripod. Extreme care must be exercised in using this accessory as a momentary lapse of concentration can result in a severely damaged camera. The legs of small closed-circuit television camera tripods are often of the twist-lock telescopic type and these should be checked immediately after extension to ensure rigidity. Where a telescopic tripod is left more or less permanently extended, the fore-going check should be repeated occasionally lest a twistlock should become loose and crash to the floor with its expensive burden. The camera is locked to the tripod mounting plate by a hand-twist screw which should itself be checked periodically for tightness. Horizontal pan is effected by releasing a lock and gently swinging the pan arm to left or right. Vertical tilt may be accomplished quite independently, again by releasing the appropriate lock. The lock in question is usually the pan/tilt handle itself, rotating anticlockwise to release and clockwise to lock. Camera height is governed by a separate lock lower down the tripod and held by a third lock. It needs little imagination to visualize the disastrous consequences of thoughtlessly releasing the tilt or height locks and for this reason all potential television operators should receive a thorough preliminary familiarization with the equipment.

For more elaborate productions, the camera tripod can be fitted with rubber-tyred wheels or mounted on a movable 'dolly'. The latter comprises a small-wheeled trolley either pushed by the camera operator or by an assistant. Where an assistant is available, the camera operator can be seated on the dolly and left to concentrate on framing and focussing. The most elaborate dollies include a mechanism capable of varying the camera height over a range of several metres.

Video mixers

Although a great deal can be accomplished in programme origination using a single camera and vtr, many producers sooner or later demand the greater flexibility of multi-camera switching or mixing.

The simplest video mixers accept two inputs (camera plus camera, camera plus vtr, or vtr plus vtr) and deliver a single output. Control facilities can be very elementary: a two-position input selector switch and a master fader. This allows initial fade-in, crossfading (master down, throw selector, master up) and fade-out. A video sync generator within the mixer allows the two cameras to be locked to the same scanning rate, otherwise picture breakup would occur during the transition from one input to another.

Prefade monitoring, a useful convenience in audio mixing, is essential in video. The producer or balancer requires a separate display screen for each incoming channel or at very least a monitor that can be switched across each input. A small video mixer incorporating its

M

own monitors is ideal for mains-powered location work though separate larger-screen monitors might be found preferable when equipping a permanent cctv studio.

Off-air television

There are several different methods of recording off-air television broadcasts. The first and most obvious is to aim a camera at the receiver, taking care to capture as much as possible of the screen without including any of the surrounding casework. Quite reasonable picture quality can be obtained in this way, provided the screen surface is free of light reflection from nearby lamps or windows. In the absence of an audio output channel, a microphone placed as close as possible to the loudspeaker should give tolerable sound. Complications may arise in overcoming hum and/or video line-frequency whistle, both of which can be reduced by using an audio filter.

The foregoing technique is only justifiable in an unexpected situation or where the need to record off-air is unlikely to arise more than once. It provides a remarkably simple form of line standard conversion in the absence of a multi-standard monitor but this factor should really be considered when the monitor is being purchased.

The second method of off-air television recording is by means of direct video and audio links with a receiver. *Plate 7* illustrates the input and output facilities provided on the cctv version of an otherwise standard 405/625-line television receiver. A multipin umbilical socket provides two-way (signal extraction and insertion) connection of audio and video. The umbilical is duplicated by uhf video input and output sockets allowing, for example, direct connection to a television camera. Better quality is obtained by recording direct than is normally possible with a screen-and-camera combination. More important than absolute quality, however, is the elimination of local sonic and optical interference.

A third choice: recording from a television tuner. This unit comprises all the essential features of a normal tv receiver but omits the reproducing screen, audio power amplifier and loudspeaker. It has the potential advantages of low cost and small size. Several manufacturers have obtained the maximum benefit from tv tuners by incorporating them in recorders though the vtrs in question are generally at the lowest end of the price scale, evidently aimed at the domestic tv market. Such a vtr may be used to record one television broadcast while the owner simultaneously watches another. The taped programme is later reproduced through the video display and audio amplification stages of the receiver, entirely independent of the latter's tuning circuitry. This feature is often taken a step further, a time-switch in the vtr allowing broadcasts to be recorded in the operator's absence.

Video effects generators

As a cctv production team become better equipped and their programmes grow increasingly ambitious, many find themselves wishing to emulate some of the effects taken for granted in broadcast television. Titling superimposed on a moving background is one example, video 'negatives' another (albeit rare). These and many other facilities may be obtained from a fairly compact video effects generator. Like the largest audio mixers, these can vary considerably in detailed functions though many of the following are common to all.

Figure 10:6 (a) represents the output from two separate television cameras. Drawing (b) illustrates a 'vertical wipe' with input 1 giving way to channel 2. Reselection of channel controls can produce (c) where channel 2 gives way to channel 1. In both cases, the wipe direction can usually be changed to give (d) and (e) respectively.

Figure 10:6 (f) shows the effect of using horizontal wipe. Many producers have employed this technique to portray two people supposedly communicating by telephone. Here again, the wipe direction and channel priority may be selected to suit the programme.

A corner wipe (g), is generally capable of being launched from any of the four corners to that directly opposite.

In the more elaborate video effects generators, insertions such as the diamond in (b) can be set to any size and any desired position on the screen. In all the foregoing cases, the speed and size of wipe or insert is controlled by hand although facilities are sometimes incorporated to allow automatic control. A typical application of the latter is allowing the loudness of a music track to modulate the size of a diamond insert.

Switching the polarity of a monochrome television camera output has the effect of reversing all blacks to whites and all whites to blacks, leaving only mid grey comparatively unchanged. The appearance is then virtually identical to that of a monochrome photographic negative. Sudden switching to video negative then back to positive can give the illusion of a violent explosion, indeed Death by Polarity Reversal is very common in science fiction programmes.

New video effects, and cheaper ways of producing old ones, are being developed rapidly and the trend towards more compact and more efficient electronic assembly could eventually bring these effects within the scope of almost every video tape recordist.

It should not be necessary to mention the irritation caused to viewers by the excessive use of video gimmicks. This lesson is soon learnt from experience.

Telecine

Vidicon cameras lend themselves well to telecine applications by

Figure 10:6

virtue of a tendency to stick. If human eyes are focused on an indoor lamp for a few seconds, a rough image of that lamp remains temporarily visible when the eyes are closed and the head is angled away. This simple demonstration of 'persistence of vision' is equally relevant to the vidicon as electrical charges on the tube surface require a finite time to disappear. Without this brief 'optical memory' telecine pictures would be spoiled by visible beating between the television field frequency and the film frame speed.

The simplest form of telecine copying is illustrated in *fig. 10:7*. If the projection lamp is of high power, a sufficiently large picture can be projected for parallax error to be practically invisible. Many non-industrial projectors, however, are only capable of throwing relatively small images and here the difference in position between projector and camera can cause obvious shape distortion.

Figure 10:8 shows a telecine arrangement which eliminates parallax error. The image is projected on a semitranslucent screen between

Figure 10:7

projector and a camera. Since this produces a mirror image of the original, a means of recovering true left/right positioning is essential. Some cameras incorporate a line-scan direction switch to correct this and any other mirror-image subjects. In the absence of this facility, the *fig. 10:9* arrangement comes near to perfection (the equipment here being seen from above). This is also an ideal arrangement for televising still slides. It also forms the basis of a versatile source of scenic 'backdrops', though here the mirror is invariably dispensed with.

Mention should be made in passing of a quite different telecine system employing a 'flying-spot' scanner and a photoelectric cell. Light

Figure 10:8

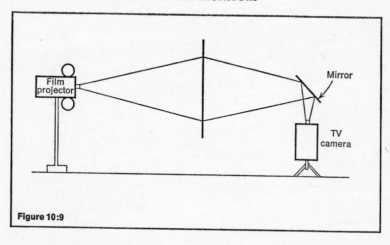

Figure 10:9

from a scanned television display screen is focused on to the filmstock and thence through to a photocell. Provided the displayed flying-spot scan is synchronized with the reproducing chain, the photocell behaves to all intents as a camera. A refined form of flying-spot telecine is employed by virtually all broadcasting organizations but this equipment hardly justifies its cost in a small cctv studio.

Lighting

One of videotape's greatest advantages over cine photography is the near elimination of lighting problems. Most vidicon tv cameras operate quite adequately in conditions of outdoor daylight, indoor daylight or indoor artificial light. Normal domestic electric lighting nearly always suffices, it being necessary at worst to remove one or more lampshades. Few vidicons will work properly in outdoor artificial light, however, though many camera manufacturers can offer specialized designs for that purpose. The cost is not unduly high.

Excessive contrast is one of the few difficulties likely to arise when working indoors with natural daylight. If a subject is placed between the camera and a window, the bright background may necessitate a reduction in iris diameter (increasing the f setting) which in turn darkens the subject image. The alternative is to place the camera between the window and the subject, thereby avoiding any suggestion of a silhouette. Even this may be unsatisfactory if the room has windows at both ends. Nevertheless, intelligent deployment of curtains (behind the subject) and, if necessary, artificial lighting from front or side will be found to cope with almost every situation.

Where additional floodlighting is considered necessary, in a poorly

lit hall, for example, this is best provided by means of quartz-iodine lamps mounted on tripods. These are capable of generating much higher intensity light than conventional lamps, for a given electrical input power. Hot or cold, quartz-iodine bulbs should never be held in unprotected hands as the special glass may deteriorate—quite apart from the risk of burns or cuts.

Plate 8 illustrates the various approaches to lighting a head-and-shoulders subject. The commonest fault is insufficient overall light, giving a flat picture (*a*) that can only be seen at all by setting to maximum contrast on the reproducing screen.

Another frequent difficulty (*b*) is excessive rear light, causing the viewer to concentrate on the background rather than on the subject.

In the third example (*c*) the subject has been highlighted from one side, leaving the background relatively dark. This, in common with lighting from above or below, tends to emphasize asymmetrical features and can even create asymmetry where none exists in reality. High-contrast side lighting is in fact the prime cause of dissatisfaction with all forms of photography, chemical or electronic.

The optimum head-and-shoulders lighting for most purposes is from a lamp in the same position as the camera itself. Since this is practically impossible, a lamp slightly offset from the camera would seem to be the best solution. But this can cause the subject to squint if any attempt is made to look directly towards the camera. It can also produce a very unsatisfactory shadow behind the subject. The solution, therefore, is to employ two side-lights for the subject and (if desired) a third light for the background. This arrangement (*d*) is shown in *fig. 10:10*.

Having the facility of instantaneous picture monitoring, a television camera crew can operate on a much freer trial-and-error basis than is possible in chemical photography. It must not be forgotten, however, that the video monitor displays the signal quality being fed to tape. Inevitably some degree of contrast deterioration occurs in the recording and reproducing process and this can render a poor signal unsatisfactory. If the deterioration is found to be particularly marked, then the tape path should be given a gentle but thorough cleansing. Fixed heads, guides, capstan and pinch wheel can be treated in a similar manner to an audio tape transport, preferably with a spirit-based proprietary cleaner on a lint-free applicator.

The video heads must be treated with great respect as, in many designs, they are manufactured from very brittle ferrite. Close inspection reveals that most video pole tips are much smaller than they seem —the exposed head surround being easily confused with these tips. Cleaning tools and instructions for their use are available from practically all vtr manufactures. Where a local importer is unable to supply

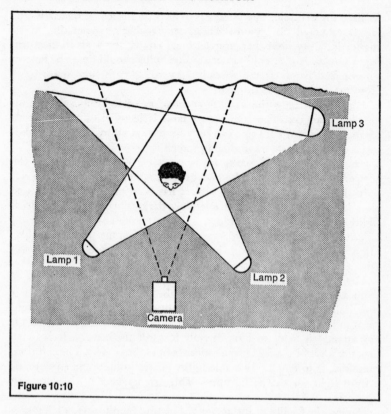

Figure 10:10

these components, the manufacturer's address should be obtained from a specialist journal or from the appropriate trade attaché. Meanwhile, the proprietary cleaning solvent *Alfenol* is the safest alternative. There is only one correct way to clean a (helical) scanner head. The scanner is turned gently by hand until the head is exposed at the cleaning gate. A solvent applicator is then placed in contact with the head and wiped to and fro in the plane of scanner rotation. Vertical wiping should be avoided.

A final point on lighting. The combination of quartz-iodine lamps and one or more lead-acid rechargeable car batteries makes a bulky but nevertheless transportable source of illumination when working independent of mains. This equipment is really only needed when working in very low light areas and could be circumvented by fitting a 'night light' vidicon to the camera or purchasing a camera primarily for that purpose.

Video reproduction

Just as a loudspeaker resembles a microphone in reverse, so a television display approximates to the structure of a camera pickup tube. Display screens are usually much larger than camera tube faces, the exact size depending on personal preference. Even the largest conventional television screens are for many purposes too small but size is limited by the need to maintain a vacuum within the glass walls of the tube. The larger the screen, for any one tube design, the greater the stress on the walls. Under no circumstances should unwanted tubes be casually smashed as the resulting implosion can cause severe injuries.

A monochrome television camera provides the display screen with two forms of information: luminance and sync. The luminance signal determines the voltage (speed) of the reproducing electron beam, depending on the amount of light present at any instant on one spot of the camera tube. This modulated beam falls on a phosphor coating painted over the inner surface of the display screen, causing the phosphor to fluoresce and thus emit a correspondingly strong spot of light. The sync signal locks the display screen electron beam to the same line-scanning rate as the camera and constitutes the familiar whistle audible in 405- and 625-line systems.

It is quite possible to feed a multitude of monitors from a single video source (camera, vtr or broadcast receiver), this requiring merely a video distribution amplifier. Video distribution lines have been built into many educational establishments while, in their absence, fairly long distances can be negotiated by transmitting along an optical link roughly resembling a laser beam. The beam in question is generated by a gallium-arsenide light emitter and is particularly suited to sending television programmes across such major obstacles as public roads where a wire link can be difficult to organize and expensive to instal.

The temptation to improve on the sound reproduction of a television receiver is great. If the picture is blacked out during a normal programme, the resultant sound quality is often found to be comparable with a miniature radio. If care is taken to filter out any continuous interference (mains hum and line sync whistle), an external audio system can greatly increase the audience's sense of involvement with the programme. The notion that a poor-quality picture needs matching poor-quality sound is absolute nonsense, provided the reproduced sound/image comes from a point as near as possible to the screen. Projection television displays are now available from several manufacturers and are capable of handling both monochrome and colour. Early systems simply relied on an extremely bright image being projected through a lens. The resultant picture luminance was low but the x-ray radiation was dangerously high. This latter should be discussed with the supplier before purchase and if possible checked independently

using a borrowed Geiger counter in the presence of a radiologist. Similar care should be taken before attempting to service colour television equipment, particularly large-screen monitors.

At the time of writing, many projection television systems are being developed around technologies that have not previously been used in this field. It is possible to declare with near certainty that the next ten or twenty years will see total abandonment of the cathode ray tube, both in cameras and in video reproducers. Flat-screen wall-mounting displays will replace bulky television receivers while cameras will fall dramatically in size and price. Laser-scanning systems are also being developed with the intention of projecting television pictures in the manner of a cine film. Yet another system involves a form of electronic transparency through which light is beamed on to the entire screen area. Video signals applied to the transparency change the surface structure, forming an outline image capable of controlling the through-flow of light. Meanwhile, for those who have not already tried it, the epidiascope system of image projection does *not* work with television screens!

The simplest conceivable television production unit comprises a closed-circuit link, video and audio, between two separate rooms. While this apparatus may at first sight seem valueless, it is in fact a useful means of extending the audience capacity of a classroom. In the more specialized situation of a medical training establishment, television allows a much wider audience to observe events than would otherwise be considered hygienic in a small operating theatre.

Almost inevitably, any organization using a live television link will eventually feel the need to make permanent record of demonstrations that would otherwise be difficult to repeat. Helical-scan videotape provides, at the time of writing, the most convenient and economical method of such storage.

Figure 11:1 illustrates the layout of a small television studio suitable for originating lectures in the presence of a live audience. While some lecturers will display greater confidence without such an audience, others find it easier to communicate to fellow humans than to the neutral eye of a camera.

Video tape recorders are much noisier than audio recorders and it is therefore important to prevent this noise reaching the medium- or high-impedance dynamic microphone. Most helical-scan vtrs come complete with a microphone on a token 2 or 3 m lead. This should be abandoned in favour of a low-impedance cardoid coupled to the vtr through an impedance-matching transformer. If audience questions are to be recorded, then separate microphones should be provided for each of the audience rows, being passed from hand to hand and faded up when necessary. The relative levels of lecturer and questioner must be carefully balanced and this is most easily achieved by equipping the sound-mixer with headphones. It is advisable not to use any automatic gain control present on the vtr audio input since the agc tends to amplify background noise in the temporary absence of fairly loud programme.

Although not essential, a video monitor placed within view of the lecturer provides some assurance that the detail of his demonstrations is adequately recorded. Before any production is recorded, the nature of such experiments should be discussed with the camera operator. If necessary, the camera can be moved forward to capture a closeup. The floor area ahead of the camera will obviously need to be clear,

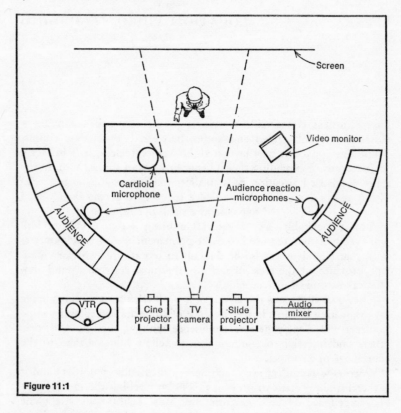

Figure 11:1

allowing the wheeled stand to be pushed with one hand while focus is adjusted with the other. A zoom lens can be added to virtually any television camera, allowing variation from long shot through medium shot to closeup at the turn of a lever. It is not uncommon for slide transparencies and cine film to be used during a lecture. Provided the room can be blacked out quickly and the projectors set straight into action, there is no reason even to pause the video recorder. Such stops should indeed be avoided as the stabilizing picture jumps usually experienced on restarting cast a pall of crudity over the entire proceedings. The secret of single camera video recording lies in preprogramme planning and in efficient presentation. This need not involve a detailed script but both the lecturer and camera operator should have notes of the subjects to be covered and the technical facilities to be used.

Titling a presentation of the foregoing kind can be achieved with a minimum of fuss or expense. A white title board large enough to fill

a closeup display area can be lettered in black with the programme label on one side and 'The End' on the opposite side. Programme production will then proceed as follows.

Five minutes before the recording is due to commence, and before any tape is loaded on the vtr, the scanner should be switched on and allowed to warm up. Failure to observe this can result in picture instability for the first few minutes of programme. After two minutes in this mode, the scanner should be stopped and the tape laced on.

When the programme is due to commence, the tape should be started and run for a few seconds with both audio and video inputs turned down. This gives a short blank leader and a nominally black screen. Video gain should now be raised to a level appropriate to local lighting, the camera being tilted down towards the title card mounted temporarily on a chair. If the resultant fade-in is found unsatisfactory, intermittent flashes being caused by dust particles in the control slide, then better results may be obtained by using the camera iris as a substitute fader.

Having recorded a few seconds of title, the iris should be closed down, the camera tilted back to horizontal, focus reset to long-shot, and the iris opened again. Audio gain should simultaneously be increased and the lecturer signalled to commence presentation.

The above process can be repeated more or less in reverse to fade out the lecture, fade in the end card, and finally fade to black.

Simple forms of electronic editing are available on most mains vtrs and have already been described. When a recording has been completed, the lecturer should be offered the facility of adding closeup inserts as these provide a useful means of emphasizing detail, not to mention keeping the audience awake. In a biology class, there may be some advantage in including microscope images that could not in any case easily have been shown to a large audience. Telephotomicrography can be accomplished with practically any combination of microscope and tv camera. *Plate 9* (*a*) shows a typical arrangement and (*b*) the resultant image. No special lenses are required but care should be taken when adjusting the microscope focus control as this may alter the space between camera and eyepiece, even resulting in a scratched lens.

Curiously, watching a video monitor microscope display is often preferable to peering through an eyepiece, though the conversion to monochrome sometimes negates this convenience.

Single-camera television systems are by no means restricted to formal lecture applications. It is possible to record stage productions with little added complication beyond perhaps a few more microphones to capture side-stage conversation. There is no need for extreme measures in placing close microphones as all stage actors need to cultivate a penetrating voice. It is nevertheless important in dramatic produc-

tions that all microphones and cables be concealed from view. A full dress-rehearsal should be monitored, even if not recorded, with each act timed. This can eliminate the danger of a tape ending in mid act. Full co-operation must be sought from the lighting operator, a small intercom link being the most effective form of communication. Remember that what appears dim light to the human eye may be total blackout to a television camera.

Most stages are set a metre or so above the auditorium floor. The camera must therefore be raised at least to the actors' eye-level; preferably slightly higher. Beware, during rehearsal, of strong light reflection from mirrors and their like. The offending objects need not be removed from the stage but should at least be shifted to a less troublesome position. If necessary, the lighting operator may be able to assist in this respect.

Resist the temptation to mount the camera to the left or right of an auditorium, even if this means ignoring a convenient 'box'. Single-camera working should always be from a centre line, except for very short sequences, or visual irritation may be inflicted on the television audience. Once again, a zoom lens enables the camera operator to produce a much more artistic programme than could be achieved with a fixed lens and a stationary camera.

Single-camera music productions can be treated in much the same way as stage theatricals. Avoid excessive light reflection from brass instruments and here take particular care to raise the camera well above the performers. Given a zoom lens, this form of mounting can allow individual close-up portrayal of practically every member of an orchestra.

Strange notions are sometimes expressed as to the kind of sound balancing most desirable in televised music productions. It is occasionally suggested that a visual closeup of an instrument should be matched by an increase in the relative sound-level from that performer. This is nonsense and would result in effects positively distressing to anyone familiar with the composition in question. There is, nevertheless, much to be said for working the other way round: bringing soloists into visual closeup when the composer so intends. This can only be accomplished by providing a programme director with a score from which instructions can be relayed over headphones to the camera operator. Both members of the team should familiarize themselves with this technique during a rehearsal or the camera operator may be left wondering which way to turn to find The Lost Flute.

A word of warning to all who work with zoom lenses. It is quite easy to offend a television audience, even to make viewers sick, by excessive panning and zooming. Good camera technique is best learnt by watching broadcast programmes of the kind anticipated.

If a television production team can produce reasonably good results from the simple apparatus of one camera, one vtr and one monitor, they should have little difficulty persuading their budget controllers to meet the cost of an additional camera and small video mixer. This adds immensely to the versatility of the system since one camera can be shifted to practically any situation while the other is in action. It goes without saying that neither camera should appear in the programme except in the classic case of a guide to video recording technique.

The addition of a second television camera permits a wide range of effects that would be difficult to achieve by normal physical means. A typical case is artificial snow. This is achieved by painting random white flakes on a black background sheet which is then run on a title roller (*fig. 11:2*). The camera output is then superimposed on the main video channel, either electronically (if the mixer allows) or optically. *Figure 11:3* illustrates the basic arrangement of a monitor

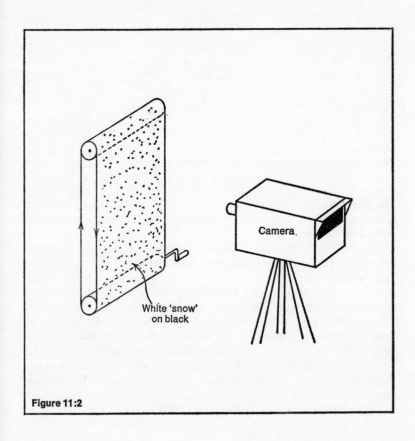

White 'snow' on black

Camera.

Figure 11:2

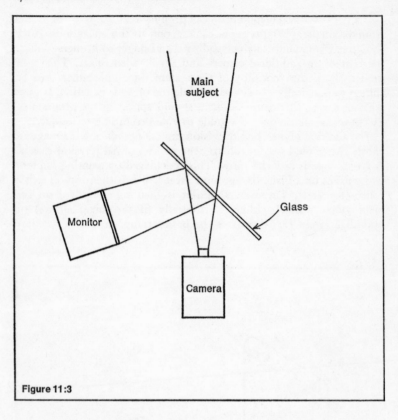

Figure 11:3

and half-silvered mirror allowing optical superimposition. Needless to say, the electronic method will generally be found more convenient and more effective.

The technique of back projection has already been described and provides a highly effective and economical method of producing background scenery.

In the absence of outdoor recording facilities, a 35 mm colour-transparency camera can be carried to virtually any location provided care is taken not to include objects associated with movement. A static background of a busy street would for many purposes be worthless. A Sunday morning shot of the same street, however, could be much more effective. An illusion of life can be added by including one or more parked vehicles in the road scene and bringing a few 'extras' to act the part of casual bypassers.

When lighting an actor in front of a back projection, a single light

source at the apparent angle of the sun is often most effective. It may also be necessary to improvise reflected light to mask severe facial shadows, either with a weaker light source or with a reflector made from white card. A 1 m² sheet mounted via a simple wooden frame to a tripod will be found a useful tool in television lighting.

It is advisable not to rely on miniature models when planning a television drama, though analog models are often of great value in educational lectures. In a dramatic production, an illusion of reality needs to be maintained throughout the programme and this can easily be shattered by, for example, portraying a railway journey with a model train-set—however good the surrounding scenery.

Not every studio can afford to assemble half a railway compartment plus a moving back projection for what may be a single occasion. Imagination must therefore be exercised in finding an effective compromise between cost and reality. Every programme production team will have access, one way or another, to a battery audio recorder and this can be used to capture the true background noise of a railway carriage. The carriage interior can then be suggested visually by front-face framing the performer or performers, the only additional scenery being appropriate seating upholstery and background veneer. A railway advertisement can add to the illusion. This background could, of course, itself be provided by back projection but this would spoil a supporting effect designed to add an impression of motion. The latter consists of flashing a bright light from one side of the set, blocking the light at random with a card. The little matter of entering and leaving the carriage can be avoided by judicious scripting. Again, the advantage of a battery vtr is obvious though the extremely high noise-level in a moving railway carriage may even then force the use of a studio set.

The lack of a battery video tape recorder need not be regarded as a sentence to permanent indoor working. Almost any motor vehicle can be equipped as a temporary mobile telerecording unit. An estate car or van requires less modification of the seating layout than may be necessary in a saloon. A vehicle with an open roof is more versatile than one without but requires greater attention to security if the equipment is likely to be left unattended. One essential requirement is a long power lead to couple the unit to local mains. Where finances permit, greater freedom can be obtained by installing a pack of car batteries and an electronic transverter in a convenient part of the vehicle. The transverter raises the car battery voltage from a typical 12V dc to the required ac mains voltage.

As television productions become more ambitious, so the size of scene sets tends to increase. Inevitably, fixed tripods are abandoned in favour of wheeled stands though this need not involve undue expense.

N

Most tripods can be converted into mobile stand by constructing wooden bases on the lines of *fig. 11:4.* Note the cutaway intended to prevent the camera operator tripping on the near side of the base. The triangular tray beneath the camera provides a useful storage area for accessories if this proves desirable.

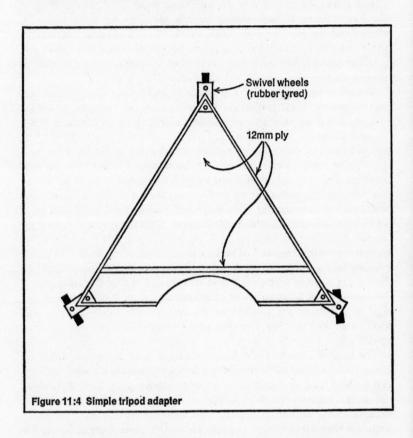

Figure 11:4 Simple tripod adapter

Semimobile cameras often require some form of equally mobile lighting and this can sometimes be most conveniently mounted to the tripod or camera body. Two floodlamps, one to the camera left, one to the right, can be mounted on swivel arms to permit direct or indirect illumination. At no time, however, should this form of lighting be allowed to dazzle a performer working face-on to the camera.

Besides creating lighting complications, semimobile cameras also demand a more flexible approach to microphone placement involving the use of one or more long booms. These differ from conventional

microphone stands in having a very long span, typically 4 or 5 m ahead of the pivot, plus a corresponding counterweight at the rear. The base is normally a wheeled trolley and the entire unit is constructed to permit interference-free changes in microphone position. A resilient coupling between microphone and boom, if necessary the cable itself, passes much less boom rumble into the audio channel than would a metal or plastic clamp. Each boom operator should be linked by headphones to the audio channel and should also have access to a video monitor. Without these provisions, the boom microphone output may prove insufficient or highly unnatural shadows may be cast on the image.

Cheaper and more versatile than the trolley-mounted boom is the hand-held boom, being simply a lightweight pole with an end-slung microphone. *Figure 11:5* shows side and *fig. 11:6* overhead views of such a boom being supported from the rear of the subject. This is an easy way to handle a multiset production where more than one camera is available but where other facilities are limited; incidentally, this arrangement is by no means limited to four sets.

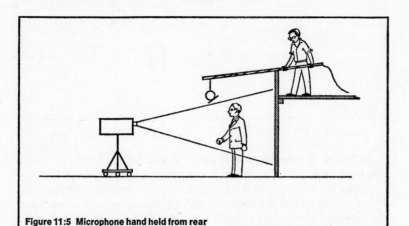

Figure 11:5 Microphone hand held from rear

Where only a single camera can be used, the *fig. 11:7* set layout can also be constructed to permit rear boom microphone placement though this involves the set constructors in very much more work. It also demands much longer time in carrying the microphone from set 1 to set 3 or 4, compared with the rapid swivel action possible in *fig. 11:6*. In practice, of course, the *fig. 11:7* layout would only be used in conjunction with at least two microphones and an audio mixer. A back-held boom is much less tiring to support than the more conventional

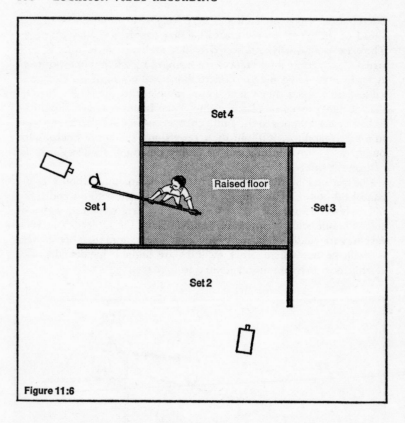

Figure 11:6

hand boom. Where substantial use is found for the latter, it is only fair to the operators to construct or purchase a trolley boom.

Where boom microphones of all kinds prove inconvenient, perhaps in very large sets, it is possible to conceal microphones in almost any position by constructing suitable disguises. A hollow book, a dummy radio receiver, an ornate chandelier; there is no end to the possibilities once the programme subject is known.

Adapting a narrative script for television demands practical knowledge of camera manipulation, microphone placement, and economical set construction. Rather than rely on an inevitably inexperienced producer, it is wisest for a newly formed production group to pool their intellectual resources. One member of the team should be allowed to specialize in optics, another in audio, another in scenery and perhaps another in matters of costume. The producer's suggested set layouts can then be checked by each specialist for possible snags. Scripts that

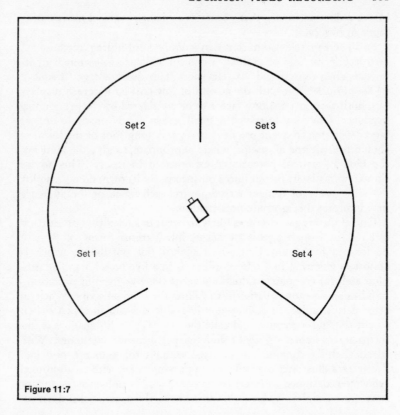

Figure 11:7

demand several dozen different sets should be rejected long before
this point is reached though this problem is only likely to arise from
locally written works or from thoughtless book adaptations. Some
production groups may in fact manage to cope with a wide variety of
sets by recording on location. Others will rely heavily on back
projection.

Set construction is an art in itself, invariably subject to a tight
budget and a tighter time schedule. Both time and money can be
saved by prefabricating a variety of stage accessories. Examples are
various sizes of pillars and cubes, two or three stair units, a ramp, an
archway, a fireplace, a door structure, straight, angled and curved
back-flats.

It is sometimes possible to make substantial savings in scenery costs
by placing scaled-down sets between the camera and the actor. Card-
board cutouts can be used to frame a distant actor in a doorway, for
example, or in the interior of a large building. This takes advantage

of the reduction in size that occurs as a pictorial subject moves away from an observer.

Small-screen television is no inherently hard-hitting medium. A horror film capable of chilling a cinema audience loses much of its impact when reproduced via television. This disadvantage (if such it is) should disappear with the advent of low-cost large-screen displays but, until then, it remains a factor to be considered by the programme producer. One way in which a small screen can be made to appear larger is by the frequent use of close-ups. A long shot of the location should precede the close-ups, where appropriate, to give the audience the kind of natural perspective experienced in reality. This advice should immediately be put into a perspective of its own: do not employ the same order of camera technique for each scene or the audience may interpret this as crude presentation.

One of the biggest disasters likely to occur in a television production is an actor forgetting his or her script. Various forms of prompt device can be provided to guard against this possibility, which is almost as irritating in a telerecording as in a live broadcast. The simplest and, for complex productions, most effective form of prompting requires an off-camera assistant to follow the original script. When an actor delays unduly in delivering a line, this assistant throws a switch to cut the audio channel and calls the cue. The audio channel is immediately switched on again and the performance continues. With practice, this technique can be used without the audience noticing. *Figure 11:8* illustrates the audio cutout arrangement with an additional refinement designed to insert prerecorded studio ambience (ventilator noise for example). Without this refinement, the occasional sudden cut

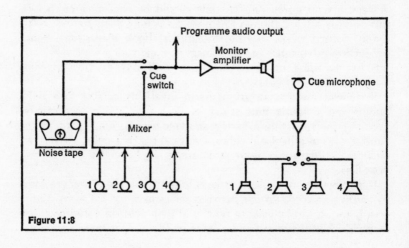

Figure 11:8

in background noise can be noticeable even to an audience unfamiliar with such techniques.

Prompting is best accomplished over a small talkback system capable of being switched only to the set in use at any one instance. An all-embracing talkback feeding several sets simultaneously can generate strong echoes that are still audible when the cue switch is turned back on.

A quite different form of prompt can be employed for newsreaders and other full-face monologue performers. This involves the use of a half-silvered mirror in front of the camera, reflecting a shifting script in the style of *fig. 11:9*. An additional mirror below the camera reflects the image of a script roll, arriving either direct or from a tv monitor. Commercially available under the trade name Autocue, this system is often used in conjunction with a normal desktop script and saves the presenter the task of memorizing several lines in advance of the sentence actually being read. Yet even this arrangement can be noticed by the audience if the performer stares too rigidly at the reflected script. A careful observer will even see the commentator's eyes scan each line of script unless the lines are narrow enough to allow centre-glance reading.

It is of course possible to forget the complexities of a script reflector and instead to display the script itself adjacent to the camera. The mere preparation of a long script roll is tiresome, however, and is generally abandoned in favour of the audio interrupter prompt system outlined earlier.

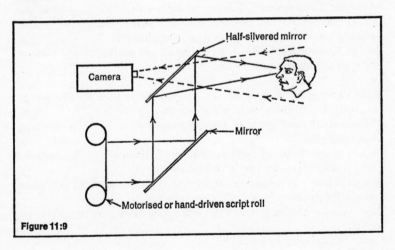

Figure 11:9

GLOSSARY

A/b selector: Device allowing comparison of after (tape) and before (tape) in a magnetic recorder.

Acceptance angle: The horizontal width of vision of a camera.

Acetate: Plastics material employed as a tape base; stretch-resistant but prone to snapping (latterly replaced by pvc and polyester). Also colloquial term for direct-cut disc.

Amp (A): Unit of electrical current flow.

Amplitude modulation (AM): Varying the strength of a nominally fixed frequency carrier in proportion to the strength of a lower frequency signal.

Anechoic chamber: Room enclosed by ideally non sound-reflecting surfaces, used for measuring acoustic parameters of, for example, microphones and loudspeakers.

Aspect radio: Ratio between the height and width of a picture (3:4 in television).

Attenuator: Fixed or adjustable device designed to reduce the strength of a signal.

Automatic gain control: See *Compressor.*

Azimuth: The angular difference between a magnetic tape-head gap and the plane of relative physical motion. Usually 90 degrees.

Backing track: Prerecorded audio accompaniment.

Baffle: Acoustic screen designed to impede air motion in the vicinity of a microphone or loudspeaker.

Bel: See *Decibel.*

Bias: In magnetic sound recorder, a supersonic tone applied to the record head in order to reduce distortion.

Bidirectional microphone: Microphone sensitive to sound arriving from front or rear.

Boom: Microphone or lamp support set nominally parallel with the floor. Usually supported by a vertical stand.

Bridge: Device transmitting mechanical vibration from the strings of a musical instrument to a flexible soundboard.

Bulk eraser: Device permitting high-speed erasure of magnetic recordings.

Cans: Headphones or earpiece.

Capacitor microphone: Acoustoelectric transducer employing the principle of capacitance to generate an electrical signal.

Cardioid microphone: Microphone sensitive to sound arriving from front or side. This characteristic is usually frequency dependent.

Capacitor loudspeaker: Electroacoustic transducer employing the principle of capacitance to generate sound waves.

Capstan: Source of tape motion in a magnetic recorder, usually an extension of the capstan motor spindle though sometimes driven via intermediate pulleys.

Capstan sleeve: Means of changing the speed of a tape recorder by altering the effective capstan diameter.

Cartridge: An enclosed recording medium comprising a single reel (usually of 6·25 mm tape) within a nominally dustproof container.

Cassette: An enclosed recording medium comprising supply and takeup reels within a nominally dustproof container.

Cement: Adhesive material sometimes employed in tape editing to join two overlapping ends, relatively little used as the resultant step can cause an audible dropout.

Chrominance: Relative colour of a television picture. See also *Luminance*.

Clean feed: Monitoring source giving a programme participant all but his own signal contribution.

Coincident microphones: Two directional microphones set at the nominal spacing of human ears and angled approximately 90 degrees to each other (45 degrees to the soundstage centre).

Coloration: Subjective result of non-linear sensitivity across the programme chain spectrum.

Compander: Combined compressor and expander.

Complimiter: Combined compressor and limiter.

Compresser: Device reducing the dynamic range of a programme, resulting in more uniform level.

Condenser microphone: See *Capacitor microphone*.

Contact microphone: Acoustoelectric transducer designed to detect sound vibrations transmitted through a solid.

Converter: Device which synthesizes an ac mains power supply from a lower voltage battery.

Continuity: Link announcements between programmes.

Crab: Shifting a camera or microphone sideways. Not to be confused with *Pan*.

Cross fade: Slow mix between two signal sources during which both temporarily overlap.

Crossover: Frequency-sensitive circuit designed to apportion the working spectrum between two or more elements in, for example, a loudspeaker.

Crosstalk: Unwanted breakthrough between parallel channels of a programme chain.

Crystal microphone: Acoustoelectric transducer employing the piezo-electric principle to generate an electrical signal.

Cue: Verbal or electronic starting signal.

Current: Essentially a 'width of traffic' measure of electron flow. Expressed in Amps.

Cut: Instantaneous switch from one video source to another.

Dead room: Room or cubicle acoustically treated to minimize internal reverberation.

Decibel (dB): Logarithmic measure of relative intensity, power or voltage. One-tenth of a Bel.

Decibel meter (dBm): Programme level referred to 1 milliwatt (mW) in 600Ω (0 dBm).

Degausser: Device for obliterating residual magnetism in, for example, tape heads.

Diaphragm: Part of a sound generator which matches the energy of a vibrating mechanism to the impedance of the surrounding air. Can also serve an opposite function, as in the case of a microphone.

Difference tone: A sometimes audible tone caused by interaction between two tones of similar frequency; superimposing a 900 Hz tone on 500 Hz produces an audible 400 Hz (900 − 500) difference tone.

DIN: Deutsche Industrie Normen (German industrial standards organization).

Dolly: Moving a camera towards or away from its subject.

Dropout: Momentary break in the signal-sensitive surface of a recording medium.

Dubbing: Copying a recorded programme or sequence.

Dynamic range: Variation between the strongest signal capable of being delivered by a device and the noise inherent in that device.

Echo: Sound bounce-back from a reflective surface.

Editing: Assembling a programme by combining or transposing separate recorded sequences.

EIAJ/1: Video tape recording format laid down by the Electrical Industries Association of Japan.

Electrostatic loudspeaker: See *Capacitor loudspeaker.*

Endless cartridge: An enclosed recording medium comprising a single reel within a nominally dustproof container, tape being pulled from the hub and returned to the reel periphery.

Eraser: See *Bulk eraser.*

Erasure: Obliteration of unwanted signals from a magnetic tape.

Expander: Device designed to increase the dynamic range of a programme.

Fader-start: Remote-equipment activator incorporated in gain control fader.

Feedback: Returning a proportion of the output from a device back

to its input, such as to reduce distortion (negative feedback in an amplifier) or for echo effects (delayed feedback in a magnetic recorder).

Field: Odd or even line component of a frame in interlaced television. See also *Frame*.

Flutter: Variations in speed of a recording medium, occurring above one-fifteenth of a second. (See also *Wow*.)

Foldback: See *Clean feed*.

Formant: Characteristic resonance(s) by which a sound source can generally be identified.

Frame: Stationary cine or television picture. In European television, 25 frames per second are scanned to create the illusion of continuous movement. Each frame is normally composed of two *fields*.

Frequency modulation (fm): Varying the frequency of a nominally fixed-level carrier in proportion to the strength of a lower frequency signal.

Gain: Ratio of amplification or attenuation, usually expressed in decibels.

Grams: Gramophone turntables.

Grille: Protective covering usually placed over the front of a microphone or loudspeaker.

Guide: In magnetic recording, one of a series of posts employed to stabilise the vertical motion of tape passing through a tape transport.

Harmonic: Frequency multiple of a fundamental tone. Whereas the fundamental normally determines the subjective pitch, the harmonic structure determines the characteristic tone.

Helical scan: Method of video tape scanning in which the tape forms a helix round one or more coaxial rotating heads.

Henry (H): Unit of *inductance*.

Herz (Hz): Unit of vibration. One vibration (or 'cycle') per second equals one Herz.

Idler: Intermediate wheel or pulley coupling a motor to a distant component, typically a tape recorder capstan or gramophone turntable.

Impedance: Resistance to alternating motion (in electronics a combination of direct-current resistance, inductance and capacitance).

Inductance: The alternating-current resistance of a coiled conductor, increasing with frequency.

Jack: Usually refers to a 6·25 mm two- or three-contact coaxial connector originally developed for telecommunications.

Jointing tape: Plastic tape with a pressure-sensitive adhesive coating, used in magnetic tape editing.

Kilo (k): 1,000.

Lavalier: Microphone suspended from neck strap.

Leader tape: Coloured plastic tape (usually white) used to identify the start of a magnetic recording.

Led: Light-emitting diode

Limiter: Device restricting the maximum level of a programme.

Loop: Short length of magnetic tape capable of providing a repeating effect.

Loudspeaker: Transducer designed to convert electrical energy into acoustic energy.

Luminance: Relative intensity of (one segment of a) television picture. (See also *Chrominance*.)

Master tape: First generation recording.

Mega (M): 1,000,000.

Micro (μ): One-millionth.

Microphone: Transducer designed to convert acoustic energy into electrical energy.

Microphone separation: Level of independence of one microphone from its neighbours in a multimicrophone array.

Milli (m): One-thousandth.

Mixer: Device capable of merging two or more programme inputs into a smaller number of outputs. A 2/1 mixer can combine two inputs to form one output; a 4/2 four inputs into two outputs, and so on.

Multiplex: Method of coding two or more programmes into a single transmission line. Essentially, the available line spectrum is divided into equal portions and one portion allocated to each programme.

Multitracking: Assembling a programme by recording a series of independent parallel tracks (usually on magnetic tape) for later integration.

NARTB: National Association of Radio and Television Broadcasters (USA).

Noise: Unwanted portion of a signal (usually random).

Nut: Bridge nearest the tuning pins in a stringed musical instrument, usually mechanically rigid.

Ohm (Ω): Unit of electrical resistance.

Omnidirectional microphone: Microphone equally sensitive to sound arriving from any angle. This characteristic tends to be frequency-dependent.

Overdubbing: Adding to a previously recorded sequence, typically in multitrack tape recording.

Oxide: Magnitizable particles coated on the plastics base of recording tape (usually iron oxide).

Pan: Swivelling a camera about a fixed vertical axis.

Panoramic potentiometer (Panpot): Stereo balance control.

Parabolic reflector: Device employed to increase the sensitivity of a microphone in a single direction. Relatively inefficient at low frequencies where the sound wavelength is greater than the reflector diameter.

Peak programme meter (ppm): Signal level indicator showing the maximum (i.e. peak) strength at any instant. For ease of reading, the decay speed is usually deliberately slowed.

Perfect pitch: The ability to judge pitch without reference to any artificial tone source.

Pinch wheel: Wheel designed to force tape against the capstan in a magnetic recorder, thereby obtaining constant tape drive.

Platter: Main rotating member of a gramophone, usually of fairly heavy construction to minimize *flutter*.

Power: In electronics, a measure of total electron flow expressed in watts. Power (in watts) = voltage (in volts) multiplied by current (in amps).

Pre-read head: Device fitted in advance of a playback head to anticipate programme level fed to a varigroove disc cutter.

Presence: Facility for boosting the frequency response of a system in the 3 k to 8 kHz region to create an illusion of nearness to a sound source.

Print-through: Transfer of a recorded pattern on to an adjacent storage medium.

Quadraphony: Four-channel sound reproduction.

Quadruplex: Video tape recording system developed by Ampex. See *Transverse scan.*

Reduction: Mixing two or more audio tracks into a smaller number of channels, typically a sixteen-track master tape down to stereo.

Resistance: Opposition to electrical current flow. The resistance (in ohms) of a circuit is equal to the voltage (in volts) divided by the current (in amps).

Resonance: Natural frequency of (mechanical or other) vibration.

Reverberation: Collective term for echoes occurring faster than 15 per second. See *Echo.*

Reverberation time: Time taken for a sound to fall 60 dB below its original intensity.

Ribbon microphone: Accoustoelectric transducer employing a lightweight conducting ribbon in a permanent magnetic field to generate electrical signals proportional to local air vibration.

Rocking: Left/right movement of tape over a playback head (usually by hand, to select an edit point).

Scanner: Rotating head unit in a video tape recorder.

Scroll: Space between recorded bands of a disc.

Search: Facility for playing back a tape recording while fast winding, liable to cause rapid head wear if used extensively.

Selsync: Playback through adjacent segments of a record head. Sometimes used in multitrack tape production.

Signal: Intelligence, however conveyed.

Signal-to-noise ratio: Ratio between the loudest signal that can usefully be handled by a device (with typically not greater than 3 per cent distortion) and the inherent noise. Normally expressed in *decibels*.

Solenoid: Electromagnetic coil typically used for remote actuation of switches and mechanical assemblies.

Spacer tape: Coloured tape between bands of a spooled reel. Traditionally yellow.

Speed of sound in air: At normal room temperature (20°C) this is approximately 340 metres per second (m/s).

Splice: Physical joining of two recorded tapes.

Squawker: Loudspeaker transducer optimized for mid-frequency operation.

Stereo: Two-channel sound reproduction (popular definition).

Tetraphony: Form of quadraphony arranged to include both lateral and vertical information.

Trailer tape: Coloured tape at the end of a spooled reel. Traditionally red.

Transducer: Device capable of converting energy from one state into another.

Transverse scan: Method of video tape scanning employed in the Ampex Quadruplex system in which the tape is cupped round the periphery of a four-head wheel rotating at 90 degrees to the plane of tape motion.

Tweeter: Loudspeaker transducer optimized for high-frequency operation.

Varigroove: Method of adjusting groove spacing during disc cutting to prevent crosstalk between adjacent grooves. See also *Pre-read head*.

Viewfinder: Miniature television monitor mounted in or immediately above a television camera.

Virgin tape: Completely new and unused tape.

Voltage: Essentially a measure of electron speed. Expressed in volts.

Voltage control: Varying the operating characteristics of a device by altering an applied voltage.

Volume Unit meter (VU meter): Signal-level indicator showing the average signal level at any instant.

Wavelength: The wavelength of a sound λ is related to frequency (f) by the formula $c = f\lambda$ where c is the speed of sound (340 m/s in air).

Woofer: Loudspeaker transducer optimized for low-frequency operation.

Wow: Variation in speed of a recording medium, occurring below one-fifteenth of a second. (See also *Flutter*.)

BIBLIOGRAPHY

Aldred, John, *Manual of Sound Recording*, 2nd ed., Fountain Press, London, 1971.

Berry, S. D., *The Application of Transistors to Sound Broadcasting*, Engineering Monograph, BBC, London, 1963.

Berry, S. D., *Transistor Amplifiers for Sound Broadcasting*, Engineering Monograph, BBC, London, 1959.

Betts, J. A., *High-Frequency Communications*, English U.P., London, 1967.

Betts, J. A., *Signal Processing, Modulation and Noise*, English U.P., London, 1970.

BBC, *Guide to Broadcasting Stations*, 16th ed., Butterworth, London, 1970.

Brooker, F. C., *Radiophonics in the BBC*, Engineering Monograph, BBC, London, 1963.

Buckingham, H., and Price, E. M., *Principles of Electrical Measurements*, English U.P., London, 1966.

Burd, A. N., Gilford, C. L. S., and Spring, N. F., *Data for the Acoustic Design of Studios*, Engineering Monograph, BBC, London, 1966.

Camies, B. S., *Principles of Frequency Modulation*, Butterworth, London, 1959.

Gee, A., and Shorter, D. E. L., *An Automatic Integrator for Determining the Mean Spherical Response of Loudspeakers and Microphones*, Engineering Monograph, BBC, London, 1956.

Gilford, C. L. S., and Greenway, M. W., *The Application of Phase-Coherent Detection and Correlation Methods to Room Acoustics*, Engineering Monograph, BBC, London, 1956.

Gooberman, G. L., *Ultrasonics: Theory and Application*, English U.P., London, 1969.

Goodyear, C. C., *Signals and Information*, Butterworth, London, 1971.

Hadden, H. Burrell, *BBC Programme Operations Training Manual: High-Quality Sound Production and Reproduction*, BBC, London, 1962.

Halliday, E. C., and Morris, B. P., *Laboratory Manual for Principles of Electricity and Electronics*, English U.P., London, 1963.

Harwood, H. D., *The Design of a High-Quality Commentator's Microphone Insensitive to Ambient Noise*, Engineering Monograph, BBC, London, 1956.

Harwood, H. D., *The Design of a Low-Frequency Unit for Monitoring*

Loudspeakers, Engineering Monograph, BBC, London, 1967.

Harwood, H. D., Hughes, S. A., and Gilford, C. L. S., *Aspects of High-Quality Monitoring Loudspeakers*, Engineering Monograph, BBC, London, 1969.

Harwood, H. D., and Shorter, D. E. L., *Stereophony: The Effect of Crosstalk Between Left and Right Channels*, Engineering Monograph, BBC, London, 1964.

Hill, C. J. W., and Bishop, H. S., *The Engineering Facilities of the BBC Monitoring Service*, Engineering Monograph, BBC, London, 1958.

Jolly, W. P., *Low-Noise Electronics*, English U.P., London, 1967.

Jones, D. K., *A Subjective Investigation into Preferred Microphone Balances*, Engineering Monograph, BBC, London.

Judd, F. C., *Electronic Music and Musique Concrète*, Neville Spearman, London, n.d.

Mankovsky, V. S., *Acoustics of Studios and Auditoria*, Focal Press, London, 1971.

Moffat, M. E. B., and Spring, N. F., *An Automatic Method for the Measurement of Reverberation Time*, Engineering Monograph, BBC, London, 1969.

Nisbett, A., *Technique of the Sound Studio*, 2nd ed., Focal Press, London, 1969.

O'Neill, L. E. H., *The BBC's Mark 2 Mobile Studio and Control Room for the Sound Broadcasting Service*, Engineering Monograph, BBC, London, 1958.

Pannett, W. E., *Dictionary of Radio and Television*, Butterworth, London, 1967.

Perkins, G. D., *Principles of Electrical Science in SI Units*, English U.P., London, 1972, I.

Petrie, R. D., and Taylor, J. C., *Programme-Switching Control and Monitoring in Sound Broadcasting*, Engineering Monograph, BBC, London, 1960.

Robertson, A. E., *Microphones*, 2nd ed., BBC, London, 1963.

Scroggie, M. G., *Foundations of Wireless and Electronics*, 8th ed., Butterworth, London, 1970.

Scroggie, M. G., *Radio and Electronic Laboratory Handbook*, 8th ed., Butterworth, London, 1971.

Shorter, D. E. L., Crew, J. R., Howorth, D., and Sanders, J. R., *Pulse-Code Modulation for High-Quality Sound Distribution*, Engineering Monograph, BBC, London, 1968.

Shorter, D. E. L., Gilford, C. L. S., and Harwood, H. D., *The Acoustic Design and Performance of a New Free-Field Sound-Measurement Room*, Engineering Monograph, BBC, London, 1965.

Shorter, D. E. L., and Harwood, H. D., *The Design of a Ribbon-Type*

Pressure Gradient Microphone for Broadcast Transmission, Engineering Monograph, BBC, London, 1955.

Shorter, D. E. L., Harwood, H. D., and Manson, W. I., *Stereophony: The Effect of Interchannel Differences in the Phase/Frequency and Amplitude/ Frequency Characteristics*, Engineering Monograph, BBC, London, 1964.

Shorter, D. E. L., and Manson, W. I., *The Automatic Control of Sound Signal Level in Broadcasting Studios*, Engineering Monograph, BBC, London, 1969.

Shorter, D. E. L., Manson, W. I., and Stebbings, D. W., *The Dynamic Characteristics of Limiters for Sound Programme Circuits*, Engineering Monograph, BBC, London, 1967.

Shorter, D. E. L., Manson, W. I., and Wigan, E. R., *Analysis and Measurement of Programme Levels*, Engineering Monograph, BBC, London, 1958.

Shorter, D. E. L., and Phillips, G. J., *A Summary of the Present Position of Stereophonic Broadcasting*, Engineering Monograph, BBC, London, 1960.

Sturley, K. R., *Sound and Television Broadcasting: General Principles*, BBC, London.

Wood, C. B. B., Lord, A. V., Rout, E. R., and Vigurs, R. F., *The Suppressed-Frame System of Telerecording*, Engineering Monograph, BBC, London, 1955.

Wysotsky, M. Z., *Wide-Screen Cinema and Stereophonic Sound*, Focal Press, London, 1971.

EQUIPMENT MANUFACTURERS
AND SUPPLIERS

Amplifiers (audio monitor)
Acoustical Manufacturing Co Ltd, Huntingdon.
Apollo Electronics, 96 Mill Lane, London NW6.
Areac Ltd, Summit Gardens, Halesowen, Worcs.
Audix BB Ltd, Stansted, Essex.
Electrosonic Ltd, 815 Woolwich Road, London SE7 8LT.
Grampian Reproducers Ltd, Hanworth Trading Estate, Feltham, Middlesex.
HH Electronic, Cambridge Road, Cambridge CB4 4AZ.
Rupert Neve & Co, Cambridge House, Melbourn, Royston, Herts.
Spendor Audio Systems Ltd, Kings Mill Lane, South Nutfield, Redhill, Surrey RH1 5NF.
J. E. Sugden & Co, Carr Street, Cleckheaton, Yorkshire BD19 5LA.

Cameras (television)
Akai (Japan): Rank Audio Products, PO Box 70, Great West Road, Brentford, Middlesex TW8 9HR.
Ampex (USA): Ampex GB Ltd, 72 Berkeley Avenue, Reading, Berkshire.
EMI Television Division, 252 Blyth Road, Hayes, Middlesex UB3 1HW
Hitachi Shibaden (Japan): Hitachi-Shibaden UK Ltd, Lodge Road, London NW4 4DQ.
Ikegami (Japan): Dixons Technical Ltd, 3 Soho Square, London W1.
National (Japan): Dixons Technical Ltd, 3 Soho Square, London W1.
RCA (USA): RCA Ltd, Sunbury-on-Thames, Middlesex TW16 7HW.
Sony (Japan): Sony UK Ltd, Commercial & Industrial Division, Ascot Road, Feltham, Middlesex.

Compressors (audio)
See list of audio mixer manufacturers.

Gramophone turntables
EMT (Switzerland): F. W. O. Bauch Ltd, 49 Theobald Street, Boreham Wood, Hertfordshire.
Garrard Engineering Ltd, Swindon, Wiltshire.

Russco (USA): Lamb Laboratories, Church Street, Chiswick, London W4 2PB.

Headphones

AKG (Austria): AKG Equipment Ltd, 182–4 Campden Hill Road, London W8.

Amplivox Communications Ltd, Beresford Avenue, Wembley, Middlesex HAo 1RU.

Beyer (Germany): Beyer Dynamic GB Ltd, 1 Clair Road, Haywards Heath, Sussex.

Koss (USA): Koss-TMD Ltd, 11 Redvers Road, London N22 6EP

Rank-Wharfedale Hi-Fi, Idle, Bradford, Yorkshire BD10 8SQ.

Sennheiser (Germany): Hayden Laboratories, 17 Chesham Road, Amersham, Buckinghamshire.

Sharpe (USA): Macinnes Laboratories Ltd, Stonham, Stowmarket, Suffolk IP14 5LB.

Stax (Japan): Wilmex Ltd, 24–6 Ensign Street, London E18 JD.

Loudspeakers (monitor)

Acoustical Manufacturing Co Ltd, Huntingdon.

Cadac (London) Ltd, Lea Industrial Estate, Batford, Harpenden AL5 5EL.

IMF Electronics, Westbourne Street, High Wycombe, Buckinghamshire.

KEF Electronics Ltd, Tovil, Maidstone, Kent ME15 6QP.

Rogers Developments (Electronics) Ltd, 4–14 Barmeston Road, London SE6 3BN.

Rola Celestion Ltd, Ditton Works, Foxhall Road, Ipswich, Suffolk IP3 8JP.

Spendor Audio Systems Ltd, Kings Mill Lane, South Nutfield, Redhill, Surrey RH1 5NF.

Tannoy Products Ltd, Norwood Road, West Norwood, London SE27 9AB.

Microphones

AKG (Austria): AKG Equipment Ltd, 182–4 Campden Hill Road, London W8.

Beyer (Germany): Beyer Dynamic GB Ltd, 1 Clair Road, Haywards Heath, Sussex.

Calrec Audio Ltd, Haningroyd Lane, Hebden Bridge, Yorkshire HX7 7DD.

Electro-Voice (USA): Gulton Europe Ltd, The Hyde, Brighton, BN2 4JU.

Grampian Reproducers Ltd, Hanworth Trading Estate, Feltham, Middlesex.

Neumann (Germany): F. W. O. Bauch Ltd, 49 Theobald Street, Boreham Wood, Herts.

Sennheiser (Germany): Hayden Laboratories Ltd, 17 Amersham Road, Buckinghamshire.

Shure (USA): Shure Electronics Ltd, Eccleston Road, Maidstone ME15 6AU.

Mixers (audio)

Alice (Stancoil) Ltd, 38 Alexandra Road, Windsor, Berkshire.

Allen & Heath Ltd, Pembroke House, Campsbourne Road, London N8.

Apollo Electronics, 96 Mill Lane, London NW6.

Audix BB Ltd, Stansted, Essex.

Bias Electronics Ltd, Unit 8, Coombe Trading Estate, 112–20 Coombe Lane, London SW20 0BA.

Cadac (London) Ltd, Lea Industrial Estate, Batford, Harpenden, Hertfordshire.

Calrec Audio Ltd, Hangingroyd Lane, Hebden Bridge, Yorkshire HX7 7DD.

Cetec (USA): Cetec UK, Shaftesbury Street, High Wycombe, Buckinghamshire.

Electrosonic Ltd, 47 Old Woolwich Road, London SE10.

Helios Electronics Ltd, 161 High Street, Teddington, Middlesex.

Magnetic Tapes Ltd, Chilton Works, Garden Road, Richmond, Surrey.

Millbank Electronics, Uckfield, Sussex.

MCI (USA): Feldon Audio Ltd, 126 Great Portland Street, London W1N 5PH.

Rupert Neve & Co, Cambridge House, Melbourn, Royston, Hertfordshire SG8 6AU.

Partridge Electronics Ltd, 23–5 Hart Road, Benfleet, Essex SS7 3PB.

Raindirk, 33A Bridge Street, Downham Market, Norfolk.

Sound Techniques Ltd, Industrial Estate, Mildenhall, Suffolk IP28 7AS.

Stellavox (Switzerland): AV Distributors London Ltd, 26 Park Road, Baker Street, London NW1.

Studer (Switzerland): F. W. O. Bauch Ltd, 49 Theobald Street, Boreham Wood, Hertfordshire WD6 4RZ.

Triad Ltd, 4–10 North Road, London N7 9HG.

Noise reducers (audio)

Burwen (USA): International Instruments Ltd, Croos Lances Road, Hounslow, Middlesex.

Dolby Laboratories, 346 Clapham Road, London SW9.

DBX (USA): Scenic Sounds Equipment, 28 Bryanston Street, London W1H 7AB.

Synthesizers (audio)
ARP (USA): Boosey & Hawkes (Sales) Ltd, Deansbrook Road, Edgware, Middlesex HA8 9BB.
DEW Ltd, 253 Ringwood Road, Ferndown, Dorset.
Electronic Music/Studios Ltd, 277 Putney Bridge Road, London SW15 2PT.

Tape recorders (audio)
Ampex (USA): Ampex International, 72 Berkeley Avenue, Reading, Berkshire RG1 6HZ.
Bias Electronics Ltd, Unit 8, Coombe Trading Estate, 112/20 Coombe Lane, London SW20 0BA.
Leevers-Rich Equipment Ltd, 319 Trinity Road, Wandsworth, London SW18 1YQ.
Scully (USA): Scully Metrotech, 14 Broadway, London SW1.
Studer (Switzerland): F. W. O. Bauch Ltd, 49 Theobald Street, Boreham Wood, Hertfordshire.
Telefunken (Germany): Hayden Laboratories, 17 Chesham Road, Amersham, Buckinghamshire.
Revox (Switzerland): C. E. Hammond, Lamb House, Church Street, London W4 2PB.
Kudelski (Switzerland): Hayden Laboratories, 17 Chesham Road, Amersham, Buckinghamshire.
Stellavox (Switzerland): A. V. Distributors Ltd, 26 Park Road, Baker Street, London NW1 4SH.
Uher (Germany): Bosch Ltd, PO Box 166, Rhodes Way, Watford WD2 4LB, Hertfordshire.
Ferrograph Co Ltd, 442 Bath Road, Chippenham, Slough, Buckinghamshire.
Philips (Holland): Pye TVT Ltd, PO Box 41, Coldhams Lane, Cambridge CB1 3JU.
Brenell Engineering Co, 231-5 Liverpool Road, London N1 1LY.
Magnetic Tapes Ltd, Chilton Works, Garden Road, Richmond.
3M (USA): 3M UK Ltd, 3M House, Wigmore Street, London W1A 1ET.
Amcron (USA): Macinnes Laboratories, Carlton Park Industrial Estate, Saxmundham, Suffolk IP17 2NL.

Tape recorders (video)
Akai (Japan): Rank Audio Products, PO Box 70, Great West Road, Brentford, Middlesex TW8 9HR.

Ampex (USA): Ampex International, 72 Berkeley Avenue, Reading, Berkshire.

Hitachi-Shibaden (Japan): Hitachi-Shibaden UK Ltd, Lodge Road, London NW4 4DQ.

Ikegami (Japan): Dixons Technical Ltd, 3 Soho Square, London W1.

IVC (USA): IVC, Liverpool Victoria House, Cheapside, Reading, Berkshire RG1 7AG.

JVC Nivico (Japan): Bell & Howell, Alperton House, Bridgewater Road, Wembley, Middlesex.

National (Japan): Dixons Technical Ltd, 3 Soho Square, London W1V 5DE.

Philips (Holland): Philips Electrical Ltd, Century House, Shaftesbury Avenue, London WC2H 8AS.

RCA (USA): RCA Communications Systems Division, Sunbury-on-Thames, Middlesex.

Sony (Japan): Sony UK Ltd, Commercial & Industrial Division, Ascot Road, Feltham, Middlesex.